Debbie Taylor worked for a year at the National Hospital for Nervous Diseases, London, following her PhD in Psychology at University College, London. She then moved to Africa, where she lived for two years in a traditional village on the edge of the Kalahari Desert. There she was initiated into the local tribe, and began her career as a writer. On her return to Britain she spent a total of seven years as editor of the *New Internationalist* magazine and wrote many major United Nations reports, including *The State of the World's Women* (1985), which formed the basis for her first book, *Women: A World Report*, published in the same year, and *The State of World Population* (1989). As a writer of what she herself calls 'documentary fiction' she has produced a book of short stories set in Thailand, *A Tale of Two Villages* (1986), and a novel about traditional magic and childbirth in Zimbabwe, *The Children who Sleep by the River* (1991).

As a film writer and researcher, she has been involved in several award-winning documentary films about women in developing countries for the BBC and Channel Four. She lives in Oxford and Scotland with the poet W.N. Herbert.

My Children, My Gold

Meetings with Women of The Fourth World

Debbie Taylor

This book was researched with funding support from Planet 21, a British charity which promotes people-centred options for sustainable development, and from the Swedish International Development Authority. Information on Planet 21 publications, including the quarterly magazine *People & the Planet*, may be obtained from Planet 21, 1 Woburn Walk, London WC1 0JJ.

Published by VIRAGO PRESS Limited August 1994
42–43 Gloucester Crescent, Camden Town, London NW1 7PD

A CIP catalogue record for this book is available from the British Library

Typeset by Florencetype Ltd, Kewstoke, Avon
Printed in Britain by Cox & Wyman Ltd, Reading, Berks.

Contents

FOR MY MOTHER, PEGGY TAYLOR

Acknowledgements

From its inception, this book seems to have had a charmed life. Every stage of its realisation has been met with a degree of support and enthusiasm I have never experienced with any other project I have been involved in.

My attempts at finding an organisation to finance the research met with immediate success, and I am very grateful to Anna Runeborg of the Swedish Authority for International Development and to John Rowley of Planet 21 for their faith in the book, and for the funds that made the research possible.

My earliest thoughts for the shape of the book were guided by Rob Cornford of Oxfam and Sunetra Puri of the International Planned Parenthood Federation, and by my partner Bill Herbert. Paul Harrison added the much-needed practical advice that turned the idea into a workable project.

At Virago, Lennie Goodings was a constant source of inspiration and encouragement: both before I embarked on the journey and after I came home and began actually writing. From the day I first approached her with the proposal, she has been both patient and incisive, making suggestions which I am sure have resulted in a tighter and more cohesive book.

The research in India, Egypt and Uganda was facilitated by Oxfam UK. I am especially grateful to Lorraine Collette, Jo Human and Peter Coleridge, who all spent hours of scarce time discussing the issues with me and ensuring that I was well looked after when I arrived at my destinations. Beyond the corridors of Oxfam House, I am also indebted to Janie Hampton and Glen Williams for advice about AIDS in Uganda; to Alex Shankland, Christina Silva and Tony Swift for help with contacts in Brazil; to Sue Monk of the National Council for One-Parent Families and Richie Smith of Gingerbread Scotland for useful discussions on the situation of single mothers in the UK.

ix

Acknowledgements

While I was in India, Oxfam's field staff – Lorraine Das, S.M. Farooque and Pramodini Pradhan – could not have been more helpful and welcoming. In Australia, too, many people gave me their time and hospitality, but I particularly appreciate the generosity and friendship of Sandy and Brian Loffler of Community Aid Abroad. In Uganda I am very grateful to Oxfam's Joseph Kato for acting as friend and adviser – as well as driver – and to Judy Adoko, similarly, for going beyond her role as Gender and Development Officer. I am not able to mention the real names of those women who helped me in China or Egypt, but I am indebted to them for accommodating me so warmly and – in Egypt particularly – at such short notice.

I am acknowledging my interpreters separately, because I literally could not have managed without them. Far more than just translating (a task which is difficult enough in itself), each also had to act as companion, fixer, adviser and general pourer-of-oil on to the continually ruffled waters that surrounded me. I feel very privileged to have had such mature, committed and unusual women to work with. The majority found themselves in tears at some point during the research: eloquent evidence of their deep empathy with the women we were interviewing and their skill at allowing such situations of intimacy to develop between us. Several were single mothers themselves, and their insights helped me enormously in trying to understand the experience of lone parenthood in their society.

Anindita Das in India approached the project with a powerful combination of passion, thoroughness and charm. Tarciana Portella in Brazil kept my feet on the ground with her good-humoured cynicism. I wish I could thank the others as directly – but I am not sure they would thank me for that. So, 'Kan', 'Bonnie', 'Sameh', and 'Zaineb': when you read this, you will know who you are. I hope you realise how important you were to me.

Throughout the three months I was travelling, Michael Du Lieu acted as a practical pivot for me in the UK, relaying messages, changing flights, smoothing cash flow – as well as talking me through attacks of long-distance late-at-night loneliness. Penny Buller, David Ransom and Peggy Taylor also did their

Acknowledgements

fair share of soothing my troubled brow while I was away. My love and thanks to you all.

Particular thanks are also due to Bill Herbert: for tireless constructive discussions on the progress of the manuscript – and for the poems which pursued me as I flew from one country to another.

Lastly, I must mention the subjects of the book: the seven women who allowed me to witness one week of their lives. To say I am grateful would be an understatement. All gave me access to their homes and their thoughts with a generosity and candour that make me ashamed of my own uptight Englishness. 'Hua' in China, 'Lydia' in Uganda and 'Amal' in Egypt did so at some risk to themselves. My time with them gave me something far more important than anecdotes for my book. Despite differences in our languages, cultures, income and experiences, I hope they would not disagree when I say we became friends.

This friendship was expressed particularly in the concern and sympathy each showed for my infertility. I think this piece of emptiness in my life went some way towards balancing the inequalities between us. And I have 'Hua', 'Jomuna', 'Lydia' and 'Maria' to thank for the traditional fertility treatments I took in China, India, Uganda and Brazil. I do not know whether it was as a result of the treatments themselves, or of the many prayers and good wishes each women sent after me – but I conceived my daughter, Isobel Mary, the week after my return to England. She was born the day after the last page of this book was delivered to the publishers. For me, if not for the women in my book, this chapter in our lives has turned out to have had a happy ending.

<div align="right">

Debbie Taylor
Elgin, Scotland
March 1994

</div>

Introduction

'I want to talk,' Lydia in Uganda had said. It was the middle of the night, and we were both in tears after she'd told me about the death of her husband from AIDS. I'd closed my notebook and was putting it away, but she took it out of my bag and opened it again on my lap. Until that point she'd been speaking in her own language. Now she dredged her memory for her small vocabulary of English words. 'You write,' she said firmly. 'I want to talk.'

This book is a group portrait of seven single mothers in seven countries. It's a picture which attempts to capture one of the world's most significant demographic phenomena: the families headed by women who now comprise one quarter of the world's population.

These women are pitted against two enemies. The first is poverty, which tugs them down on to the lowest rungs in their societies. The second is patriarchy, which sabotages their attempts to climb higher. This double-bind traps one in four families in what I have called the Fourth World.

My choice of women was dictated by the need to cover the issues as comprehensively as possible. I wanted the women I portrayed to be somehow representative of large numbers of single mothers in each region of the world. I wanted to speak to unmarried mothers, divorcées and widows. And I wanted to discover how their situation was affected by their culture, their religion and their economic background. Considerations like these determine the clothes each woman wears, but the expression on her face comes from her own unique story.

Most accounts of life in developing countries revolve around statistics: of population growth, malnutrition, infant mortality. These are vital, forming the landscape against which

1

real people can be understood. But if the landscape dominates, individual faces blur and fade into one another. Personalities are reduced to stereotypes; opinions to sound-bites that illustrate some global point. The result is a sanitised two-dimensional snapshot that invites us to distance ourselves from the information we are receiving. It's this distance – this sense of things happening 'out there', to people who aren't like us – that I am trying to bridge with this book. That's why I spent seven days with each of the seven women I met: eating what she ate, watching her work, sleeping – where possible – in her home. With her permission and co-operation, I investigated the dramas and minutiae of her life with the kind of attention we usually reserve for a close friend. What emerged were seven love stories played out against seven completely different cultural and economic backdrops.

But just as personal drama is often omitted from accounts of life in poor countries, so a sense of global perspective tends to be missing from our analysis of societies closer to home. That's why I've included women from two rich countries: to demonstrate the pervasiveness of the phenomenon of single motherhood; and to highlight the many experiences they share with their counterparts in developing countries. Together, these seven women represent a picture of life in the Fourth World.

The so-called 'breakdown of the family' in both hemispheres of the globe was one of the main justifications for the International Year of the Family in 1994. And the most visible symptom of this 'breakdown' is the one quarter of households managed by women without the support of a male partner.

Of course, this global total conceals wide regional disparities: in Europe, Asia and North Africa the figure is approximately one fifth; whereas in Latin America, the Caribbean and sub-Saharan Africa it is nearer one third. But one thing that's certain, whatever the region, is that the totals are rising in every country. In Ghana, for instance, 'woman-headed households' increased from 26 to 32 per cent between 1960 and 1984. In Morocco the numbers shot up from 11 to 15 per cent in one decade. In the

USA, too, one-parent families almost doubled from 12 to 23 per cent of families with dependent children between 1970 and 1989.

Households headed by women comprise an expanding underclass in every society – even in the rich world. Recent statistics from Europe reveal that single mothers are twice as likely to be living in poverty as couples with children. In the USA, too, the income of one-parent families is only a third that of the average couple-run household. North or South, it's the same story: half of woman-headed families in Brazil are below the poverty line compared with just a quarter of two-parent families. At every level in every society, the loss of a husband or partner pushes mother and children down the socioeconomic ladder. It is this impoverishment of increasing numbers of single-parent families which is responsible for what has been dubbed the 'feminisation of poverty' in every continent.

Women of the Fourth World occupy tenuous, difficult-to-define niches in their societies. Their days are fragmented by their responsibilities for earning an income and caring for their children. Their lives are hyphenated: they are part-timers, shift-workers, char-ladies: always hurrying somewhere. Often non-formal, sometimes semi-legal, many are forced out into the eddies around the mainstream: as hawkers and seasonal labourers; prostitutes, shebeen queens and beggars.

This fragmentation is one reason for their poverty. A part-time income can't meet the full-time needs of a growing family. So they stretch the day – rising before dawn and working long into the night – putting their health at risk so that the health of their children doesn't suffer. One wide-ranging study in the UK found that 'lone parents are in poorer health on all measures available' than mothers in two-parent families.

But the main reason why single-parent families are so poor is simply because they are supported by a single parent. The problem boils down to what demographers call the 'dependency ratio' – the number of wage-earning (or food-growing) adults divided by the number of dependent children (and sick or disabled people) in a family.

'The failure of fathers to pay maintenance for minor children is a serious problem for women,' said the UN's Committee for the Elimination of Discrimination Against Women, summing up the situation around the world. Only 30 per cent of British single mothers get any kind of regular economic support from their ex-partners. In countries without a welfare system, the problem becomes even more crucial.

The issue, then, is not the increase in single motherhood, but the decline in responsible fatherhood around the world. Because most single mothers do not choose to support their children on their own: in the vast majority of cases that decision is taken out of their hands by their husbands' departure – through desertion, divorce or death.

Until recently it would have been almost unthinkable for a man to abandon his family. In traditional societies, where labour and harvest are shared, families are held together by the firm knots of necessity – ties which are far stronger than love. Like his hoe or his herd, a wife and children are vital to a husband's survival. Without them he would have to work his land and tend his animals on his own; and there would be no one to care for and support him in his old age.

Viewed in these terms, marriage can be seen as a 'licence for fatherhood': a means of guaranteeing a man's access to these valuable helpmeets. This is why marriage is so important in traditional societies: why virginity is valued so highly, why couples are matched so carefully – sometimes against their wishes – and their unions sealed by formal exchanges of dowry and bridewealth. And why the vast majority of couples stay together until death do them part.

But lifestyles are changing in even the poorest countries. Increasingly people have individual jobs, which earn them individual wages. This undermines the reciprocity in the family, turning those without an income – like schoolchildren – into burdens on those who have. As a result, the 'licence for fatherhood' is less sought after and the institution of marriage has begun to decline: fewer couples are getting married in the first

4

place, and divorce rates are rising all over the world. With his practical need for his wife and children diminished, all that is left to keep a husband at home is responsibility – and love. If love wanes, responsibility alone may not be enough.

The likelihood of a woman's marriage breaking up before her mid-forties is now one in four in Asia and North Africa and one in three in Latin America, the Caribbean and sub-Saharan Africa. Since 1960, divorces have more than doubled in almost every European country. Where widows once comprised the majority of single mothers in most countries, their numbers are now dwarfed by the dramatic rise in the number of divorced and separated women with children.

Coping alone with their families is hard enough for the single mother. But on top of their practical problems – their poverty and the competing demands on their time – women of the Fourth World also face a battery of obstacles constructed by patriarchy. These obstacles seem designed to prevent them from creating a convivial independent existence. This patriarchal backlash took many forms for the different women I visited: from mild disapproval to outright sexual harassment; attempts to throw them out of their homes or take away their children; rules to prevent them from earning a living, remarrying, or even moving around freely.

The combination of poverty and patriarchy robs women twice. First they are denied their partner's support. Then – most cruelly – they are robbed of the recognition and admiration due to them for shouldering their responsibilities alone.

The thing that struck me most forcefully on my seven-country journey was the support each single mother was receiving from other women. The Fourth World seemed to be surviving almost completely independently of men. Maria, whom I visited in Brazil, put it succinctly: 'One mother is worth a thousand husbands'. This leads me to believe that we may be witnessing the emergence of a new form of matriarchy.

Often it's a reluctant matriarchy: interviews with unmarried teenage mothers in the UK revealed that they were extremely

resistant to any attempt to house them together. They still hoped to find a man to settle down with, and hated the thought of being confined to what they saw as a single mothers' ghetto. But in societies with a longer history and larger numbers of single mothers, women no longer see men as a potential solution to their problems. In much of the Caribbean, for example, there have been high numbers of single mothers for generations following the systematic dismantling of traditional families that was one result of slavery. Colonialism in sub-Saharan Africa had a similar effect, conscripting millions of men to work on colonial farms and mines, and leaving women to cope alone with their children on the infertile land the invaders didn't want. These two regions still have the highest proportions of single mothers in the world.

The way these women have learned to cope with the absence of their men is to reduce the 'dependency ratios' in their households as far as possible. They do this in two main ways: first by combining forces so that two or more adult women share a household, and one – often an elderly grandmother – minds the children so that the younger women are freed to go out to work. This was how the women I visited in both China and Brazil managed their competing responsibilities. These kinds of sharing arrangements have also been reported among long-term welfare recipients in the USA and Australia, and in poor communities in Mexico and the Philippines. The second way is to reduce the number of children per household by fostering and adoption within an extended family of women. A quarter of Liberian children and an eighth of those in the Dominican Republic grow up in families that don't contain their mothers.

It is these new kinship ties – based on communities of sisters, aunts and grandmothers – which may provide single mothers with a working alternative to the insecurity and disappointments of their failed marriages. Apart from the two widows, every one of the seven women I visited had decided for herself – however unwillingly or unhappily – that her marriage had come to an end. Where men have proved themselves unreliable partners, women are beginning to discount them from their

families. To start with, this often feels like a tragedy. But in time, many single mothers discover new strengths and new rewards in their independent lives.

In the Fourth World children must be the priority, not husbands. Long before I set out on my journey, when I was living in Botswana, I met a young woman named Suzanne. She had just given birth to her third illegitimate child. When I asked her whether she was angry at having been deserted by the fathers of her children, she seemed surprised by the question: 'If I find a purse of gold lying on the ground, I do not ask who the purse belongs to. These are my children, my gold.'

Hua

*After the imposition of the infamous One-Child
Policy, divorce rates in China began to rise rapidly,
doubling from 3 to nearly 6 per cent of marriages
between 1979 and 1983. This increase was partly
due to a relaxation in marriage laws, but a survey of
divorce cases in 1986 discovered that 30 per cent
were couples who had split up because their One
Child was a daughter. The husbands had simply dis-
carded their wives so that they could try for a son
with another woman.*

*Hua lives in a smog-shrouded slum in the north-
eastern megalopolis of Shenyang, gripped by winter
for six months of the year. Her nights are spent
working at a factory making soya milk; her days are
spent sleeping in the tiny two-room house she shares
with her mother and sister – and her One Child, a
daughter named Ling Ling.*

'WE hired three dogs yesterday,' remarked Kan, my interpreter.
I blinked at her. I had just arrived off a twenty-hour flight from
England, and things were beginning to seem somewhat surreal.
'One dog for ten minutes costs the same as one day's salary
for a worker,' she continued, while my brain started to seethe
with dogs driving trains, shining shoes, mopping floors. 'In the
park,' she explained. 'People hire them for their children to play
with. Rich people. That's how it is these days. Since the eco-
nomic reforms the difference between rich and poor has been
going like this – ' and she formed her slim hands into fists and
ratcheted them apart.

We were sipping green tea at Beijing airport beneath
a dusty plastic vine hung with pallid gourds. The walls were

festooned with posters depicting athletes in various forms of heroic endeavour, each proclaiming 'The New Open China welcomes the 2000 Olympics'. Kan's brother had just disappeared with my passport and most of my yuan. Apparently the yuan I had been given as a foreigner was different to the ordinary yuan used by the Chinese. 'It's special tourist currency,' Kan informed me. 'You can only use it in tourist hotels and tourist shops – and for tickets, of course. It's to prevent foreigners going to places the government doesn't want.'

Kan's brother was trying to get us tickets for Shenyang, the main industrial city in north-east China where I was going to do my research. Kan had already tried three times the previous week: 'I queued up for hours. But if you don't know someone it's hopeless. My brother does business with the brother of someone who works at the airport. Don't worry. It will be okay now.' She smiled reassuringly, and I began to realise how impossible it would have been to achieve anything in the New Open China without her.

Kan was one of the few academics who had supported the student protests in 1989. As a result, she had been forced to leave her home – and her five-year-old daughter – after government troops crushed the Tiananmen Square uprising. A divorcee, she had since remarried and was living in London, finishing a doctoral thesis on Chinese marriage.

It was during a discussion about China's infamous One-Child Policy – which punishes couples who exceed the one-child limit – that she had mentioned the abnormally high divorce rate among women whose One Child turned out to be a girl. 'So the One-Child Policy only really applies to women,' I had commented. 'Exactly. The husband tries again with someone else. But no one wants to marry the wife. And it's impossible to raise a child on one salary. I read about one woman who jumped off a high-rise building with her baby daughter after her husband divorced her.'

Kan had said she was planning to return to China soon to bring her daughter – now aged eleven – back with her to England. 'If you come at the same time, I will help you to find one of these divorced women for your book,' she had offered. So

here she was, sitting opposite me: a tall, slender woman in her late thirties, with wispy shoulder-length black hair and an oval face full of energy and fierce intelligence. 'When my brother comes back with the tickets, we'll take you to a hotel where you can sleep until the flight to Shenyang. There's no room at his place,' she explained apologetically. 'Chinese apartments are very small.'

'He filled this van with bread for the students during the democracy protests,' Kan told me proudly as we piled into a rickety little minibus parked outside. 'He even tied crates of milk to the roof. It cost a lot. Everyone in Beijing tried to give the students something. There were some poor traders who gave just one can of Coke. That was a day's income.' Her eyes shone at the memory. 'They were so young and so brave,' she said.

Beijing jolted past the window, disappointingly similar to any other megalopolis: the usual wide pavements and pale highrises; the usual pleated skirts and high heels, beige anoraks, denim and trainers. I looked in vain for a Mao suit – for any trace of revolutionary China. 'Do you think the students will try again?' I asked, and Kan shook her head firmly. 'No. The government was humiliated by the students and has become much stronger since then. China is open for money, not democracy.'

The only halfway charming feature of the 'tourist-quality' Bell Hotel was the eponymous brass bell dumped in the courtyard in front. The staff were lackadaisical, the sheets were grey and the carpet was covered with grit and dustballs. Every stick of furniture was broken and slightly squint, and rocked to the touch. The cold tap came off in my hand, and tepid water only came out of the hot one after a paroxysm of coughing from the very bowels of the hotel. 'We hope your life here will be happy and colourful, making you satisfied and memorable', said the dog-eared leaflet on the bedside table. I smiled and fell into a deep sleep.

Kan knocked on my door five hours later and introduced me to her daughter, Miao: a face-pulling, gum-chewing girl in a mauve Minnie-the-Mouse tracksuit and a pony-tail, with a fluffy

11

rucksack in the shape of a teddy bear on her back. She grinned
shyly at me and offered to carry my satchel. 'She's coming with
us to Shenyang,' Kan told me. 'She's been living there with my
mother-in-law ever since I left.'

Boarding the plane for the internal flight to Shenyang
was like braving the first day at the sales. We had to hold on to
each other to avoid being split up by our ruthless fellow-
travellers as we were shoehorned in through the narrow door.
Recovering in my aisle seat, I saw that they were mostly busi-
nessmen, with little crocodiles sewn on to their socks and
Armani labels sewn on to the outsides of their suits. The plane
itself was not quite so nattily turned out: the carpet covered
with great sticky stains, the signs pockmarked and written
in a language I didn't recognise. Then I did recognise it, and
my heart gave a lurch of dismay: Russian. We were in a
pensioned-off Aeroflot plane, a reject from the airline which
crashed more often than any other national airline. I wondered
if the engine was in the same state as the plumbing in the Bell
Hotel.

Miao burrowed under her seat and resurfaced, her bright
eyes circular with alarm. 'She says there are no life jackets,' said
Kan, trying to smile. I tried to smile back. Miao offered us each
a stick of green bubble gum. The three of us sat stiffly in a row,
studiously chewing while the plane juddered unsteadily into the
air.

At Shenyang we were met by a plump middle-aged woman with
frizzy permed hair. 'This is Jung,' said Kan. 'She was my best
friend at university. She's found us an apartment. We were
going to put you in a university room, but there would be too
many questions. This other place is safer, and you can see how
typical middle-class Chinese live.'

Safer? Questions? I didn't like the sound of this. 'What
would happen if people found out what I was doing here?' I
asked. 'They would report you to the police,' Kan said simply.
'And your notebooks would be taken and you would be sent
out of the country. They don't mind you looking at shrines and

12

temples. But they are ashamed of foreigners seeing how our poor people live.'

Jung led us to a large brown car driven by a handsome besuited man with large teeth. The car had velvet upholstery and maroon lace curtains. 'This is a company car,' said Kan as we set off. 'There are almost no private cars in China.' Jung was one of the new breed of business people at the heart of the economic reforms, she explained. It was her influence and 'friends' which had procured the loan of the apartment we would be staying in. This was clearly a vital aspect of middle-class life: 'friends' who lifted the bureaucratic red tape high enough for one another to scramble under.

Driving through Shenyang was like driving through a city at war. Dust and pollution hung in the air like beige muslin, casting the metropolis into a perpetual twilight. Many of the eight-abreast swarms of cyclists wore masks, or had shrouded their faces in trailing scarves. Street sweepers, like walking wounded, bound their heads so thoroughly with bandages that only black eyes showed, screwed up against the grit in the icy wind. A few people were dressed like refugees, bundled up in long heavy coats, with the bloody scabs of frostbite on their ears and lips from the city's sub-zero temperatures. I found out later that these were peasants from the surrounding countryside, who had come in to sell their produce and bedded down with their potatoes and cabbages in open carts at night.

Every so often we would turn a corner to find that whole terraces of little one-roomed houses had been razed to the ground. The flat open spaces smoked with the fires of scavengers, systematically sorting the rubble into piles of bricks, tiles and wood for sale. Cycle-carts with huge teetering loads – of waste paper, cardboard, window-frames – were pedalled away by small grim-faced men, like ants urgently evacuating a broken-open nest. 'They are getting rid of the slums and building apartment blocks,' said Kan. 'That's why there's so much dust.'

After a while the car turned into a courtyard surrounded by seven-storey concrete buildings. We began a slow ascent up a dark stairwell to an apartment on the sixth floor with a steel door

as thick as the walls of a safe. 'It's because there are so many rob-
beries,' said Kan. 'All middle-class apartments have doors like
this nowadays.'

Jung bustled in and started showing us round our new
home. It didn't take long. There was one main room, furnished
with two metal chairs, an iron bed with a padded plastic head-
board, a small black hi-fi tower and a pale pink telephone.
And a kitchen – too small for a table – with a single cold tap
dripping rusty water into a stained concrete sink. The adjoin-
ing toilet – which, by some trick of plumbing, vented its odours
via the plug-hole in the kitchen sink – was a hole flanked
by raised footprints. There was no bathroom, but Jung had
provided us with two plastic bowls and plenty of small towels
decorated with appliquéd rabbits.

'The apartment belongs to a company,' said Kan. 'Most of
the bigger companies provide housing for their workers. It's
been given to a man who's getting married next month.' The
walls had been newly whitewashed; the concrete floors were
freshly coated with red lino-paint. This was going to be some
young woman's dream home.

The next morning we breakfasted on noodles boiled with sliced
cucumber and beaten eggs. 'Now remember,' Kan warned as
I struggled to grasp a slither of egg in my chopsticks, 'don't
answer the door while I'm gone. Just keep quiet and pretend
there's no one here.' She was off to interview someone Jung had
identified as a possible subject for my book. If all went well, she
would bring the woman back here to meet me that afternoon.

'How did she find the woman?' I asked.

'She knows someone at the Women's Federation' –
another of those invaluable 'friends'. 'They help women in
difficult divorce cases. Jung asked for a list of wives who'd been
divorced for having a girl baby. It's mostly working-class
women, because their husbands are more traditional. Until two
years ago a third of all divorces were because of that. But
I found out last week that they changed the law now so a man
can't have another child if he divorces his wife for having a girl.'

14

'At least that's fairer than before.'

Kan smiled and shook her head. 'No. What happens now is the husband beats the wife until she divorces him instead. Then it looks like her idea, and he can get married again.'

After she left I went and stood by my sixth-floor window, peering out into a world blurred by the smoke from thousands of factory chimneys. An old woman sat in a window opposite, painstakingly cutting her fingernails, beneath a fringe of onions drying like clothes on a line. Many of the other windows were obscured by piles of baskets, pans and boxes, all the colour of dust. Above, the flat roof bristled with a vast complex of television aerials, like masts on a beached ship. Below, there were bars on all ground-floor windows and a sparse hedge of black bicycles growing against the wall. As I watched, an old man in white gloves emerged from one of the dark stairwells. He unlocked his bicycle and wiped the chrome with loving care, then pedalled majestically away.

Two pre-school children were playing in the centre of the courtyard, pushing sticks into the bare flowerbeds that surrounded three dismal dust-caked conifers. Dressed in vibrant red and turquoise tracksuits, they glowed like jewels in the dingy monochrome of their environment. I wondered if they were sisters; then realised they couldn't possibly be. Each city child is its parents' sole offspring, the sole bearer of the family's ambitions and frustrations. It seemed a heavy burden for such tiny shoulders.

The phone rang suddenly. I picked it up unthinkingly and said 'Hello'. A man's voice barked something in Chinese, and I suddenly remembered Kan's warnings. Staring stupidly at the receiver, I put it slowly back down, hearing his tinny voice recede. It rang again a few seconds later, and this time I didn't answer it. It went on ringing for five minutes, then stopped. Then started again half a minute later. I sat down miserably on the bed. Had I been discovered already?

Three hours later I heard feet on the stairs, and someone started banging on the steel door. I stood frozen in the little hallway,

not daring to breathe. Keys were inserted in first one lock, then the other.

'Why didn't you open it?' Kan asked, ushering a pale, curly-haired woman inside.

'You told me not to.' I was weak with relief. The pale woman stood with her back pressed against the wall, and smiled uncertainly at me. She had a long face with puffy eyelids, and her sturdy body was wadded with several layers of clothing topped with green woollen leggings and a tight grey checked jacket. 'This is Hua,' said Kan. 'I've told her we are both divorced, so she won't feel ashamed. She has never met a foreigner before, so this is very strange for her.'

'Would you like some tea?' I asked, ever the English hostess. Kan translated and Hua nodded, but when I went into the kitchen she rushed after me and tried to wrench the kettle out of my hands, miming that it was not right for me to serve her; I was the guest. When I refused to let go, she became quite agitated and an almost pleading expression came over her face – as though my boiling the kettle took the whole experience beyond the merely strange and into some intolerable realm of heresy.

'Can you say that in England it is traditional to offer people tea when they come to your home?' Kan translated and Hua reluctantly let go of the kettle, making a helpless little gesture with her hands. 'She says it's not usual for intellectuals to be so friendly,' said Kan.

'What are they usually like?' I asked, lighting the gas.

'She says she doesn't know any, because she is just a worker. But she thinks they would not want to talk to her.' So much for the Cultural Revolution, the forced mingling of professors and peasants. 'Can you say that in my country it's the same? The intellectuals never bother to talk to the workers.' Kan grinned at me, acknowledging the parallel.

We sat on the floor in the bare bedroom, sipping jasmine tea: me cross-legged, Hua and Kan with their legs neatly folded to the side. 'Is it okay for me to sit like this?' I asked suddenly, remembering the strict etiquette that was applied to women's sitting postures when I had worked in Japan and Thailand. 'Good

Chinese women are supposed to sit with their knees together or their legs crossed,' said Kan. 'That's why the Chinese character for "woman" has two lines crossed over each other. It means women sit still and stay at home. The character for "man" is a mixture of the symbols for "field" and "strong".' I changed my position, and Hua patted her padded thighs approvingly.

'Does she know why I'm here?' I asked.

'I said you were interested in divorce in different countries. But I didn't tell her you were writing a book, because she'd think you were a spy.'

'A spy?' I rolled my eyes. 'Who on earth would I be spying for?'

Kan leant forward: 'Chinese people are still very suspicious. Millions were arrested or killed after they were reported to the Red Guard. Lots of people betrayed their neighbours. My parents were put under house arrest – everyone knows someone who suffered. People lost their trust – it's impossible to forget that time.' Impossible for them, but all too easy for me.

'Do you mind talking about your divorce?' I asked, turning back to Hua. She gave another little helpless gesture: 'I had to talk about it to the Women's Federation, so I am used to it,' she said in a dull, resigned voice. 'But I feel the pain again every month, when I go to collect the money from Husband's factory. He's supposed to give me forty yuan for my daughter every month. I feel like a beggar going there to ask for it.'

'Divorce is very common in England,' I said. 'Almost all my family are divorced: me, my sister, my brother and my parents. The only one who's not is my youngest brother, and that's because he never got married in the first place.' Hua's eyes widened with surprise when she heard this: surprise, and more than a hint of disapproval. Though Chinese divorce rates were increasing rapidly – from 2 to 7 per cent in five years – it was obviously still a scandalous event.

Hua looked thoughtful. 'Do you think divorce is a good thing?' she asked. I swallowed: I didn't want to fob her off with a platitude. 'I think it's good for a woman to escape from a man who's cruel to her,' I said slowly. She frowned, considering, then spoke passionately: 'I think you should choose your husband

very carefully. You should find out everything about his character and his family. If you are cautious you will avoid divorce. That's the mistake I made with my husband. I was suspicious, but I let him convince me.' Hua reached into her breast pocket, pulled out some much-folded pieces of yellowing paper, and handed them to Kan.

'These are her official divorce papers,' said Kan, unfolding them. 'It says: "Reasons for divorce. Lack of affection, man is not happy with girl baby, he beats the woman often and does not provide money to support her." Then it says: "The woman insists on divorce". That's what I told you – he beats her until she can't stand it any more. And here it says: "The child has been raised by the woman and has affection for her, therefore it is better that the child stays with the woman". And then further down: "It is better that the apartment should belong to the man".'

'So he gets a place to live and she's out on the street with her daughter? Do they give any justification for that?'

Kan frowned, reading on. 'No, but I expect it's because it was given to him by his company, like this one. Apartments are only given to male workers.'

'What did she get?'

'It says here that "the man keeps everything except the following items". That's because she was the one who wanted the divorce. They even made her pay the court fee. Then there's a list of things she was allowed to take with her. It's mostly her own clothes – listen: "red woollen tights, thermal underwear, jacket, old green trousers, old checked jacket, old flowered shirt, old, old, old – "' She looked up: 'It's all old clothes. Then "a plastic fruit dish, one plastic apple and three plastic pears, two pounds of brick-coloured knitting wool, a picture, four small towels, a quilt, a clock, pressure cooker, thirteen square metres of plastic matting – "'

'No furniture?'

'I'm just looking. There's nothing valuable here. Wait: "washing machine and washing machine cover made of cloth, folding table, two wooden boxes, one double bed".'

'At least she had something to sleep on.' I looked at Hua,

18

sitting patiently while we exclaimed over her pieces of paper. She was still wearing the 'old checked jacket' and 'old green trousers', but she had bought a new scarf and trainers since this was written three years ago. I tried to imagine a room furnished with the few things she had been left with. Then a thought struck me. 'Where is she living now?' I asked.

'She's in a two-room slum house on the other side of town. Jung brought her out to meet me, so I haven't seen it. But it's a very poor area. I don't know how we can get you in there, or if she'll agree. Let me ask'. The two women talked for a long time: Kan's face animated and charming, Hua's running the gamut from suspicion to incredulity, uncertainty to eagerness. Eventually they arrived at a decision. 'She didn't understand why you want to stay in her house,' said Kan. 'But I explained that you want to see how an ordinary family lives. Then she was worried that you would not be comfortable because she lives in such a poor place. She is more worried about that than about neighbours thinking you are a spy.'

I turned to Hua. 'I've stayed in lots of poor houses,' I said. 'I feel honoured visiting a poor home, because if someone is poor, their hospitality is more valuable.' It sounded trite, but I meant it.

Hua nodded thoughtfully. 'There is just one bed – for Mother, Little Sister, Daughter and me. If you want, you can sleep in my place with the others when I'm at work. I work the night shift at the factory, so there will be room. And it will be safer than coming in the daytime because it's too late for visitors and no one will notice you if you arrive in the dark.'

I wondered what the others would think about a stranger coming and sleeping in their midst. 'Will I be able to see you before you go to work?' I asked.

'I leave at nine o'clock, so you can come at seven. If no one is suspicious, you can come back again the next night.'

I saw my ambition of shadowing Hua through every aspect of her life slip inexorably out of my grasp. The New Open China might welcome the 2000 Olympics, but it was clearly not ready to welcome me. Yet Hua's anxious expression told me that the glimpses of her life she was offering me would

be dearly bought. I touched her shoulder, wanting to communicate that I knew how much this was costing her. 'What's your daughter's name?' I asked. 'Ling Ling,' she said, smiling. 'It means little flower.'

After Hua had left, I told Kan about the phone calls. 'Maybe it was a friend of Jung's,' I suggested.

'No, they wouldn't call here.'

'Maybe it was a wrong number.'

'Maybe.' She didn't look convinced.

'Do you think it was the police?'

She smiled thinly. 'I don't know,' she said. 'But if it was, we'll soon find out.'

The next day I sat at the window again, writing up my notes. A pale sun shone weakly through the poisonous milky air, and six pigeons – the only birds I had seen – slewed and skidded round an invisible racetrack circling the rooftops. From my vantage point I had a good view of the playground of the neighbouring school. It was like a building site, strewn with heaps of rubble and pipes. At the far end was the toilet block: a row of small brick stalls open to the sky.

Kan had gone to visit her daughter, leaving me staring down at my small slice of China, like a Muslim woman in purdah: allowed to see but not be seen, to look but not touch. An icy wind gusted outside, shaking the small panes in the windows and driving dust in through the cracks. Since I'd arrived at the apartment, I'd gone out only once: to the little restaurant on the main road.

The restaurateur had been frosty at first, seating us at the coldest table by the door. Kan and I had huddled over the tepid radiator with our coats on, fumbling chopsticks with numb fingers. It turned out that he thought I was Russian. It was my old leather jacket, he explained apologetically when he discovered his mistake. And my red hair. The Russians came with big empty bags, he said, and filled them with cheap Chinese leather

jackets to sell in Moscow. I enjoyed the irony: socialism-turned-
capitalism with a vengeance. Exploitation, he called it: making
a profit out of poor Chinese workers. And he shook his mop
of greased hair, almost snarling his disapproval. Then he gave
us free dumplings as a peace offering; and a thick pink drink
made from hawthorn berries.

That night we took a taxi to the slum where Hua lived. A little
picture of Mao in an ornate frame swung from the driving
mirror like a talisman. We got out beside a row of tin-roofed
café-cum-amusement-arcades on the main road. 'In case the
driver gets suspicious,' Kan whispered, then: 'Don't speak to me
until we're inside her house. I don't want anyone to hear
us talking English.' I had tied a dark scarf over my hair, and
hurried after her with my face averted.

There were no street lights in the slum settlement, and a
strong stench of sewage hung heavily in the dark lanes. Using
my torch, we picked our way gingerly down an alley between
the one-storey terraces, sidestepping muddy puddles and edging
between the forest of parked bicycles and the looming piles
of sacks, buckets and chicken coops that leant against each tiny
brick-and-tile dwelling.

I flashed the torch at peeling turquoise front doors as Kan
scrutinised the numbers. Then we held our breath as she
knocked on a door near the end of an alley. It opened almost
immediately and Hua beckoned us silently inside, locking
it behind us. With her finger on her lips, she led us through
a small smoky outhouse into a warmly lit room beyond, where
the rest of the family stood in a formal little group waiting to
greet us. It wasn't until she'd closed the second door behind us
that she spoke.

'This room has a proper ceiling, so the neighbours can't
hear. In the other room there's a gap between the walls and the
roof, so it's not safe.' Kan nodded approvingly, and we slipped
off our boots and stepped into the plastic slippers Hua placed
ready for us.

'Is this her mother's house?' I asked, bowing and smiling

at a vigorous old woman with narrow bird-like shoulders and straight bobbed grey hair. The old woman beamed, her eyes disappearing into deep doughy creases, then gestured disparagingly round the room. 'It was given to her because her son is in the army in Tien Jing,' said Kan, translating. 'She is ashamed for you to see such a poor place.'

I looked round at the cosy little room. Measuring about twelve foot by twelve, it was dominated by the bed, a two-foot-high square structure in one corner with a neat stack of quilts and pillows at one end, covered by a decorative flowered cloth. 'These beds are very traditional,' said Kan. 'They're hollow so they can be heated by smoke from the cooking fire in the outhouse. They stop people freezing to death in the winter.' I put my hand on the fake-woodgrain Fablon-covered surface: it was as warm as toast.

Hua and her mother bustled around preparing tea, while her sister – in lipstick and red leggings, with two geometric black lines painted where her eyebrows should be – wiped the Fablon carefully with a cloth and invited us to sit on the bed.

There was nowhere else to sit. The room had been carefully arranged to utilise every inch of available space. A big wardrobe without legs, perched crookedly on four bricks, took up most of one wall. Wedged beside it were two wooden chests on which perched a small black-and-white television, a rechargeable battery and a small reading lamp. Beside that was a green twin-tub covered with the piece of flowered cloth I recognised from Hua's divorce papers.

I searched the room for the three plastic pears and located them, and the plastic fruit bowl, on a heavy sideboard, also legless, also propped up on bricks. The sideboard was covered with the same woodgrain Fablon as the bed, and had tropical birds painted on its glass doors. Stacked neatly against the wall, a circular folding table and two metal folding stools completed the furniture. The rest of the wall space was occupied by sacks, cardboard boxes and dusty polythene bags. A bikini-clad Chinese woman smirked over her shoulder at me from a poster-sized calendar. Faded red New Year's streamers hung from a square electric clock, with the time frozen at five-past-four.

After a while I became aware of Hua's five-year-old daughter, Ling Ling, staring silently at me. She was standing by the wardrobe with her hands folded: thin and pale, like a flower grown in the dark. She had a delicate pixie face, with perfect skin pulled tightly over tiny features, and a cap of glossy black hair. She wore a string of pearls around her neck, and a pink smock and trousers trimmed with lace and embroidered mice.

'She probably thinks I'm a monster,' I said, and Kan laughed and went to kneel beside the child. 'She says your nose is very big and your hair is a funny colour.' I touched my nose self-consciously. Hua handed us tea in chipped enamel mugs. 'She says all Westerners look the same, with round eyes and big noses.'

'How long have you lived here?' I asked Hua, as she set up the round table and sat down on one of the stools.

'About ten years. Ever since Father died. Before that we were in a bigger place, with two rooms, but it was quite crowded because there were six children as well as my parents living there.'

'Were you happy?'

Hua hesitated a moment, glancing quickly at her mother as if seeking permission to speak. The old woman sighed, neither approving nor disapproving.

'It was very difficult for Mother, because Father had a very bad temper. He was an honest man –' this was obviously important to her – 'but he didn't have much self-control. He used to work at a tofu factory and one day there was a big fight there – he never said what it was about. But after that he went mad and had to give up work. So Mother had to get a job, even though Little Sister was just a baby. It was during the Great Leap Forward, when lots of women went into the factories. Father's factory gave her a cleaning job, but it was very badly paid so they gave her leftover tofu to take home for us.' Hua's mother interrupted, patting her stomach through her grey cardigan. 'Sometimes I had to work the whole day on an empty stomach so the children could have food,' she said.

'Did your father get any treatment?'

Hua shook her head. 'There was no money to take him to hospital, so he stayed at home all day. He used to walk up and

down shouting, and hit us for no reason. Sometimes he would wander out of the house and disappear for two or three days, then come back tired and dirty.'

'How old were you when all this was happening?'

'It was just after Little Sister was born. So I must have been three when he first went mad.'

The ghosts of six frightened children seemed to inhabit the room for a moment: going cautiously about their chores, all bundled up in layers of ragged wool, or sitting wordlessly together on the bed, watching their father's restless movements with wary eyes.

'He died in 1981,' she continued. 'Just after my twenty-first birthday. That was when we moved to this place. My two eldest sisters and my two brothers had got married by then, so there was just me and Xiang still at home.' So the three women had been living in this tiny house for twelve years. 'Are you divorced too?' I asked the younger woman, who was fluffing up her permed fringe in a broken mirror. She made an angry throwaway gesture with her free hand. 'After seeing how that man treated Elder Sister, how can I trust anyone? Men have made approaches, but I never liked any of them.'

She was thirty, she said: three years younger than Hua. 'Do you think you'll ever get married?' I asked, and she shook her head, pouting and reapplying dark lipstick. 'A neighbour wanted to introduce me to someone last year, but he was a peasant from outside Shenyang.' Her look of disgust said she would have to be absolutely desperate to accept life with a man who smelt of sheep and straw.

I was becoming intrigued by these 'approaches'. Kan had already explained that meetings between unattached men and women were arranged with great care in most sections of Chinese society. Parents, neighbours, relatives and friends conferred constantly over the merits of potential spouses, setting up excruciating encounters where the unfortunate couple could scrutinise one another over tea and sweets. 'Is that how you met your husband?' I asked, and an expression of real distress came over Hua's face.

'I was so stupid,' she said bitterly. 'Sister-in-law said she

knew a nice man who wanted to meet me. She said his name was Reng and he worked as an electrician in a big factory. I asked if he was reliable and she gave him a very good character reference, so I agreed to see him.'

'Were you nervous?'

'Oh yes – I didn't have anything new to wear. So I put on my red skirt and curled my hair. It was at Sister-in-law's house. There were a lot of people there – it was embarrassing to eat with everyone looking at me. But I liked the look of him, so I told my sister-in-law I was willing to meet him again.'

'What were you looking for?' I asked, and was surprised to see her squirm with discomfort and glance sideways at her sister.

'What's the matter?' I turned to Kan in alarm. 'She doesn't have to answer if she doesn't want to.'

'It's because Chinese women are not supposed to be choosy,' Kan explained. 'It's one of the worst things you can say about a woman. We're supposed to just accept what we're offered. I think she's afraid we'll disapprove of her.' Eventually Hua admitted that she had been looking for someone quiet and honest, and that no one she'd met before Reng had fulfilled these criteria.

So Hua's sister-in-law had set up another meeting – in the street this time, so that the couple could be alone. They had walked together for a while, then Reng had escorted her home and she'd introduced him to her mother. 'After that he used to come every day after work. And he was so helpful. We'd been collecting bricks to build the outhouse, a few at a time, whenever we could afford some. And Reng brought the cement, and did all the heavy work, and fixed the lights – ' Her voice broke suddenly and I noticed that she was crying, knocking the tears impatiently from her eyes with the back of her hand.

'Would you rather talk about something else?' I asked, but she shook her head. 'I'm crying because I'm so angry. I really trusted him. But inside he had a heart of stone.'

'Did he tell you he loved you?'

Hua shook her head, embarrassed again. 'We never say things like that. You show love by doing things for the person

25

you love. That's how Reng tricked me into marrying him – even after I'd met his mother.

'She hated me from the start – because Father was dead and had lost all his friends when he went mad. She wanted someone better for her darling son. When I met her she was cold as a block of ice. She didn't even try to make me feel welcome. So I refused to see Reng any more. I didn't want to live with a woman like that, so I locked the door and Mother told him to go away. But he came round every day, begging me to let me in, swearing he wouldn't let his mother spoil our life together.' Hua shook her head, marvelling at her own folly. 'It's my own fault. I should never have believed him.'

'Was he lying, then?' I asked, and she sighed heavily: 'No, I think he really did love me at the beginning. Otherwise he wouldn't have gone against her. But she kept on and on. And when I had a daughter instead of a son, that was the end.' I looked at Ling Ling, listening solemnly to our conversation. While we were talking, Xiang had painted kohl around her almond-shaped eyes and they seemed huge in her tiny triangular face: wise and wounded beyond her years.

'Can you find out where the toilet is before you go?' I asked as Kan bent to pull on her boots.

'There are public latrines, but they're disgusting,' Hua explained apologetically, taking my hand and leading me into the outhouse. 'So we go in this' – pulling a pink plastic spittoon from the shadows – 'and tip it into this' – a big aluminium canister – 'with all the dirty water from washing. And when it's full we empty it into the latrines.'

'You'll have to use hand signals from now on,' said Kan as Hua unlocked the outhouse door. 'But I think you should be safe. No one will come round at this time of night.'

After she'd gone, the small room seemed to fill up with silence. We stood awkwardly smiling at one another. I looked at the three women's faces, each straining to please their strange visitor. Xiang patted the bed, asking whether I was tired yet. Her mother gestured to the Thermos on the sideboard to find

out if I wanted more tea. Hua led me into the outhouse, to the cold tap, miming that I could wash if I wanted to. I felt trapped, hemmed in by their curiosity and kindness. And abashed, knowing I would never have been so generous with my hospitality. And finally angry with myself for putting us all through this agony.

Praying for the awkwardness to pass, I made a great show of examining the cooking fire: small and circular in a neat concrete surround. Then I sat on the bed and picked up Ling Ling's toys: a minute wooden steam-train and coaches and a sheet of small adhesive squares, each depicting a cartoon animal.

Hua began to get ready for work, heating water in the kettle and washing her face, neck and arms. Then she pulled on another layer of clothing and smeared moisturiser and pale pancake on to her face, flattening and whitening her features for her nocturnal existence. Though her shift didn't begin until midnight, she always left home at nine because it was dangerous for a woman to cycle through the city any later. 'Men might jump out at you and knock you off your bicycle,' she had explained. She preferred to go earlier and sleep in the factory doorway until the foreman arrived to let her in.

'When do you get the rest of your sleep?' I had asked, imagining her huddled shivering on the cold concrete.

'When I come back, after breakfast. It was difficult to start with, because the room is so small and everyone else was awake. I still get very tired, but I'm used to it now.'

After she'd gone, Xiang began to get Ling Ling ready for the night, stripping off the pink smock and the layers of bulky wool underneath and revealing, like a shameful secret, a body as thin and pale as lotus roots hidden in the mud. I had known they were poor, but it wasn't until I saw those wasted limbs that I understood just how poor they were.

Meanwhile the old woman was preparing the bed for the night, laying out the pile of bedding. Ling Ling snuggled down near the wall, and Xiang stripped down to cotton leggings and yellow roll-neck and wrapped herself in a quilt to watch television. Following her example, I removed my black tracksuit, unrolled my sleeping-bag and wriggled into it in my long

27

thermal underwear. Switching off the fluorescent light, the old woman smiled and nodded towards the television, expressing what I felt: that we were united at last, like families all over the world, in the monochrome glow of the small screen.

We watched the end of a love story involving oriental actors in eighteenth-century European costume sighing and clutching their lacy bosoms. At its climax the wronged heroine swooned in sexual ecstasy as her beloved applied his lips passionately to the back of her hand. This was followed by instructions for breeding Japanese koi and a variety show involving slapstick comedians and twenty energetic men with whistles of various sizes – all interspersed with adverts for make-up and steroid medication: symbols of the New Open China.

At about eleven, when I couldn't put it off any longer, I reached for my torch and opened the door to the dark out-house. Xiang and her mother had clearly been waiting for this moment, because they were beside me in a flash, each with a torch of her own, solicitously extracting the pink bowl from its recess and spotlighting it so that I could admire it in all its pastel glory. I thanked them, smiling, trying to indicate that I could manage on my own. They smiled back encouragingly, unwaveringly, and it dawned on me that they were not going to leave until I had finished. I pulled down my long johns and squatted with two torches playing on my bare bottom. Nothing happened: the silence was total and terrifying. I closed my eyes and thought of waterfalls and dripping taps: still nothing. Finally, finally, it came: an apologetic, strangulated dribble that seemed to go on for half a century. I think we were all relieved.

The night was long and broken. A big alarm clock ticked loudly on the sideboard and the old woman snored juicily, spluttering occasionally and rolling against me. Every two hours she woke properly and got up to blow her nose on the outhouse floor, then piss loud and long into the pink potty. Twice she lifted Ling Ling out of bed too, and held her, still sleeping, over the potty, hissing gently in her ear to inspire her and prevent her

from wetting the bed. By morning the outhouse smelt sour and earthy, like a stable.

At five-thirty Xiang got up and went out to buy breakfast: long fresh pieces of bread, fried like doughnuts, and little cucumbers, which her mother cooked with eggs and shallots, squatting by the fire. Compared with the pickled vegetables and cold rice they normally had, it was a feast. But I didn't realise that at the time, nor the fact that they had got up an hour earlier than usual in order to buy it and prepare it for me.

Kan came to fetch me after breakfast, hurrying me out through the narrow alleys, looking neither right nor left until we reached the anonymity of the main road.

When we got back to the apartment, someone had pasted two huge red Chinese characters on the wall of the apartment opposite. 'It means "double happiness",' said Kan. 'There will be a wedding here today.'

The wedding party was being held at the restaurant round the corner, and the pavement was jammed with bicycles. The bride arrived at the same time as we did, ducking out of her hired minibus, resplendent in traditional scarlet with a headdress of pink net and roses, pinned to a froth of permed curls. She frowned suspiciously at me at first, but when she discovered I wasn't Russian, she gave me a piece of 'happy candy'.

The party itself was strictly segregated: men in one room, in suits or army uniforms; women in the other, in jumpers and skirts. The women laughed uproariously as the bride lit their 'happy cigarettes' – ordinary cigarettes smoked ceremonially at weddings – then coughed as they took the obligatory but unfamiliar happy drags. They poured us beers and pushed meatballs into our mouths with their chopsticks; jostled boisterously, trying to blow out the bride's happy matches. The bride threw her frothy head back and laughed aloud, cheeks glowing, earrings gleaming. Self-conscious in glasses and pinstripes, the groom watched her. Their eyes met: it was the happiest day of their lives.

*

'What was your wedding like?' I asked Hua that evening. We were sitting in the crowded little room, as before, sipping tea, as before. But the atmosphere was different: less anxious, more relaxed after the undignified intimacies of the previous night. Hua snorted angrily when Kan translated the question: 'I was insulted at my own wedding party! There should have been sausages and chicken, but his mother was too mean to buy any. I heard people whispering what a poor feast it was. But she had no shame, that woman. She even put a nail in the food!'

'A nail? You mean the thing you hammer into the wall?' I raised my eyebrows in astonishment, and Hua laughed despite herself. 'I was so stupid!' she said. 'I pretended it was an accident. But a rusty old nail doesn't just drop into a cooking pot. And the guests were really shocked. They knew she was trying to show how much she hated me.'

'Didn't your husband say anything to her?'

'Not then, no. But after the wedding, when I first moved into their house – yes, sometimes. But he was scared of her. She took all the decisions in that family. She had a job making burglar alarms and she was short and fat, but she had an evil tongue. Her husband just used to sit in the corner and say nothing. Even the neighbours were frightened of her – '

'And what about you – were you scared?'

Hua's chest began to heave beneath her red cardigan: 'I really tried,' she said, her eyes filling with angry tears. 'But it was impossible. She wouldn't let me cook on the stove, but when I went to buy fast food from the market she said I was lazy and wasting money. So I started working late to earn extra, but then she told Reng I had a lover and he beat me until I promised to come home earlier. Once she even held my arms so he could beat me. I kept hoping if I was polite and patient, she'd start to like me. Reng's brother's wife was treated better, because her father worked in a good factory and because she'd arranged for them to meet. She couldn't forgive Reng for choosing a wife without consulting her. She used to say he'd chosen a piece of garbage – in front of everyone, even when I was in the room!'

I tried to imagine what it must have been like to come

home to that hothouse of hostility after a twelve-hour shift in the factory. 'Sometimes I lost my temper,' Hua confessed. 'Once I was invited out for a New Year party and you have to take rice wine, so I asked Reng for some money. Well, she just went crazy, screaming and calling me a greedy girl. So I switched on the tape-recorder to record her so she could hear what she sounded like – ' My startled laugh broke into her angry narration. 'It was a bad idea, wasn't it?' she said, flashing a look of sly merriment at me.

'What did she do?'

'She ripped the tape out and started hitting me. Then she called Reng and told him he should keep his wife under control, so he started hitting me too, just because she told him to. That hurt more than his fists, so I rushed into the other room and tore up our marriage certificate. Then I took all the pills I could find, just stuffed them into my mouth and chewed them. But I was crying so much I couldn't swallow properly, and I didn't have any water to wash them down, so when he came and hit my back I just vomited them up again. I didn't know what else to do,' she said earnestly, trying to make us understand. 'I knew it was going wrong, but nothing I tried made any difference.'

That night I felt more at home sitting on the warm bed with my back against the smoke-stained wall. Xiang settled down beside me to read the newspaper, a single folded broadsheet without photos, closely typed with columns of characters. It was Hua who put Ling Ling to bed this time, washing her with brusque efficient movements as the little girl stood naked and shivering in the outhouse, pale arms folded against her fragile rib-cage. Afterwards, she patted her daughter affectionately on the head, then tugged on her checked jacket and manoeuvred the heavy bicycle out into the night.

The child had been coughing during the evening, so the old woman reached a plastic bag down from behind the electricity meter and extracted a small orange pill to give her. I picked up the carton and read the English label: it was streptomycin,

an antibiotic; patients were urged to complete the full course of treatment. I'd also been coughing – everyone coughed in Shenyang – so she offered me one too, insisting so strongly that I pretended to swallow it with my tea.

Later she rolled Ling Ling on to her back and rubbed fragrant oil on her throat, pulling at the skin as though to tug out the irritation inside. Using the same oil, she greased the rim of a large glass jar, then tipped a little in, shaking it to coat the inside. Then she took a small cone of wax and lit it with a match, placing it carefully on Ling Ling's chest and upending the glass jar over it until the air was consumed and replaced by a swirl of black smoke. The child whimpered in pain from the heat, but lay still as the jar stuck fast to the skin of her narrow little sternum, held firm by the vacuum inside. The old woman made a sucking gesture with her mouth, indicating that this would draw out the badness. Then she pointed at her own chest, shaking her head in disgust, and went to hawk and spit on to the outhouse floor.

Watching her undress, I was struck by the tiny bird-like skeleton that was hidden under her layers of grey wool: the pigeon chest of rickets; a history of hunger written in her bones. Before she switched out the light, she leant over and smoothed Ling Ling's hair off her face. It was wet with perspiration, and stood up in little damp spikes above the delicate feathers of her eyebrows.

'Would you like a traditional Chinese bath?' Kan asked as we got into the taxi the following day. 'We can't go with Hua to the baths at her factory, but you can see something like it.'

'Don't tell me – a "friend" of Jung has arranged it.'

She grinned. 'They're council baths. Usually only employees are allowed in.'

The guards at the gates wore guns. Inside – once they had discovered I wasn't Russian – the woman attendants approved of my lacy wool vest but advised me to throw away my leather jacket and buy a cheap new Chinese one instead. We went into a large pink-tiled room lined with lockers. It was full of women:

old and young, fat and thin, dressing and undressing. Steam billowed as they passed in and out through the door to the showers.

Finding a vacant locker, I started peeling off my clothes. To be fair, the other women tried to be polite. Only the very young and the very old stared openly at my freckled arms and pink nipples, and the hair on my arms and legs that had never seemed unduly excessive at home. I felt ungainly beside their neat boyish figures with their buff skin and brown nipples, their smooth muscular cyclist's legs.

Since the majority of urban Chinese have access to a place like this only once or twice a week, the cleansing process is extremely thorough. As one stands under scalding showers, soap is lathered all over the body, then rinsed off. Then comes defoliation, accomplished by scrubbing a rough cloth over the skin, as though removing a particularly stubborn label from a glass jar with a Brillo pad. The women helped each other, lending shampoo and soap and scraping one another's backs with concentrated zeal until the skin sloughed off in greasy grey strings. Afterwards I washed my headscarf in one of the sinks. Though I'd worn it only a few times, the water was scummy and black from the dirt in the air.

Then we went shopping. I wanted to see the market Hua went to, and the big department stores that had sprouted since the economic reforms. Following Hua's directions, Kan and I wandered down a long wide street lined with stalls of every kind: simple barrows, loaded with potatoes and greens; a sandy dog tethered outside a butcher's shop waiting to be slaughtered; racks of leggings and jumpers; scarves trailing like folded peacock tails; hairdressers in glass-fronted Portakabins draped coyly with lace curtains. And food – fast and slow food, raw and cooked, hot and cold – everywhere we looked. 'Ten years ago you couldn't buy a biscuit in the shops,' said Kan.

In the department store everything was covered with dust, and dimly lit with twenty-watt bulbs. The escalators were a solid mass of people surveying the wonders of capitalist invention. Young women in pink uniforms stood shoulder to shoulder behind the counters, demonstrating hairdryers and

wind-up toy turtles with equal dedication. On the top floor – in poses of tortured exuberance – an army of wigless child-mannikins modelled elaborate party frocks in purple and orange velvet.

I paused curiously at the women's underwear section. 'All the bras are padded!' I exclaimed. 'It's the New Shape,' said Kan. 'Ten years ago no one dared to emphasise their breasts. You had to be flat to be a good socialist.'

We took Kan's daughter with us that evening, and she pounced on Ling Ling and began combing her hair, putting make-up on her as though she were a doll. 'Do you have a child too?' asked Hua as we watched them.

The question was inevitable: I knew I'd be asked it in every country I visited. Hua gave me a long sorrowful look when she heard about my fruitless battle against infertility; then she called Ling Ling over and whispered something in her ear. The little girl was convulsed with shyness for a moment, then she straightened her back and made a little speech, clasping her hands formally in front of her. 'What's she saying?' I asked, seeing Kan's eyes soften. 'Hua has asked her to call you "Mother". She was saying: "Mother, I am happy that you have come to stay in our house".'

'You have a lovely daughter,' I said to Hua as the two girls ran off to buy bubble gum. 'Were you disappointed when she was born?'

Hua held two tiny red acrylic socks in her hands, and started smoothing them and rolling them up over and over. 'When I was pregnant, the fortune-teller said I would have a boy, so that was what I was expecting. I thought Reng might treat me with more respect if I had a son. But when she was born she was so beautiful I just loved her anyway. If a baby comes out the normal way, it gets red and squashed. But I had to have a Caesarean operation, so she was absolutely perfect.' She smiled softly, and I noticed for the first time that she had dimples in her cheeks.

'What did Reng think when he saw her?'

Hua's face hardened: 'He didn't want to see her. When he found out she was a girl, he left the hospital and went home. He didn't even come and visit me. None of them did. I was in hospital for ten days and no one from that family came near me. My heart was broken. The doctors said that was why my milk dried up. And my belly became infected and swelled up after the operation. I just used to lie there hoping he would come. All the other patients were looking at me and I felt so ashamed. In the end I had to go home with my mother because I knew Reng's mother wouldn't look after me if I went back there.'

'It's traditional for a woman to stay in bed for a month after having a baby,' Kan explained. 'She's supposed to be pampered and given chicken soup and a special kind of fish. It should be a time when a new wife is really accepted as part of her husband's family.'

I turned back to Hua. 'Why was a son so important to them?'

'Oh, lots of reasons,' she sighed, getting up to cram the socks into a sideboard drawer. 'Boys get better jobs, so they can help you better when you're old. And men have more contacts, so they can get things done if there's a queue. We wouldn't have this place to live in if my brother hadn't got it for us. People just respect you more if you have a son: they don't insult you so much, or try to take advantage, because they know that one day they might need him to do something for them. If my brother had been living here instead of miles away in Tien Jing, Reng wouldn't have beaten me so often and his mother wouldn't have dared to treat me the way she did. Also, if a man doesn't have a son, his colleagues say that he has failed to continue his family line.'

I raised my eyebrows. The other things made sense, but I didn't understand this last one. 'That's the worst insult you can give to a Chinese man,' Kan explained. 'It's his duty to carry the family name from one generation to the next. It's how masculinity is defined, especially among poor people.'

Suddenly there was a knock at the door and we all stiffened. The old woman went and pressed her ear to the bare

wood, then beamed with relief. Chewing madly and smelling of pear-drops, Miao and Ling Ling burst in and ran to their mothers, full of some story of their adventures in the world outside the cramped little rooms.

'What's this?' I picked up an exercise book that was lying on the sideboard. It was full of addition and subtraction sums in pencil. 'Ling Ling's not old enough to go to school, is she?'

'I've been teaching her,' said Hua shyly. 'Reng wouldn't give me money for the kindergarten and I didn't want her to fall behind. She likes to learn,' she said proudly. 'Look – ' and she pulled out a book full of Chinese characters and little drawings showing how they could be combined to form words. 'There are two hundred characters in the alphabet and she can already read half of them.'

'You know the character for "good" is a combination of the sign for "woman" and the sign for "son",' said Kan. 'It's one of the first words a child is taught to write.' 'That can't do much for a daughter's self-esteem,' I said, watching Ling Ling leafing through the book. 'Can you try to find out something about that – without upsetting her?'

Kan went and squatted beside the little girl. 'Do you remember your father?' she asked gently, fingering the pearls round her neck. Ling Ling shook her head shyly, then said something in a low voice. Kan turned a stricken face towards me: 'She says: "I don't have a father because I'm a girl. He doesn't want Mother any more because I'm a girl."'

The next day we visited the hospital where Hua had given birth. It was dismal and green, like a dank cave, with twenty-watt bulbs at wide intervals along the echoing windowless corridors. The latrines were flooded and the water seeped out into the hall. An old woman with underwater skin trembled on the arm of her son, and bandaged patients on stretchers lay on the floor by the lift. People with anxious faces trailed up and down the main stairs clutching pieces of pink paper. Peering through an open door on the way up, I saw a row of patients

36

sitting motionless with their arms bared, beneath a row of drip bags hooked to the wall. 'That sign says "Population Control",' said Kan, pointing to a door at the end of a long corridor. 'It's where they do abortions on women who go over the one-child limit.'

We made our way to the second floor: I'd decided to use the opportunity to consult a traditional Chinese practitioner about my infertility. Jung's 'friend', a young man in eager glasses, bustled us to the head of the queue, and I found myself sitting in front of a grey-haired woman with fierce bloodhound eyes. Cocking her head like a blackbird listening for worms, she took my pulses, then rapped out a few brisk questions and scribbled a prescription before I had a chance to answer. Afterwards we followed Jung's friend down to the basement, where we exchanged the prescription for three bags of dried fungi and roots, plus instructions for brewing a healing tea.

'Did you ever go back to live with Reng?' I asked that evening, my hands cupped round the inevitable mug of green tea. Hua nodded. 'His factory gave him an apartment because he had a baby. It was nice, like the one you're staying in. With a private toilet and a balcony for hanging washing, and the sun came in through the windows. In this place you never see the sun because everything's so close together.'

'And did Reng treat you better when he was away from his mother?'

'For a while, yes. He even held the baby sometimes. But then he stopped giving me any money, to force me to go back to work. That's when I started the night shift, so I could look after the baby during the day. But that meant I never got any sleep, especially if she was sick. And he just ignored her if she woke up during the night when I was at work. Then when I complained, he said I should pay his mother to look after her during the day. But I couldn't bear that, so I went to his factory and told Leader Jing that he'd refused to give me any money – even though he was getting the One-Child Allowance from them –'

'Is that normal?' I asked Kan. 'To involve your boss in your marital problems?'

She nodded: 'In China the factories are owned by the government and provide lots of social services – like housing and help with medical expenses. If you want to get married or divorced, or even have a baby, you have to get the leaders' permission. And they are always invited to the wedding. It's a way of controlling people,' she added simply.

Turning back to Hua, I asked what Leader Jing's reaction had been. 'He told Reng to give me what he owed for the Allowance and I put it straight into the bank in my name. I didn't trust him any more, you see. It was soon after that he got hepatitis and had to go to hospital.' And serve him right, too, I thought, then realised that this would have left Hua alone in a strange apartment, with hardly any money and a ten-month-old baby to look after.

'How did you manage?'

'Leader Jing wouldn't let me have an advance on Reng's salary,' she said wearily, 'so I had to take all the money I'd saved out of the bank to pay his medical bills, and buy fruit and chicken to make soup to take to the hospital. He was only supposed to be there for three weeks, but he got much worse suddenly and the doctors said he'd have to stay there for at least six months. They said he needed someone to come every day and take care of him.'

'It's because there's hardly any nursing care in Chinese hospitals,' Kan explained. 'And the food is barely enough to keep you alive.'

'I wanted to help,' Hua said earnestly. 'But Ling Ling needed me all the time. And it was going to cost three thousand yuan for his treatment – that's more than I used to earn in a year. I knew I couldn't cope, so I went to his family to ask for help. I'll never forget that morning. His father was retired, so he was just sitting there watching television. But he said Reng was sick because I'd given him dirty food, so it was my duty to look after him.' Angry tears stood in her eyes again, and I realised that it was never self-pity that made her cry: injustice was what hurt her most. 'They never came to see me when I

was in hospital!' she burst out, wiping her eyes. 'But they expected me to go and see him every day.'

'And did you go?'

'Not every day – but whenever I could. I really wanted the marriage to work, you see. I thought if I looked after him properly, he would stop being so attached to his mother. But then, three months later, when I went to collect his sick pay from the factory, I found out his family had arranged for the money to be given to them instead of me. They'd told Leader Jing that I was too busy with the baby to go to the hospital, so it would be better if they looked after the money.'

'What on earth did you do?'

'I complained to Leader Jing and he lent me fifty yuan, but I think he was tired of hearing about it. I didn't get any more money from Reng until I went to the Women's Federation nine months later.'

'And how did you cope until then?'

'Well, I had fifty yuan maternity pay from my own factory every month, and I sold the colour television and the tape-recorder for nine hundred. And I still took food to Reng in hospital because I knew his mother wouldn't bother.'

'And was he grateful?' I had to ask, but I already knew the answer. 'He went back to live with his mother as soon as he came out,' she said dully. 'Even though I came especially to fill in all the hospital forms when he was leaving. That's when I knew it was hopeless.'

'Did he ever move back in with you?'

She shook her head. 'No, because I moved back with Mother a few days later. I got sick, you see. I don't know what with, but it made my legs swell up. Then Ling Ling got sick too, with pneumonia.' This, surely, was the nadir: plodding painfully down the stairs with her dangerously ill daughter in her arms, knowing that her marriage was at an end. 'I had to take her to hospital every day for two weeks,' said Hua, 'because there weren't any empty beds. But I couldn't walk without a stick, so Mother had to come with me. I used to sit with Ling Ling on my lap while Mother held the drip.' The old woman came over and rubbed her arms, wincing, showing how

they had ached from holding the bag of plasma at the requisite height.

'Did Reng know that Ling Ling was ill?' I asked.

'I went to his factory to tell him, but he said I should let her die. He got married again three months after the divorce,' she added matter-of-factly. 'His mother arranged it. They're living in the same apartment – there are still some of my things there. His new wife had a son last year.'

The next morning we went to Hua's factory, a three-storey brick building plus a huge chimney above an underground furnace. Piles of coal spilled out of the coal sheds across the courtyard. At the gate, Kan ingenuously explained that I had always adored soya milk in England and had developed a passion to see how it was made. I smiled as winningly as I could and we were taken to the top floor to meet Leader Xi: a short woman in ornate horn-rimmed spectacles, marooned behind a small desk in a huge concrete-floored room crisscrossed with a bunting of empty soya-milk packets.

There was no such thing as lifetime employment any more, she declared, leading us downstairs. Since the economic reforms everyone had been put on to three-year contracts. But she wasn't worried about her workers: business was good, and she didn't think their jobs were at risk. I glimpsed a grey concrete shower room, then we were ushered into a large chamber, fully tiled and spotless, in which a naked stainless steel digestive system gobbled up the softened beans, passed them along a rumbling intestine, then expelled them, neatly packaged in thin plastic, through a giant glass colon.

The writer in me had hoped for something more graphic: screaming oily machinery, perhaps, and men shovelling, stripped to the waist; women in rubber gloves dealing with unspeakable gunge. Instead there were calm workers in immaculate uniforms quietly monitoring the nutrition of a placid steel giant: Gulliver in intensive care tended by Lilliput's nurses. The atmosphere was pleasant, peaceful. Hua had said that her closest friends worked here. The woman in me was glad she had this place to come to.

❋

'Did you meet Leader Xi?' asked Hua when we told her we'd been to the factory. 'She helped me a lot during the divorce. She met with Leader Jing twice to discuss ways of keeping the marriage together. And when I decided to divorce Reng, she took me to the Women's Federation to get advice. I had to go to court twice, because when I showed the Women's Federation the first settlement, they said it wasn't fair. They thought Reng must have had friends in the court, because they didn't order him to pay anything towards Daughter's expenses. The second time it was much better. There was a woman judge and I got awarded forty yuan a month.'

'How do you feel about it all now? Are you still unhappy?'

Hua sat down on a stool and began combing Ling Ling's hair for the photograph I'd requested as a memento. 'Not unhappy, no,' she said slowly. 'It's much easier living here. Because Mother and Little Sister help with Ling Ling and we share all the housework. And I don't have to worry about being beaten or insulted. And even though I don't have much money, I know it's mine and no one can take it away.'

'Would you ever marry again?'

'Oh no – ' a decisive shake of the head. 'I know I'll never find a man who'll accept Ling Ling.' And she put her hands on her daughter's shoulders and turned her round to face me. The child's hair was glossy as a raven's wing; her eyes were ringed with kohl. Her tiny mouth was rouged, and Hua had painted a small red circle on her forehead. I photographed them together, the mother's arm protectively draped over the daughter's narrow shoulders.

That evening, minutes after Kan had left and before Hua had relocked the door, a middle-aged woman knocked and walked determinedly into the room. She wore a thick coat and a felt hat with a jaunty feather, and she had a little boy with her, in a smart wool suit.

My heart started to race and I shrank against the wall,

pretending to read the paper. She plumped herself down on the bed without being invited, and looked round the little room expectantly. Hua and her mother sat down opposite her on the two stools, and Xiang leaned against the wardrobe. I scanned their faces for any sign of disquiet, but all I detected was a kind of cold politeness. The four women conversed for a while in stilted tones, but tea was not offered, and after ten minutes the stranger got up and left.

I tried to mime a question about police, but Hua seemed disgusted rather than worried by the visitation. And as soon as the door was safely locked again, she picked up a damp cloth and wiped the place on the bed where the visitor and her podgy grandson had been sitting. For her the interlude was over. For me it was a sign that I had taken too many risks with her fragile security. I decided I would not be coming back again.

I sat at the sixth-floor window, staring down at the dusty court-yard. Kan was out shopping with her daughter, leaving me alone with my notebook in my lap. It was over; we'd said our goodbyes to Hua's family that morning. But I was worried about the fat woman's visit and its repercussions. Would Jung's 'friends' be able to protect Hua and her daughter? Had I been too greedy with their lives?

Sitting dejectedly on the floor, I fiddled with the dial on the hi-fi tower and found the BBC World Service. By a quirk of coincidence they were transmitting a programme about the United Nations Year of the Family. 'The family is breaking down,' said a presenter portentously. I thought of Hua's family in their cosy little home. It didn't seem broken to me.

There was a knock on the door: tentative at first, then loud and insistent. I turned off the radio and crept into the hall, trying to imagine who it could possibly be. Kan had the keys, so it couldn't be her. Jung would have shouted my name. The banging stopped and someone tried the handle. I crouched, watching it turn, hardly daring to breathe. Then I heard a scraping noise: someone was trying to push something under

the door. There was a long silence, then the sound of footsteps going slowly back down the stairs.

When I was sure the coast was clear, I opened the door. There was a flat parcel, wrapped in paper, on the floor. Inside was a red glass crescent with Chinese characters etched on it in gold. Kan translated it for me when she came back. It said: 'Do not forget me'.

Jomuna

One quarter of women in Asia see their marriages end before they reach their mid-forties. Because men tend to die earlier than women, and women often marry men much older than themselves, around half of single mothers in India and elsewhere in this region are widows.

It's the wedding season in the fishing villages of the north-eastern state of Orissa. But Jomuna, as a Hindu widow, is banned from such celebrations. Nor is she allowed to remarry, nor to eat meat, nor to wear anything intended to enhance her beauty – all this and more for the rest of her life. Three years of widowhood have made her fierce and canny. Determined to provide for Tirtha and Baikhunta, her two children, she's prepared to do one of the most despised jobs in the village: selling the stinking dried fish door to door in temperatures of over a hundred.

AN air hostess in a gold-trimmed sari proffered a tray of little white packets. Thinking they would contain peanuts, I took one and ripped it open. Inside were two small wads of cotton wool. Mystified, I slipped them into my pocket and fastened my seat-belt ready for the internal flight to Bhubaneswar.

I sat back and closed my eyes. After just one day in India, they felt as though they'd been crammed with images: holy white cattle dawdling; fat men in shirtsleeves squealing by on tiny scooters; lorries hand-painted like gypsy caravans. And the flight of grubby angels wiping the taxi's windscreen, then reaching out, beseeching, for money. When I had opened my purse, twenty more had streaked like spirits through the belching traffic. And the truculent beggar who had pushed them away,

flaunting the wound where his arm should have been. 'Don't give to him,' warned the taxi-driver. 'I know him. He eats well from that arm.'

The plane engines started, and an ear-rending roar filled the cabin, jolting me upright and shaking drowsy mosquitoes out of the upholstery. The cotton-wool mystery was solved. I scrabbled in my pocket and hurriedly stuffed the wads into my ears.

Bhubaneswar is the capital of Orissa, one of India's poorest states, on the north-east coast. From the air I looked down on a sea of red clay, rippled with newly ploughed furrows, dotted with an archipelago of tree-covered hills. Brown rivers snaked lazily across it, casting cool shadows of irrigated green. My heart lifted at the thought of two weeks in this rural Eden.

But the heat hit me like a hammer as I stepped out of the plane. The metal gangway burnt my hand; the tarmac sent hot gusts up my skirt as I walked to the terminal. Waiting for my case to be unloaded, I stood limp as a dead fish in sweat-soaked clothes, wondering how on earth I would survive.

My unremarkable hotel was opposite Bhubaneswar's main temple, an enormous truffle-coloured confection, crenellated like a chocolate gâteau and guarded by a pop-eyed bestiary. Bearded devotees with sun-blackened ribs lay in white loin-cloths sleeping in the dust. Consulting my map, I saw that Oxfam's office was down a side street behind the temple. But first I had to cross the main road: a horn-blowing stampede of scooters, lorries and taxis, zigzagging among suicidal cyclists and rickshaw-wallahs.

The office was a big tin-roofed bungalow in a garden of oleander. Inside, a fan stirred the hot air like a food-mixer in gravy. A man with a broad smile and spectacles bustled forwards, his hand outstretched. 'I'm Farooque,' he said. 'The others are all out on mission, but the arrangements are all made. You leave for Odegiry tomorrow. It's a very remote tribal area. The project leaders are excellent. I'm sure you'll be able to find what you want.'

'A tribal area?' My heart sank. India's aboriginal tribal people lived on the fringes of mainstream society; I wanted to be in the thick of Hindu culture.

'I was hoping to find a Hindu woman for my book,' I said.

'Oh, that's all right.' Farooque waved his hand breezily. 'There are lots of *Harijans** in Odegiry.'

I took a deep breath. I didn't want to make trouble for this charming man. 'I'm sorry,' I said slowly. 'But it must be a caste Hindu, not a *Harijan* – because I'm trying to find a woman whose experiences are in some way typical of the majority of Indian women. Also, I know that the rules governing the behaviour of tribal women and *Harijans* are not as strict as those for caste Hindus. I'm interested in society's attitudes towards single mothers as well as their poverty.'

He rallied magnificently. Only the briefest of frowns betrayed the irritation he must have been feeling. 'So: a caste Hindu woman. That narrows the choice a bit – Oxfam works mainly with *Harijans* and tribals. Still, we'll see what we can do.'

'I was hoping to concentrate on a widow, actually,' I said. 'They're often worse off than divorced women, aren't they?' Farooque nodded thoughtfully: 'Hinduism doesn't allow them to remarry. So they're on their own for the rest of their lives. If they're young, that can be as much as fifty years. Now there's a good women's project at Lake Chilka, with a lot of widows involved because the fishermen have been dying of cholera – '

Someone had switched on the air conditioning in my hotel room while I'd been out, and it was freezing. I went to the window to turn it down. Below, in the full heat of the sun, some labourers were resurfacing the tennis court: thin women in faded saris, walking stately to and fro carrying woks of wet cement on their heads; men crouching like toads, smearing and smoothing it like grey glass. The sun pressed solidly down on them like white lead. Hot air boomed up at them as they moved slowly across their grey world. On their dusty arms the women

Harijans: people [*jan*] of God [*Hari*], formerly known as 'untouchables'.

wore glass bangles which cascaded up and down as they lifted the woks on to their heads.

The phone rang. It was Farooque, saying that an interpreter would be arriving at the hotel at any moment, and that he had organised a hire-car and driver to pick me up at six the next morning. 'Good luck at Lake Chilka,' he added.

I hurried downstairs, and a small plump figure in a vivid yellow silk sari bustled across the foyer to meet me. 'I'm Anindita Das,' she said breathlessly, smoothing back her unruly mass of waist-length hair. 'Oxfam said you were looking for an interpreter, so I hope I can help you.'

I hoped so too: she looked altogether too glamorous for the job I had in mind. 'Did Farooque explain that I need someone to stay with me in the village? I have to spend a lot of time with the woman I'll be writing about, and I'll want to stay at least one night with her. Have you done this kind of thing before?'

'Not exactly. But I have been doing research on domestic violence in working-class and middle-class families, so I'm used to talking to people about personal topics.' She smiled, showing perfect white teeth.

'And you wouldn't mind sleeping in a poor fishing village?'

'Not at all,' she assured me, dimples dancing in her round cheeks. 'I enjoy new experiences.'

I walked her to the door, where she marched over to a man-sized motorscooter, heaved it off its stand, and sped off, black hair and yellow silk streaming out behind her.

I was ready at six the next morning. By seven the driver had still not materialised. He eventually appeared at eight, grinning and wagging his head politely from side to side like an owl. He didn't have an alarm clock, he explained via the receptionist. And then the car needed some little screws turning. He led me out to a battered red Fiat, with a rug of matted blue fur and a bunch of plastic flowers in the back window. After several false starts – searching doggedly for Anindita's house in the wrong street, then 'just checking' with the car's owner behind

a haberdashery counter in a distant shopping mall – we were on the road by ten.

It was then that I discovered that beneath the driver's respectful demeanour lurked a man possessed. Bhubaneswar passed in a blur, jolting into focus only when the car hiccoughed across a ramp of speed humps. Outside the city it clung like an enraged corgi to the heels of every lorry we approached, yapping loudly until there was an opportunity to overtake. I had a vague impression of ploughed fields and stubble either side of the road, and of slower rural traffic veering hurriedly out of the way. We left a wake of men swerving bicycles on to the sandy verge, ox-drawn carts trundling sideways, dusty-legged children chasing cattle into ditches.

Every so often a new series of bone-shaking speed humps would herald our arrival at a little tree-shaded roadside settlement: rusty kiosks on legs, made of flattened tin cans; open-fronted wooden cafés belching smoke from clay ovens; piles of green coconuts, a few petrol cans, crates of Pepsi and Seven-Up. And now and then we passed a lorry on its back like a dead turtle, or concertinaed into a tree in a pool of broken glass. I turned to Anindita: 'Can you ask him to slow down?' He scowled and moderated his speed by 3 per cent.

Our destination – another office in a bungalow – was just off the main road. Manju was waiting for us. A slim, soft-spoken woman in a pale sari, she offered us strong sweet tea and a lunch of vegetable curry and dhal. We ate sitting on grass mats on the floor, while she explained about their work. 'We used to work with men, but we found the women are more motivated,' she said. 'So now we only concentrate on them.'

An hour later we were on our way to Lake Chilka, bumping down a wide sandy track between groves of bamboo and eucalyptus, dry mud banks and red termite mounds sculpted like Gaudi towers. We passed a procession of women with loads of firewood the size of sofas on their heads; and little girls patrolling herds of drowsing cattle, collecting cowpats in their baskets.

Suddenly I smelt the sea, and saw a plain of blinding silver stretching out towards a hazy horizon. I felt elated: 'Is

that Lake Chilka?' 'That's where it used to be twenty years ago,' said Manju. 'It's just sand flats now because the rain washes the earth down into the lake. The villagers have had to dig a channel so they can get their boats to the water.'

As we approached Tangi village, the road became more crowded. The car leapfrogged along the rutted track yodelling imperiously, forging a path through a motley procession of carts, bicycles, cattle, children. A series of large ponds came into view along the road: some little more than scummy mud wallows, others full of green water, with naked children splashing and divebombing each other from the bank. Opposite, on the other side of the road, was a big open patch of ground littered with dry leaves and black pebbles. Then I realised they weren't pebbles, but dried shit: a woman was squatting there, her knees in her armpits, staring curiously at the demented red Fiat.

We skidded to a halt beside a small temple guarded by two outsize stone baboons. Before the engine had been turned off, the car was surrounded by a solid press of half-naked children. 'I'll introduce you to the women's group,' said Manju, levering the door open against a mass of small brown bodies. 'They've started a revolving fund, so they're not so dependent on money-lenders. They each contribute every month and take it in turns to use the money.' She gathered up the folds of her sari and led us into the heart of the village, pursued, like the Pied Piper, by scores of scampering children.

Again, I had the sensation that my eyes were overflowing with images. Narrow dusty streets wound between terraces of clay houses whose raised verandahs were shaded by overhanging thatched roofs. The verandahs served as bedrooms, storerooms, shop-fronts, workshops, as though exuberant life was spilling out of the houses: froths of blue and yellow fishing net, sacks of dry leaves and dung cakes, heaps of plastic shoes, piles of oranges, trays of tiny steaming tin cups. We passed two more temples: one pillared like a miniature Acropolis; the other decorated with blue cattle and bearded monkey-men. A white chicken painted with cerise dye ran hysterically ahead of us.

Eventually we arrived at a wide balcony outside a small

wooden door. It was opened by Sori, an old woman with blue tattoos on her face and arms. She invited us to sit, listening attentively as Manju explained why we had come. The children formed an impenetrable wall around us, staring unblinkingly at me, blocking every breath of air with their hot bodies. Flies settled on their eyelids. Sweat trickled between my breasts and shoulderblades.

'She says they selected three of the poorest women to receive the first money from the revolving fund,' said Manju. 'They were all widows. But there are lots of poor women in the group: widows, divorcées, women whose husbands gamble or are too sick to work.'

The old woman issued a few sharp instructions and five of the children ran off in different directions. Within minutes a quiet crowd of about twenty women had materialised around us, standing with their saris pulled modestly over their hair, looking shyly over the heads of the children.

'Are any of the three widows here?' I asked, and a minuscule woman, barely four foot tall, was ushered to the front. Puni's round face was a picture of anxious misery, lines etched in an inverted V on her forehead. Her fisherman-husband had drowned in a storm fifteen years ago, leaving three daughters. Puni had married the two elder ones off when they were only eleven years old, because she had no male relatives to guarantee their virtue and no one would have believed they were virgins if she'd delayed any longer.

Something about her wizened little face disturbed me: though she was managing to hold the edges of her frayed life together, she exuded defeat from every pore. Manju confirmed my suspicion: 'She never goes to group meetings. She says there's no point.' 'I wonder why she has such a negative attitude,' I said, and Manju frowned: 'It's not her attitude. It's because she has no self-esteem,' she said severely. I looked again at Puni's tiny body, testament to a childhood of neglect and starvation – and I accepted the rebuke.

The second of the three widows, Pitabera, appeared a moment later, plumping herself down breathlessly on the veran-dah and looking expectantly at me. Like many older women,

she had an indigo design tattooed on her forehead and arms. Before her husband died of cholera she'd never left the village alone, she told us. But the group had lent her money to buy dried fish, so she'd started going to inland villages, selling door to door. She beamed round at her friends. But her sons were old enough to go out in the boats now, so she didn't have to do that any more. It wasn't decent to go door to door if you had a son to support you, she said.

I gestured admiringly at the tattoos on her face. 'It's to make her ugly,' said Manju. 'People used to do it after they got married so other men wouldn't want them.'

We waited in vain for Jomuna, the third widow. Sori said she'd gone to a distant village to sell dried fish. But Pitabera thought she'd seen her out in the jungle collecting leaves. No, countered Puni, she was sure she'd spotted her buying fresh fish from the boats. Anindita laughed: 'This mysterious widow seems to be in three places at once.' I liked the sound of that. 'Let's try and find her,' I said.

Jomuna was squatting in front of a heap of little silver fish, an orange sari pulled carelessly over her hair. Men in open shirts and dhotis stood around her, looking down as she scooped handfuls, like glistening coins, into a wire basket attached to a measuring rod. One was obviously querying her method of weighing and she looked up sharply, loosing a stream of impassioned invective until he smiled sheepishly and extracted a dirty grey banknote from his breast pocket. She grinned mischievously up at him, and knotted it carefully into the end of her veil.

We pushed through the crowd towards the squatting woman, who covered her fish with a cloth, then stood up, wiping her hands on her sari. 'She's frightened someone will steal her fish,' said Anindita. 'So we have to talk here.'

'How many children does she have?' I asked.

'She says two: a girl and a boy.'

'And how has she managed since her husband died – does anyone help her to support them?'

Jomuna opened her arms in a theatrical gesture of despair.

'She says this is her life now: fresh fish, dried fish. She went to stay with her parents when her husband died, but they asked her to leave because there was no room and they couldn't afford to look after her. So she went back to her in-laws, but they're always beating her, trying to make her leave because they want the room.' Jomuna glanced angrily at the crowd of curious onlookers, and tears shone suddenly in her eyes. She sniffed and wiped her nose roughly on her hand, then squared her shoulders and made a short polite speech to Anindita. 'She says she's sorry, but she can't talk to us now. She must finish selling these fish because they will be bad by tomorrow.'

The boats were coming in as we walked back to the car, speeding like birds down the canal, their sails lowered and folded like great black-and-yellow wings. Men with bunched muscles and black skin strode past with poles and nets on their shoulders, baskets piled high with metallic fish. They were beautiful: dark aliens from a land of shining silver.

'Why do so many die of cholera?' I asked Manju as we drove back to the main road.

'It's the bad water they drink when they're out on the lake. They have to get food and water from special trading boats in exchange for the best fish.'

'Why don't they take it with them?'

'There's no room to cook on their boats. And they're out for much longer these days, because there are fewer fish and they have to sail further because the lake is shallower.' A week on that blazing expanse of molten silver, eking out a pot of murky water, not daring to return until another sack of rice could be paid for. No wonder they got sick; no wonder they died, with their tongues burning and their bodies leached dry, and days of blinding water between them and the comforts of home.

'Do the men who own the trading boats live in the village?'

'Some, yes. They used to live separately from everyone else, but the caste system has changed a lot recently; people are mixing more. In the old days the fishing caste used to be divided

into four sub-castes, depending on what work they did. The traders were at the top: they lent money, and bought the best fish and prawns to sell in the city. Then there were the men who caught fish from boats. Then below them the men who set nets in the shallows for prawns and smaller fish. And at the bottom were the people who bought the fish the big traders didn't want. They salted and dried them and sold them door to door.'

'How is it different now?'

She waved a dismissive hand. 'Oh, everyone does everything now. If a man can afford to buy a boat, he'll catch whatever he can, even if his parents are from the lowest sub-caste. If he does well, he'll set himself up on a trading boat. And some people have become very rich from farming prawns, even though that used to be a poor thing to do. But there's still a lot of shame about selling fish door to door. That's why only the poorest women do it.'

It was growing dark when we set off again for Bhubaneswar. Lorries with dazzling headlamps hurtled towards us; unlit ox-carts and dead trucks lurked treacherously in the darkness. Once we passed a procession of musicians, walking festooned with fairy lights lit by car batteries on a cart. 'It's a wedding,' said Anindita. 'The groom is going to collect his bride. This is the season for weddings in Orissa, because the harvest's over and people have time to enjoy themselves.'

Later, we stopped briefly for a warm Pepsi and another procession passed by. Anindita and I were invited to join a jostling queue of perhaps a hundred women in gold-trimmed saris waiting to see the bride. She was sitting in state in the corner of a small room: an exquisite doll of fifteen, weighed down with jewellery and gold brocade, painted with henna, kohl and vermilion, totally hemmed in by female relatives as though she might jump up and flee into the night.

'I prefer this,' Anindita pronounced the next morning as we set off – with me at the wheel this time. 'You drive nice and slowly.'

I certainly did: hiccoughing along in first gear among the cycle-rickshaws, struggling with the Fiat's nonexistent synchromesh. A flat black face with mocking, staring eyes swung wildly from the rearview mirror. 'That's the god Jagganath,' Anindita explained. 'He was made by a carpenter, but the king inter-rupted him before he was finished. That's why he doesn't have a proper body. He's very important in this region: on his feast-day, worshippers used to throw themselves in front of his wagon. That's where the word "juggernaut" comes from.'

'How does he fit in with Vishnu, Shiva and Kali?' I gasped, locating second gear at last and venturing out among the yim-ming motorscooters.

'Really he's an aspect of God. It's easier to worship a god with a personality than a distant power. I like Durga, the war-rior goddess. She goes naked into battle and holds a different weapon in each of her ten hands.' I changed into third, gripping the fur-covered steering wheel with two mortal white-knuckled hands.

We went straight to the village this time, parking in the same place, surrounded instantly by the same mass of little bodies. They conducted us excitedly to where Jomuna lived, and we knocked on the door. There was no answer, but while we stood debating what to do next, an older woman emerged from the next-door house. Her name was Moni and she was a widow too, she said, inviting us through a stable-like room and into a dusty courtyard. Closing the door on our retinue of children, she unrolled a grass mat for us to sit on. 'You shouldn't talk to that Jomuna,' she sneered. 'She's always quar-relling. That's why her parents wouldn't have her in the house when her husband died.'

I raised my eyebrows at Anindita, and she grinned. 'We'll soon find out,' she said. 'Here she comes.'

Jomuna was walking quickly – almost running – up a narrow track between two houses, with an enormous load of dry leaves on her head. Hefting it on to the ground, she flexed her neck, wincing. Drops of sweat beaded her upper lip, and there were great dark stains where her sari clung to her back. 'Look at my miserable life!' she groaned melodramatically.

'I used to buy a load like this for four rupees. Now I have to spend a whole morning collecting it.'

Moni said something sharp to her and she snapped back, chin jutting, eyes blazing. Moni responded in kind, gesturing angrily, and they were off, rattling insults at each other across the dusty courtyard. I turned to Anindita for an explanation. Her dimples danced as she suppressed a smile. 'It looks like Moni's the one who's been trying to make Jomuna leave – because she wants her room. She's the aunt of Jomuna's husband, and she's been getting her nephews to beat Jomuna. Now she's accusing Jomuna of making her children defecate in her part of the yard –' 'Isn't that a disgusting insult?' I interrupted. Anindita giggled. 'It's more impertinent than disgusting,' she said. 'But I don't think she did it on purpose. She claims she was too exhausted after selling fish all day to take them to the proper place.'

The spat came to an end as quickly as it had begun, with the two women turning their backs on one another. 'I have to collect the children from my mother now,' Jomuna announced wearily, wiping her face on her veil, then setting back off down the muddy path. 'My in-laws won't let me use their door to the main street,' she called out over her shoulder. 'So I have to go down this dirty place, where everyone throws rubbish for the dogs.'

She reappeared ten minutes later, with a boy of about four on her hip. She was followed by a pretty seven-year-old girl in red shorts, her plaits looped up and tied with pink ribbon. Unknotting a key from the end of her sari, Jomuna unlocked the padlock on the door to her room. 'That woman' – nodding towards Moni – 'started stealing things,' she said shortly. The door swung open on a narrow room, about ten foot by five. There was practically nothing to steal: a few much-scoured much-dented tin pots and trays, a sack of rice, two bottles corked with screws of paper, three tin cups, an array of baskets and a couple of grass mats rolled up in one corner. As she unrolled one of these for us to sit on, a slow drift of children began to seep in through the narrow alley and stood around, silently staring at us.

'She says she doesn't have much time to talk to us, because she has to cook lunch for the children,' said Anindita.

'Can you ask if she minds talking to us while she works?' I asked, and Jomuna shrugged as if to say 'suit yourself'.

She went into an open outhouse adjoining her room and unhooked a strange tool from the wall. It consisted of a curved blade set like a giant claw in a wooden base. Kneeling and holding the base steady between her knees, she pushed tiny onions against the blade with her fingers, slicing them rapidly and throwing them into a shallow tin pan. Then she dragged a large flat stone from the corner, wetted it with water from one of the battered tin pots, and began rocking rhythmically to and fro, grinding spices: red chillies, garlic, and a wizened brown turmeric root that dissolved into glorious yellow under the grinding stone.

The little boy clung to her side like a shadow; the girl stood on one leg against the wall, fiddling with a silver charm around her neck.

'What are their names?' I asked Jomuna as she scraped the golden paste into a pan.

'My daughter's called Tirtha Basini. It means "the end of the pilgrimage", because I was barren for eighteen years before she was born. And my son's called Baikuntha, which means "heaven". When he was born they took a boat out to tell my husband and he said "I would have been punished for not having a son, but now I'll go straight to heaven when I die."' She hugged Baikuntha briefly as she got to her feet, and wiped his runny nose on the end of her sari.

The next five minutes were spent cooking: stuffing dry leaves into one of three tiny stoves moulded directly from the mud in the courtyard, then lighting them with a match and adding a couple of dried cowpats. The fire blazed fiercely in seconds and she crouched beside it under the blazing sun, frying the spice paste and onions in a trickle of oil with a couple of tiny dried fish. The flame died as soon as the food was cooked, and she swept quickly round the stove ready for the next user: by now I'd worked out that at least four families' doors opened into this courtyard.

She ate hungrily, squatting; scooping handfuls of cold fermented rice from a tin pot, then squeezing the water out through her fingers and stuffing it into her mouth with a smidgin of fish sauce – then doing the same for her son. 'Only poor people eat wet rice like that,' Anindita said quietly. 'It swells up, so they need less to feel full.'

When Jomuna had finished, she lifted the pot of leftover rice-water to her children's lips for them to drink, then gulped the remains herself. 'Poor things. They haven't had anything since dawn,' she said, wiping her mouth and sitting back on her heels. 'It took longer than usual to collect the leaves, and my mother doesn't feed them unless I leave her with some food.'

'Do you remember being hungry when you were a girl?' I asked.

She shook her head vehemently. 'I had two mothers, so I was always looked after,' she said. 'My aunt was barren, you see, so she asked my father if she could adopt me. When he agreed, she started keeping me behind whenever we went to visit, giving me money and nice things to eat. My aunt and uncle were richer than my parents, but she used to say: "What good is a big garden if there are no flowers in it?" She said I was her flower. I was very spoilt because when I went home, my mother didn't want to let me go.'

'Why did your aunt adopt a girl instead of a boy?'

'She adopted a boy first, from her husband's brother. He was sixteen when I went to live there. But you need a girl and a boy if you want a complete life: a girl to give away in marriage and a boy to perform your funeral rites.'

'It's *karma*,' explained Anindita. 'Every person has certain tasks to complete if they want to be reborn at a higher level. Giving away a virgin daughter is very important. That's why some girls are married so young.'

'How old was she when she got married?' I asked.

'My aunt promised me when I was seven and I got married when I was eight. But I didn't live with my husband until I was twelve. I remember people used to tease me, saying: "Be careful, Bawan's coming" if I was out at the pond or the temple – that was his nickname, because he was left-handed.

And I'd have to hide and pull my sari over my head so he couldn't see me. But sometimes I peeped out –' her eyes shone. 'He was twenty-one then – I thought he was so handsome!'

'What about the dowry?'

'I got all my jewels when I was eight. Nose-studs, earrings and toe-rings from my parents, some necklaces from my uncles, and the rest from my adopted mother and father. They gave me lots of things: bracelets, six pairs of earrings, chains for my ankles and waist. I wore almost everything on the day I was married, and for ten days after that when I stayed at my husband's house. I was supposed to take them off when I went back to my aunt's, but she said I should keep them on because I looked so pretty. She used to hold my face in her hands and just look at me.' She shook her head fondly. 'People were really angry with her for that. They said I'd lose them running around and playing in the pond. But she said she didn't care, because I looked so lovely in them. She said she'd buy more if I lost them.' She sighed and smiled softly.

I warmed to this aunt, who had poured such love into her adopted daughter. This must be why Jomuna had so much fight in her: because someone had taught her that she deserved good treatment.

'Have you still got the jewels?' I asked, and she opened her arms wide, displaying her few thin silver bracelets, her unadorned ears and neck. Only the filigree gold studs in her nose remained. 'All gone,' she said. 'Sold back to the goldsmith to pay the doctors for my husband. And everything else I could sell. I even sold my carved dowry chest, and the bronze pots in it. My husband said I should save something to look after myself when he was dead. But how could I see him suffering and not do something to help him?'

We spent that night in the guest room at the project headquarters, taking turns to sluice ourselves with buckets from the well, then sitting on the floor for supper cooked by one of the younger staff members. She lodged with a high-caste widow who had been reduced to begging after her opium-addict

husband died of an overdose. 'She can't work because she's a Brahmin,' Manju explained. 'And she can't join the women's group because their meetings are in the evenings. She couldn't eat with them anyway, because they're much lower caste than her. Someone gave her a cow for dung and milk, but she still has to send her sons out begging.'

'But Jomuna goes out to work,' I objected.

'She's fourth caste,' said Anindita. 'The rules are much stricter for higher-caste women.'

'And even stricter for widows,' added Manju bitterly. 'No gold jewellery or brightly coloured clothes; no meat. I know an old woman of eighty whose husband died when she was twenty – so she hasn't eaten meat for sixty years. Last year she went mad and started begging people to give her chicken and eggs to eat. It's all she can think of. But it's not just food. You can't go to weddings or *palas**. You can't even pray the way you did before. And if anyone sees you enjoying yourself, you'll be suspected of being unfaithful to your husband.

I began to see a terrible logic to *sati*†: it relieved the in-laws of supporting a non-working family member – and it dispensed with the burden of policing her behaviour for the rest of her life. But why forbid the widow to work in the first place? Could it be that a productive widow, free of men's authority, was too much of a threat?

Though we'd asked Jomuna to meet us the next day, the court-yard was deserted and the door locked when we arrived. 'She's gone to try and find fish to buy,' said Moni sourly when we knocked on her door. 'You talked to her for such a long time, it was all gone when she went yesterday evening. If she doesn't get any today she won't have anything to sell tomorrow.'

I could have kicked myself: for not asking if she'd had other plans; for just assuming she could make time for us. Now

**pala*: ceremony of thanksgiving for the birth of a child.
†*sati*: the burning of widows, alive, on their husbands' pyres, now outlawed but still occasionally reported.

it seemed her regular suppliers had sold to someone else. I prayed we hadn't damaged her reputation.

We wandered the village streets searching for the now-familiar figure in the orange sari. Anindita sent some of the children running ahead to ask if anyone had seen her and we eventually tracked her down inside a big courtyard, with raised verandahs on two sides, supported by ornate pillars. A white cow dozed in the shade of a tree and a flock of chicks puttered in the smooth sand: a lovely home; a richer family.

A woman with gold bracelets was crouching on the verandah with a basket of dried fish in front of her. She frowned as Jomuna examined them. They'd been gutted and she opened them reverently one by one, like books, brushing off the big salt crystals inside, then hanging them from her brass weighing rod. The woman greeted us warmly, sending her daughter off to make lemonade, then turning to Jomuna, full of questions about us.

Anindita laughed. 'The woman thinks we're *tatas* trying to buy votes to take control of the lake.'

'*Tatas?*'

'Businessmen. There have been lots of battles here between the fishermen and *tatas* who want to use the lake for prawn-farming. Jomuna told her she didn't know why we were here. She said: "They just follow me, like children. What can I do?" I looked at Jomuna. She was grinning at me.

Back outside her own house, Jomuna unfolded a piece of black polythene and squatted by the basket to lay out the fish she'd bought, carefully brushing off the remains of the salt. 'People complain if they see too much salt,' she said. 'They think I'm cheating them, weighing the salt as well as the fish.' Then, in ironic self-deprecation: 'Look at me! A common fish-seller. It used to be me opening the door to some poor widow with a basket. My husband used to bring home the fish, and I'd clean it and dry it in the sun. He used to go out in the boat he shared with my adopted brother. People respected me then.'

'What was your husband like?' I asked, wondering if he

was as violent as the men Anindita had encountered during her research.

'His name was Bharat, and he was always gentle and funny. Everyone loved him.' Jomuna gazed at the fish she held open as though she was reading a story. 'And he was so good to me. When he went out at night in the boat, he used to try not to wake me. Most men make their wives get up first and make food for them, but he just used to whisper goodbye and remind me to lock the door after he'd gone. And when he came back he was always mad for me' – looking sideways, shyly, to make sure I understood – 'rushing round the village until he found me, begging me to come home so we could be alone.'

'Did your in-laws treat you any better when you were first married?'

Jomuna jerked her head in disgust: 'They never really accepted me because they thought my dowry was too small. I had lots of jewellery, because of my aunt. But there wasn't much for my in-laws, so they were disappointed.'

'And how did they react when you couldn't have a baby for all those years?'

'They were pleased – it gave them another excuse to insult me. They said my husband should divorce me. You know, it's very easy to abandon a woman who's barren – no one will blame a man for taking another wife. But he never threatened to leave, and when I used to cry about it he'd say: "Don't worry. I'm your son and your husband. I'll be everything to you."'

'Were you worried about him going out on the lake?'

'I wore this for him,' she said, fingering the thickest of her few silver bracelets. 'If you count the silver on a woman's arm you can tell how many men she has on the lake. And I used to pray to Kalijai and make pilgrimages to her island. In the stormy season you can see hundreds of women there.'

'Kalijai?'

'She was a little girl who drowned on the way to her wedding on one of the islands, so her virginity was preserved and she became a goddess to protect the fishermen. I used to lie awake and listen to the wind and say: "Oh please, Goddess,

wrap your sari around my husband and keep the storm away from his boat."

'Are you married?' she asked me suddenly, running her fingers down my arm. I nodded and extracted a photograph of Bill from my bag. She held it reverently between finger and thumb: he smiled out at her, quizzically, muffled in his scarf and donkey-jacket, screwing up his eyes against Scotland's winter sun. 'He has a kind face,' she said, giving it back to me. 'Why don't you wear bangles for him?'

'All married women wear glass bangles,' Anindita explained. 'Our mothers give them to us on our wedding days. I don't wear mine, because they're a sign of slavery.' She translated what she'd said, and Jomuna frowned disapprovingly. 'It's not only women who show they're married,' she said, laying the fish on the black polythene and picking up another. 'If a man has a watch or a radio, everyone knows they must be part of his wife's dowry.'

She picked up another fish. 'How many children have you got?' she asked.

I explained that I was barren, like she'd been; that I'd been to all kinds of healers, but that no one had been able to help me. 'You must go to Baya Takure in Kalapadaghat,' she said firmly. 'He's possessed by the goddess Parabathi. She spoke through him and said my inside was blocked, so he sucked the badness out of my belly and throat. I told him about the nightmares I used to have when I had my period – about a demon smothering me. Parabathi said it was because my home was haunted, so he came and smeared the walls with cow-dung and hammered an iron nail in to scare the ghost away. Then he wrote the names of God in sandalwood – look – ' And she got up and opened the door to her little room. There, on the dark-brown wall, was a white line of Hindi script with a design like a tendril of columbine beneath it.

'What's that drawing?' I asked Anindita. 'It's like the Christian crucifix, except it's for the female aspect of God. It means "*Oma adi shakti*": Mother, you are almighty.'

'Did it work?' I turned to Jomuna.

'The nightmares stopped.' She caressed the writing with

her fingertips. 'And I conceived my daughter the following year.' I imagined her watching the moon wax and wane, counting the days since she'd last tied the rags between her legs. 'Go and see him,' she urged, touching my hand.

Later, she showed me a photograph of herself, with her daughter sitting on her lap. 'I was pregnant again when this was taken. My husband said we'd come back when the baby was born and have a picture taken of the whole family.' The photographer had touched up the eyes, and they stared out unnaturally dark and solemn. Jomuna's arms were wreathed in glass marriage bangles. Invisible, beside the camera, her husband looked with love at his wife and child.

The heat: there was no escape from it. In the sun it was a pounding white hammer. In the shade it hung like treacle, gluing my clothes to my body. It crept over my scalp like a wet worm, beneath my breasts, between my toes; trickling from the creases of my elbows and knees. Flies swam sideways in it, drawn like magnets to my damp skin. Mosquitoes danced like thistledown round my ankles. I was thirsty all the time, sampled every one of Orissa's beverages: coconut milk from fresh green nuts hacked delicately open with a machete; local fizzy drinks in a dizzy variety of colours; spiced tea thickened with condensed milk. I became reckless, despite Anindita's warnings, gulping great draughts of fresh lemonade, diluted with water of dubious origin, tangy sherbets made from unpasteurised curds, or just water scooped from a tin barrel outside a roadside café.

We arrived early at the village the next morning with our bedding in the boot of the car. Jomuna had agreed to take us to Baya Takure, whom she referred to as 'the Saint'. Afterwards we were going to eat with her and spend the night at her home. 'Don't worry about your work,' I'd said. 'We'll reimburse you for any money you lose by coming with us.' And I'd apologised for the trouble we'd caused the previous day. She shrugged:

'It didn't matter. There's a lot of fish in the village at the moment.'

By now it all felt familiar: the fish smells, the children, the haze of the lake in the distance. Recognisable faces smiled or scowled at us; hands waved. We marched confidently along the winding streets and down the muddy little passage. But she wasn't there. The padlock hung like a taunt on her narrow door.

'She went out before dawn to sell fish,' said Moni, with a satisfied smile. 'She won't be back until late afternoon. Did you tell her you were coming?'

I groaned: how could I have been so thoughtless? Jomuna and her children lived on the very edge of destitution. She'd probably spent everything she had buying the fish yesterday. She couldn't buy anything to cook for us until she'd sold them. I sighed: it was a lesson I'd try hard not to forget. 'We should have given her some money,' I said to Anindita. Then: 'Can we go to the Saint on our own?'

The village where the Saint lived was peaceful; trees swayed in a soft breeze. A murmur of quiet voices came from a crowd of women and children sitting patiently outside a small thatched house at the end of a balconied terrace. We walked over, prepared to wait our turn, but our presence caused such consternation that a gold and white figure burst from the dark interior to see what was going on.

Naked apart from a white lungi, the Saint was broad and bronze, with a great mass of white dreadlocks secured in a large bun on top of his head. His nose was hooked, his eyes were sharp, and there was a large glossy swelling on the left side of his forehead. He beckoned us forward and invited us into the narrow hallway where he conducted consultations.

Curious bodies sealed the entrance behind us as I squatted beside Anindita on a low stool in the dark airless passage. The Saint sat opposite us, relaxed and genial, his golden skin sheened with perspiration. Behind him, through an open door, I glimpsed a blue room, hung with portraits of Krishna, Jagganath,

Ganesa, Durga – and countless others I couldn't identify – plus rows of black-and-white photographs of solemn women holding babies in their arms. On the floor were seven clay pots.

An assistant handed him a battered book and a sprig of something that looked like thyme. 'That's tulsi,' whispered Anindita. 'It's grown in sacred places. Some people worship it as a goddess.' The Saint kissed the book and touched it to his heart, then leaned forward and looked into my eyes. 'A woman is like a lotus flower,' he said gently. 'She has the seeds of children deep inside. Sometimes there are problems releasing those seeds. If you believe, I can help you release your children.' My eyes filled with tears: for myself; for the hundreds of other women who'd sat here. I longed suddenly for him to touch me.

'I'm nearly forty,' I confessed, and he smiled. 'Age isn't important. You can have children until you're fifty. I'll give you four cotton necklaces, and you must wear each one until it breaks. And medicine from seven pots for you to take every day of the week. But take this now – ' he rapped out an instruction to his woman assistant – 'it will begin the treatment.' She disappeared into a room at the end of the passage, returning with a lump of brown paste on a piece of palm leaf. It was fierce and pungent, burning my tongue and making my eyes water. Anindita squeezed my arm encouragingly as tears poured down my cheeks.

Later he led us to a roofless ruined building, abandoned to the sun. In the centre was a tulip-shaped shrine ringed by desiccated tulsi bushes, gauzed with glittering spiders' webs. Red hibiscus flowers lay like soft birds in the dust, and a jumble of bronze pots, bananas and loaf-sugar crystals had been placed on the steps in front of the shrine. A half-naked priest presided, emaciated and irascible, seeming resentful of his secondary status.

'This is where the Saint becomes possessed by Parabathi,' said Anindita. 'She's Shiva's consort, the goddess of fertility. He's been coming here since she first possessed him when he was eight years old.'

'Do you believe?' asked the Saint, searching my face. And

I hesitated, not wanting to lie. Yes, I believed he was a powerful healer. Yes, I believed that there are gods in all of us. I nodded, hoping that would be enough.

Satisfied, he beckoned to his assistant, who made me kneel and doused me with green water from a large gourd. She then led me before the priest, where I knelt again and ate sacred food from his hands: tulsi and loaf-sugar crushed with banana and a single small hard nut. I knelt there with all eyes on me: chewing, trying to swallow; clothes dripping, covered with dust. Red ants were climbing up and biting my wet thighs. My mouth was full of tulsi stalks, my teeth were cracking on a nut like a stone.

Anindita tugged on my arm: 'Now you must kiss his feet.' I shuffled over to the Saint on my knees, and touched my lips to his dusty brown feet. He nodded absently, receiving the tribute as his due. 'If you can't swallow the nut,' he said, 'you must keep it in your mouth until it's soft enough to crack. You mustn't throw it away.'

'I have six other women to treat today,' he said conversationally when I'd scrambled, bedraggled, to my feet. 'Four have daughters but no sons. The other two are barren, like you.' He called them to him, one by one, and each was doused, like me, then fed holy food by the priest. 'Now watch,' he said. 'This woman is blocked at two *chakras*.' His assistant made one of the barren women lie on the ground, and pulled her sari skirt down to reveal a pale expanse of belly.

Kneeling by her side, the Saint smeared vermilion on her throat, then loosed his white dreadlocks so that they cascaded down his back. Flinging his arms and head back like a diver, he froze for a long moment, then screamed to the sky, shuddering convulsively as the goddess entered his body. Still trembling, he buried his face in the soft exposed belly, shaking and sucking with the lust of a vampire until the tremors receded. Then he raised his head slowly from the woman's bruised skin and spat a mouthful of blood on to the palm leaf on the ground beside him.

The crowd gasped. Anindita gripped my arm. The barren woman rose unsteadily, trancelike, to her feet.

A moment later the Saint had snatched up the goddess's iron trident and was marching, dreadlocks flying, to the funeral ground outside the village. It was a bleak open space, bleached by the sun, stirred by the hot wind. Palm trees and tulsi bushes grew on its perimeter; clay pots littered the ground like skulls. A red-headed crow hopped in the pit of white ash in the centre, raising ghost-dust that spun in tiny whirlwinds up into the sky. The Saint strode across to the funeral pit, and the crow flapped languidly away. Planting his sceptre firmly in the ash, he began picking up the clay pots, one by one, and smashing them into tiny pieces.

'They're saying people are frightened to walk here at night,' Anindita whispered. 'So he has to cleanse this place after every funeral. The wood is put in the pit, then the body, face down, then more wood. Afterwards the ashes are collected, with a small piece of bone, so people are sure they have something of the dead person with them.'

The Saint called the woman he'd treated out of the crowd and bade her lie in the funeral pit. Head back, trembling, he screamed again, gripping the trident and placing his foot on her forehead. At his command, she rolled over three times in the white ash, crying 'I submit my body to the goddess'. Then she rose, pale as a ghost returned from the dead.

On the way back to the village I turned off down a quiet track and squatted by the car, stripping off my filthy wet clothes and changing into a dry skirt and T-shirt. A cow watched me: chewing, swishing its tail. I took the rock-hard nut from my mouth and put it in my pocket.

Jomuna's door was still locked when we got back. Moni said she'd returned from selling fish, but had gone out again to repay the women she'd bought from on credit the day before. I began to see what a precarious business it was for someone without capital: tiny time-consuming transactions, odd bits of credit, minuscule profit.

We were just setting out to track her down when she appeared, walking quickly as usual, with a basket of fresh-

picked greens under her arm and a pot of water on her head. Her step faltered and she smiled uncertainly when she saw us. 'The women I bought fish from were expecting their money,' she explained, lowering the water-pot to the ground.

'Why didn't you say?' I asked via Anindita. 'We could have arranged to see the Saint another day.' She looked sideways at me for a moment, then: 'My brother wouldn't allow me to go with you. People have been saying you are brothel-owners looking for young widows. He said if I got into the car you would kidnap me and take me to Bhubaneswar.' Anindita could hardly contain herself as she translated. I burst into startled laughter too; I couldn't help it. Eventually Jomuna joined in: 'I told him you were writing a book, but he didn't believe me. He is coming tonight to meet you himself.'

Then her face changed, growing serious, and she picked up the water-pot. Kneeling, she unlaced my gym shoes and washed my feet, picking them up one by one and tipping the water carefully over them. 'Welcome to my home,' she said.

Later she went to fetch more water from the well down the street, and returned with her son hoisted on her hip. 'I worry about him all the time I'm away,' she said. 'Last year a cow butted him into the pond and he nearly drowned. I used to tie his leg to a pillar, but he can untie himself now.'

She unhooked a sari from the wall and extracted a little tin from a basket hanging beside it. Opening it with one hand, she dipped a finger inside and rubbed it on her gums, then hurried off down the passage. 'She's going to defecate,' said Anindita. 'That's what the drug is for. You have to plan it in advance because the place for defecation is so far from the house. The sari is a special one used only for defecation. Afterwards she'll wash in the pond to purify herself for cooking. We're supposed to wash ourselves all over twice a day.'

Her brother, Jaladhar, arrived while she was away: tall and broad, with an immaculate white shirt and a checked cloth knotted round his waist. Anindita made a little speech of introduction; he nodded grudgingly and sat down beside us on the grass mat. There was an awkward silence. He lit a chillim and sucked on it, staring at the ground. I looked askance at

Anindita, and she shrugged minutely. A woman emerged from one of the houses backing on to the courtyard and began lighting a fire. Jomuna's daughter appeared with a brown glass bottle and took it into the little room.

'I'm writing a book about women who have to support their children on their own,' I said at last, proffering my notebook. 'Jomuna seems to have had a lot of trouble with her in-laws.' He looked up. 'At least they have kept her,' he said shortly.

He thawed a bit during supper, due to Anindita's gallant efforts at conversation and a couple of sharp reprimands from his sister. I soon realised he was not a bully; simply concerned about Jomuna's reputation. Though she was his elder by some four years, she had become his responsibility since her husband had died. Whatever happened to her would reflect on him.

It was dark by the time we started eating, dipping companionably into wet rice, as before, and fish curry, plus the greens fried with subtle spices. The children fell asleep almost immediately they'd finished. Afterwards Jomuna cleared up quickly, sweeping stray rice grains off the mat with her hands by the light of a little smoky oil lamp. Then she gathered pots and trays and crouched on a flat boulder, scouring them with ashes and a twist of grass, then rinsing them with clear water.

'He is not happy in his marriage,' she said after Jaladhar had gone. 'His wife is kind, but she's ugly with teeth that stick out. My adopted brother arranged the match because she's from a good family and the dowry was generous. But he hates to look at her.' She sat down again on the mat. 'I was so lucky,' she said quietly into the darkness.

'When did your husband get ill?' I asked.

'Just before the children were born. Lots of fevers and coughing up blood. He was in the tuberculosis hospital at Khordha for three months – I used to go every two days to cook for him. And I had to sell most of my jewellery to bribe the doctors to treat him. But he got better and went out in the boat again. Then a year after Baikuntha was born the illness came

back – but this time it was much worse, and I couldn't bribe the doctors because I'd already sold everything and my adopted brother refused to buy my husband's share of the boat. And I couldn't go to the hospital to cook for him because the children were so small.' I thought of Hua in her cold apartment in Shenyang, struggling down eight flights of stairs to take chicken soup to her husband in hospital.

'Didn't anyone help you?' I asked.

'My adopted brother sold some land the first time he was in hospital. But when he got ill again everyone thought he would die, so they didn't want to waste their money. I begged them to help, but my husband told them they should save their money to help me after he'd died – Ha!' she laughed bitterly. 'He really thought they'd look after me.'

'How long was he in hospital the second time?'

'He discharged himself after two months. The doctor said he needed nineteen more injections and he shouted: "Am I a man or a cow that you give me so many injections? Let me die! Let me go home to my children." And the next day the *pundit*[*] came to the village, so I invited him in and brewed tea and he said my husband would die at the next full moon. After that he just gave up: he refused to go back to hospital, even after his brothers agreed to pay the doctors. And he just got thinner and weaker until he couldn't walk. He used to say he could hear his parents calling him.

'Then, on the last day, he asked me to clean the outhouse so he could lie there where there was more space. And he sent me to gather all the relatives around him. He'd promised a ring for his niece's dowry, so he called his brother and said: "Don't bother my wife for this ring. When Baikuntha's older, he'll work for five years on your boat without wages to make up for it." Then he turned to my mother and said: "*Bon*, I am giving your daughter back to you." You see he was thinking of me all the time.' And she wiped tears off her cheeks with the end of her sari.

'I remember it was dark by then, and I'd sold the lamp. So

[*]*pundit*: fortune-teller.

someone went to get one and put it on the floor next to him. Then he spoke to me: "Look after the children," he said. "Even if you have to beg, make sure they always have food." Then he said: "I'm going," and he died when the full moon started to rise, just as the *pundit* predicted.' The outhouse gaped blackly behind us. I looked up at the sky, half-expecting to see the same moon floating there.

'What happened then?' I asked gently.

'The men took a rock and smashed it down on my wrist to break my glass bangles. And the women took all my bits of jewellery off. I just stared at the lamp. I think I was crying; I can't remember. And someone stole my last gold bracelet.' I thought of the pretty eight-year-old bride, splashing in the sunshine in the pond, sparkling with gold jewellery and silver water. And the numb widow in the flickering darkness, with bruises and glass splinters on her bare wrists, stripped of her identity. I guessed who had stolen the bracelet: it would have been far more valuable than the promised ring.

'And was the funeral the same day?' She nodded, and her voice sounded distant, almost dreamy, in the darkness. 'There was a huge storm in the afternoon, so they built a polythene canopy over the pyre and used lots of kerosene. I had to sell a silver chain and my gold earrings to pay the priests and buy clothes for the pall-bearers.' I could see her running through the mud to the goldsmith's, to the market, with her sari clinging to her body and rain on her face.

'Baikuntha was only one-and-a-half, but it was his duty to light the fire. Someone had to hold him up to do it. Afterwards he was supposed to serve the food to the guests. But he was too small to carry anything, so he just touched the palm-leaf plates. When they saw him the priests were so upset they refused to take any payment.' At the sound of his name, Baikuntha woke up and came to sit next to her, butting his head under her arm like a puppy looking for the nipple.

'What are these?' I asked, pointing to the selection of little charms he wore round his neck. 'This is a *deunria*,' she said, touching a little silver cylinder on a string. 'It's to protect him from the jealousy of barren women.' I looked up sharply,

scanning her face, wondering if she was worried about me. But she was picking up the two other charms: a pair of tiny silver cow's horns and a grubby ring of leather. 'I bought these from a cowherd who knows magic. They're for frightening demons away. After my husband died, Baikuntha was very sick – with fevers and terrible screaming nightmares. I couldn't get him to eat anything, and I was terrified he'd die too. The cowherd said it was because my husband's spirit was calling him, and he couldn't resist because his own spirit had been weakened by all his duties at the funeral. He said it was too much responsibility for such a little boy. That was why he was ill.'

'Did you think you'd been cursed?' I asked, and she sighed resignedly: 'People say I ate my husband,' she said.

I turned to Anindita. 'It's what people say when they think someone's caused the death of someone else,' she explained.

'Did you think it was your fault, then?' I asked.

'I sinned in my previous life,' Jomuna said dully. 'So now I have to suffer.' Then, after a pause: 'Perhaps I had too much. A good husband. Two beautiful children. Something had to be taken away.'

Anindita and I laid out our bedding on the verandah: thin mattress and sheets for her, sleeping-bag for me. Jomuna showed us where to piss – among a jumble of boulders – and gave us a pot of fresh water to wash with. Brushing my teeth in the darkness, I remembered the nut and felt for it in the pocket of my skirt. I tried the other pocket, but it was no good. It had gone.

Jomuna moved around for a long time after we'd lain down: washing, pissing, piling pots and rearranging things in the little room, then finally curving herself, like a cat, around the sleeping bodies of her two children on the outhouse floor. I looked up at the sky: pricked with silver needles, slashed by the black knives of bats' wings. I could hear dogs snuffling in the alleyway. Cockroaches and toads waddled among the discarded rice grains. Somewhere in the dark dust was the seed the Saint had given me.

Later I woke briefly. There were low voices, a lamp flickering in a window across the courtyard: a woman waking her husband and sons to take the boat out on the dark lake. All over the village, wooden doors were opening; figures were walking with nets over their shoulders, converging by the lakeside: ghostly mermen returning to the water.

At dawn I followed Jomuna to the pond, joining a quiet procession of women: choosing a space in the field, then wading into the water, fully clothed, saris floating like coloured weed. They stared at me without hostility, letting their heads fall back on the surface and their hair fan out like black oil around their faces. There was a shrine in the centre of the pond, a stone lily rising out of the water. One by one the women turned towards it and prayed to their gods.

The sky blushed and swallows dived under the trees. A line of Hindu scripture came into my mind: 'She has thrown off her veil of darkness, awakening the world with purple horses'.

After a breakfast of plain wet rice, Jomuna locked up and took the children to her parents' house before setting off round the village again to buy dried fish to sell the following day. 'You make me so slow,' she complained as we prepared to go with her, so we took the hint and went instead to the jeweller's shop where she'd sold her wedding finery.

A small man with gold teeth showed us into a dark room behind a barred shop-front where two craftsmen sat cross-legged surrounded by tiny tools and scraps of gold filigree. It was a man's place: the owner's friends were there, smoking and drinking tea; the customers ordering dowry jewels were all men. When I asked if he bought second-hand pieces from widows, he bridled as though I'd accused him of some heinous crime. But Anindita worked him over with a volley of dimples and he eventually admitted that, along with unemployed labourers, widows were his most frequent suppliers. 'But I always give them a fair price,' he said defensively.

There was a basket full of dried fish on the verandah when we got back to Jomuna's house, and she was talking politely to an old man with a black leather bag slung over his shoulder. 'He's a moneylender,' she told us when he'd gone. 'Baikuntha got chicken pox last month so I had to stay home and look after him. I had to borrow to buy medicine and food because I couldn't go out selling fish.' 'How long will it take to pay him back?' I asked as she crouched and started laying out the fish in the sun. 'I was just giving him the interest,' she said. 'I don't know when I'll be able to pay him back.'

'Wasn't there anyone else you could have borrowed from? What about the aunt who adopted you?'

'She died when Baikuntha was born. The old people wait until their children are settled before they die. She left the house to my adopted brother, but when I went to him he said he didn't owe me anything because he'd already contributed towards my dowry.'

'What about your brothers?'

'They have their own families to look after, and they're just helpers on someone else's boat, so they never have any money to spare. That's why I couldn't go on staying there after my husband died. They're so poor my mother even comes with me to sell fish sometimes.

'I wasn't happy there anyway. My sister-in-law said I'd stolen some money, even though I swore on my son's head that I was innocent. Then she found it the next day – she'd forgotten where she'd hidden it. Her baby died a few weeks later, and people said it was because she accused me unfairly.'

I stared at her, shocked: 'And what do you think?'

'We have a saying that if a widow is mistreated, even her breath has the power to punish you,' she said mildly.

'Are you sure about this?' asked Anindita. Supper was over and we were laying out our bedding on the last night. We'd arranged that I would accompany Jomuna when she went to sell fish in the inland villages the following day. I was dreading it – that was why I'd put it off until now – but I felt I owed it

to Jomuna to try and experience at least something of what her working life was like before I left.

'What time do you get up?' I asked, lying down on my sleeping-bag and rolling on to my stomach. Jomuna raised herself on one elbow, the other hand on Baikuntha's thigh. 'The bus comes at five,' she whispered. 'But I have to be up hours before that – when it's still dark.'

'So how do you know when to get up?'

'If you wake and your necklace is cool, then you've slept long enough,' she said.

A moment later Jomuna was shaking the children in the dark and lifting them on to their feet so that she could sweep the out-house. They stumbled blearily over to the jumble of rocks and pissed, then sat against the wall and fell asleep again, while she swept around them, holding the oil lamp aloft in one hand. While Anindita and I packed our things, she hurried off to the pond to wash, returning with a pot of water for us.

She had to wake the children again to feed them, and they lolled against her with their eyes shut while she stuffed handfuls of wet rice into their mouths, then nudged them awake to make them chew and swallow. When they were finished, she hauled them to their feet, plonked the half-empty pot in her daughter's arms and marched them along the dark alleyway to their grandparents' house for the day. She came back running; the bus was waiting. We'd have to hurry or we'd miss it.

It was revving its engines impatiently when we arrived, and Jomuna joined the crowd of women paying to have their baskets strapped to the roof. 'They won't allow them inside,' she explained. 'The smell's too strong. So we have to pay extra. Rickshaws won't take us at all, so we have to walk to the villages.' She looked at me doubtfully. 'It's a lot of walking,' she said. 'Are you sure you want to come?'

We climbed aboard and I sat down amidst a ripple of speculation. Jomuna stood beside me, shaking her head when I pointed to a vacant seat. Then I saw that all the women were standing, ignoring the empty seats; but the men were sitting.

Discrimination, I wondered, or disinclination to sit beside a strange man? Discrimination, I decided later, as the remaining seats filled up with men from stops along the main road, and the aisle became jam-packed with bodies of both sexes, making modesty impossible.

We disembarked half an hour later along with four other women from the village. They split into two pairs and set off along two separate sandy tracks, while Jomuna pointed to a third track branching off on the other side of the road.

Lifting the heavy basket of fish on to her head, she set off, walking quickly. I walked beside her, squinting into the sun, feeling the heat pulsing already in the morning air. A flock of sparrows dust-bathed in the middle of the track, then whirred off across an expanse of sunken paddy-fields crazed with dry mud. A rickshaw passed, carrying two plump children in immaculate school uniforms. I began to feel thirsty, a kind of mad thirst that made my tongue ache and filled my mouth with saliva. I glanced at Jomuna and she smiled, and nodded reassuringly into the distance, to where the road dipped into a shallow valley, then rose again to a cluster of trees. 'Nayagarh', she said, then gestured to left: 'Saranakul'.

She'd been vague about distances when we'd questioned her the previous evening. About forty kilometres in the bus, she thought; then maybe ten on foot. I began to focus on individual trees along the track, longing for each brief moment of shade. The sun rose higher and I could feel the hot dust through the soles of my gym shoes, the hammer pounding the top of my head. I looked down at Jomuna's bare feet, stepping quickly on the burning stones, the silver toe-rings covered with dust. How many kilometres did they cover every day, door to door around the village, to the wood and the well and the pond? How many kilometres for each precious rupee?

The road stretched out in front of us: hard and hot and dusty. I would never have to walk along it again.

Anindita caught up with us before we got to Nayagarh, bouncing along in the Fiat, enjoying the opportunity to drive a car.

'I was worried about you getting thirsty,' she said, handing us each a bottle of warm Pepsi. Jomuna nodded her thanks and drank thirstily. 'Can we go in the car now?' she asked Anindita, wiping her mouth on her arm. 'Your friend walks so slowly.'

The rest of the day passed in a blur: driving to the village and parking under a tree, then wandering from house to house in the midday heat while Jomuna weighed fish and haggled over the price, waiting while women disappeared to search for their money, then haggling again when they returned with too little. 'They often do that,' she said bitterly. 'Promising to pay me next time, then pretending they've forgotten. But they're my customers, so what can I do?' Her patience was boundless: with women who sneered and picked at the flesh of the fish, women who accused her of cheating them, boys mocking and running after her, shouting 'Mother of Fish!' Somehow she managed to keep up a continuous flow of chatter and smiles.

When the basket was still half full, and there was at least one more village to visit, I decided I couldn't walk another step. The children jostling and staring, the heat bludgeoning my body, the endless negotiations at every house. Enough: I had seen what it was like. Half a day was more than I could stand.

On the way back to Lake Chilka, Jomuna was full of energy: chattering and laughing with Anindita then, when we arrived at the village, telling everyone we saw that I had gone on the bus with her and walked with her to Nayagarh.

Later, when it was time to go, she came to the car with us, wading through a sea of children. The sun was low and our shadows stretched grotesquely towards the lake. I unlocked the boot and we threw our things inside: my skirt and T-shirt, still wet and filthy from their dousing at the Saint's village, bundles of bedding wrapped round warm bottles of Pepsi, a bag of man-goes as a parting gift from Jomuna. She smiled shyly as Anindita translated my speech of thanks, then knelt quickly and kissed my feet.

I tried to reciprocate, but she grabbed my shoulders to prevent me from kneeling. 'Please,' I said, looking into her eyes.

'Let me show my respect for you too.' It was in English, but she seemed to understand. And she released me and allowed me to kneel, and touch my lips to the feet that hurried tirelessly along the maze of village streets every day, paced the forest track for hours with a load of kindling on her head, walked down a ten-kilometre road of burning dust and back again three times a week.

Helen

(PERTH, AUSTRALIA)

Forty per cent of Australian marriages contracted since 1970 now end in divorce, and recent figures reveal that the mother's standard of living drops dramatically after divorce compared with that of her ex-husband. In fact single mothers are fourteen times as likely as two-parent families to fall within the poorest income bracket. This 'economic shock' is greatest in middle-class households, where ex-husbands pay proportionately less towards the upkeep of their children.

Helen lives on the outskirts of Perth in Western Australia. Part-time social worker, mature student and devout Christian, she is the mother of three ebullient school-age children – Jane, Nicola and Mike. Divorce has left her with a low income and even lower self-esteem. But her faith, and her work with women caught up in domestic violence are helping her cope with the bitterness left behind by her accountant husband's infidelity.

A streak of red feathers flashed across the road. A parrot? In the centre of Perth? 'Brian and the kids are in a tennis tournament all weekend,' said Sandy, steering the station-wagon down wide tree-lined avenues. 'So I thought I'd take you to the nudist beach. Is that all right?' I nodded dumbly, staring at the cloudless sky, the landscaped parks, the cascades of jasmine and bougainvillea which tumbled over the verandahs of every bijou bungalow. People in shorts and sneakers wandered along the pavements eating ice creams. It was like programming 'vacation' on the holo-deck of the *Starship Enterprise*.

As we drove out of the city centre, we passed through

81

several different leisure zones: the river and botanical gardens; streets of open-air restaurants and boutiques; then out along a garish five-kilometre ribbon of car and furniture showrooms, interspersed with burger bars and garden centres, which plunged gaily through acre after acre of bungalows and on into the open country. Speeding through an autumnal landscape of flushed bushes and golden grass, we passed cars towing yachts and camping trailers; clumps of thigh-pumping cyclists in helmets (obligatory under Australian law) and shiny lycra (seemingly equally obligatory).

The beach – reached by steps down a flower-studded cliff – was an endless white crescent shelving gently into a crystal sea. It was sparsely dotted with gleaming brown bodies, lolling like sealions. No lumps of oil or crushed plastic bottles; no lolly wrappers or suspicious floating objects. 'The American Dream is to become President,' remarked Sandy, spreading out her towel. 'In Australia it's to quit your job, and go and live on a beach in Queensland.'

I stripped and walked into the sea. It was cool and calm, soothing away the anxieties of the last four days. That was how long it had taken to get here. 'I assure you there is no such flight.' The woman at the airline office in Bhubaneswar was growing angry. She strummed the computer keyboard with fat, beringed fingers: 'Everything else from Delhi is fully booked because of the strike –' 'What strike?' I asked, but didn't listen to her reply. My mind had already fast-forwarded to Australia, where any delay would mean clashing with the Easter holidays when everything would be closed. 'What about Bombay?' I said at last. 'The computer is not linked with Bombay,' she said, an unmistakable gleam of satisfaction in her eye.

In the end we cobbled together an elaborate route, via a series of tiny stifling airports to Bombay. At one memorable stop it was a hundred and twenty-six degrees at midnight, with the passengers standing around like wet zombies in front of the non-functional air conditioners. Once in Bombay, I had to kick my heels in an overpriced hotel for two days while my wait-listed name edged gradually on to a flight bound for Australia.

But now I was here at last, in a place that seemed more theme park than country, floating on my back and staring at the sky.

The idyll continued the following morning, when Sandy took me to the house I'd be staying in: a charming Victorian bunga-low with an ornate wrought-iron porch and a sunny patio edged with a riot of sprawling geraniums. 'The owners have gone away for Easter,' she explained, then: 'You realise every-thing will be closed over the holiday, don't you?' I realised only too well: I had to find the woman I'd be writing about before the end of the week.

I began that afternoon, working systematically through the list of contacts Sandy had provided for me. And I soon dis-covered that Australia's social provision appeared every bit as genial as its leisure culture, with an optimistic acronym for every situation. JET trained and retrained rusty homemakers, providing crèches and after-school care for their children and subsidies for potential employers. COPE organised group therapy plus training to help single parents to discipline their wayward children. There was a special range of grants and benefits – including the Single Parent Pension – specifically tailored to the needs of single mothers. Not to mention Parents Without Partners, whose annual Mother of the Year contest was evidently an event not to be missed.

I telephoned the current Mother of the Year, but she was going off to Adelaide the following day, in a convoy of coaches packed with other Parents Without Partners, to the annual PWP convention. 'I know lots of women who'd love to be in your book,' she said brightly. 'But they'll all be on the coach. Try Harry.'

I tried Harry, a veteran PWP member who seemed to know everyone. 'What kind of girl are you looking for, dear?' he asked in a fag-hoarsened voice. 'You realise it's Easter,' he added helpfully. 'Lots of people are away. And the rest are going on the coach trip to Adelaide.' I explained that I wanted a middle-class woman with school-age children; preferably

someone who'd gone back to work after she'd split up with her husband. 'Ooh, I don't know,' he said in the portentous tones of a plumber surveying problematic pipework. 'Depends what you mean by middle-class. You could try Sally, I suppose,' he said grudgingly. 'She was married to an architect. Or Vicky. Her ex-hubby's a lawyer.'

In the end he gave me six numbers, and I spent the next three days on the telephone, talking to women I'd never met – and the friends they passed me on to, and *their* friends – about the breakdown of their marriages. Strange lonely days they were: sitting in the pretty bungalow by myself, dialling other lonely women in other pretty bungalows, listening to their tales of hurt and betrayal. Some were only too pleased to talk, excited by the idea of being part of the book. Others spoke in guarded, bruised voices.

After a while I noticed the same phrases recurring: 'he wanted his freedom', 'it was fine until the kids came', 'he used to get plastered and thump me', 'he went bankrupt and bug-gered off'. I heard this last phrase so often that I began to won-der if financial mismanagement were some peculiar Australian disease. Then it occurred to me that it might be part of the general flight from responsibility that Barbara Ehrenreich iden-tified in *The Hearts of Men* as being endemic to the modern-day Western man: a *Playboy* ethic that leaves Western woman literally holding the baby. This was the flip-side of the Australian dream: a pile of unwashed dishes in the sink; a wad of wet tissues in your hand.

'If a woman's husband buggers off, her confidence goes too,' said Mo, who worked on the checkouts at Bi-Lo's super-market. I was at a meeting of a local Single Mothers' Support Group, a ramshackle tea-party with a posse of ill-assorted chil-dren, who charged periodically through the open-plan kitchen grabbing flapjacks and cheese sandwiches.

'The worst thing is the stigma,' said Adele, part-time nurse, sipping Liebfraumilch. 'I went out with a collecting tin last month and people were almost spitting at me. One man said: "What's a nice girl like you doing collecting for those bludgers?"' 'And people assume you've got a houseful of men

all the time,' added Debbie. 'My daughter hurt her fanny falling off the climbing frame, but when I took her to the doctor, he accused me of letting some man abuse her. I was furious – there's no men in my house. Even the cat's been to the vet!'

'What do you think of Parents Without Partners?' I asked. Mo made a face. 'It's a real meat market,' she said. 'Full of divorced men looking for an easy lay.' 'Not that we don't like men,' Adele added quickly. 'It's just that we try to be a bit choosy. Me and Anne went to the Desperate and Dateless last night – that's what we call the Computer Ball. You fill in a form and they pair you off with Mr Right. I got an ostrich farmer and she got a karate teacher. We dumped them in the end, but it was a laugh.'

At the end of the third day I began to panic. Every woman I'd spoken to was unsuitable for some reason. Half had relinquished their children to their ex-husbands over Easter. Others were going away themselves, or were in new relationships. Then there were the vulnerable women who didn't want to expose themselves – and who could blame them? Jan, for instance, battling with clinical depression. Or Joy, raped by a new neighbour after moving to an outback town because part-time teaching work was so scarce in the city. 'I'll think about it and get back to you,' said Jan. 'Catch you later,' said Joy. But I knew they wouldn't.

In desperation I went to visit Sandy, to see if she could succeed where Harry had failed. 'I'll phone Jenny,' she said, picking up the phone. 'I'll just bet she knows someone.' She listened for a moment, then: 'Yes! Why didn't I think of her?' Then: 'Great, what's the number?' She scribbled it down then looked up at me, beaming.

'Her name's Helen, and she's a part-time social worker. Three kids at school. Hubby's an accountant who's gone off with someone young enough to be his daughter. Jenny thinks there was some kind of emotional or sexual abuse involved, but she can't remember the details. And lots of hassles with hanging on to the house.' But would the kids be staying

with her over Easter? I wondered. Or was she about to marry the new man of her dreams? Most important of all: would she agree?

'Hello, is that Helen? Jenny Baxter gave me your number – I hope you don't mind –' and I went into my spiel for what felt like the six-hundredth time that week. 'Can you tell me a bit about your marriage?' I asked finally.

'Today I would describe it as sexually and emotionally abusive,' said a disembodied voice with a bright candour I found vaguely disturbing. 'At the time I just assumed I was useless. Then Lawrence started having affairs and it gradually became obvious that he had absolutely no commitment to preserving the relationship.' She spoke with a kind of jolly-hockey-sticks bravado, exposing the pain but masking it at the same time.

I asked whether she'd be willing to be part of the book. She didn't hesitate: 'The kids are off with Lawrence for a few days over Easter, so you should come tomorrow if you want to spend any time with them. And I expect you'll want to see me working – I'll arrange that. And I'm sure no one at Murdoch will mind you sitting in on a few lectures.'

'Murdoch?' This was unexpected.

'At uni – the university. I'm doing a part-time psychology degree. So I have to fit studying in with everything else.'

Helen lived in one of Perth's older meandering suburbs. 'It's the house with all the greenery,' she'd said cheerfully. 'The garden was the first casualty of the divorce.' I wandered around the big red-tiled bungalow, peering through the shrubbery for a front door. After a while I gave up and knocked at the kitchen window.

A broad red-haired woman was stirring a large mixing-bowl. 'Sorry about the jungle,' she said, handing the spoon to a bespectacled eight-year-old girl. 'Wait there and I'll conduct you to the back door.' She reappeared a few minutes later and

led me under a vine-swathed pergola, and in through a utility room full of margarine cartons, crusted cat bowls and pots of dead seedlings.

'We're somewhat chaotic today,' she called over her shoulder. 'It's Jane's birthday, and Lawrence is picking her up at four. He's arranged a party, but I've just been informed that I'm supposed to supply the cake.' I followed her into a big low-ceilinged room made gloomy by the dense vegetation outside. There was an impression of scuffed parquet and grubby magnolia paint, books piled higgledy-piggledy, heavy tweed furniture, heaps of ironing.

'That's typical.' Helen warmed to her theme. 'He never takes complete responsibility for anything to do with the kids. When it's his weekend to have them, he always finds some excuse to drop one of them off back here. Or he'll ask me to fetch them from somewhere at the last moment. Right: this is Jane' – the eight-year-old grinned up at me – 'and Nicola' – a freckled ten-year-old with a shock of ginger curls, creating a Lego wonderland on the floor. 'Mike will doubtless emerge eventually. Would you like a cup of tea?'

I sat down at a pine table covered with brochures and bills. On top was a handwritten list on a torn envelope: 'ballet shoes, piano lessons, nebuliser'. 'I was adding up what he owes me for their extra-curricular activities,' Helen explained. 'He's usually quite reasonable, but I wish he'd just increase my monthly allowance. I hate asking for money all the time.' I remembered Hua in China saying the same thing: how each payment involved an act of humiliation.

She handed me a mug and a giant carton of low-fat milk, then began rooting noisily through a drawer for food-mixer attachments. 'I'll have to carry on with this, but feel free to fire questions,' she said briskly, pushing her curls off her forehead. Her hair was extraordinary: a dense thatch of springy orange above milk-white skin spattered and smudged with pale freckles. Her sandals were flat, her chin was square, her blue eyes were innocent of make-up; her big flowered skirt swayed as she bustled round the open-plan kitchen. I noticed the glint of a crucifix on a chain beneath the parrots on her T-shirt.

I took out my notebook. 'Maybe you could describe a typical week,' I began.

'Well, Monday I go to work, so the lodger comes home early to babysit the kids after school. She's got the room Lawrence used to use as an office. I charge her less in return for babysitting the kids when I'm working. So she takes Jane to piano, and Mike – that's my eleven-year-old – takes himself to his flute lesson. Nicola stays at home watching television – she's only ten, so I'm not very happy about leaving her on her own, but it's not for long. And if she's alone then at least she can't fight with the others! One of the kids always goes to Lawrence for the night on Monday – though when he started at his new partnership he was too busy. On Tuesday Jane's got ballet and Nicola goes to recorder, so I ferry them to those after uni. Wednesday's similar: uni, then cricket practice for Mike. Thursday's Nicola's drama class, but I insisted on Lawrence taking her to that because he arranged it without consulting me and it's one of my heaviest social-work days – so he usually gets his secretary to do it. Then Friday's another social-work day, so Lawrence picks them all up from school and takes Jane to ballet and keeps them until nine o'clock. It's much more complicated during school holidays, of course. I still have to do my three days' social work and uni tends to go on right through, so I really have to battle with Lawrence about doing more childcare.'

'Is it normal for kids to have so many classes after school?' I felt exhausted just contemplating all this cultural enrichment.

'Oh, I haven't finished yet.' She brandished whisk attachments. 'Lawrence takes Mike to cricket on Saturday morning, and Jane and Nicola both go to ballet – one at nine and one at eleven. Then Mike has drums at twelve.'

'But it must be so expensive – '

'All the middle-class parents try to organise something for their kids outside school – even if it means cutting back on what they spend on other things. Half my kids' clothes are second-hand, and we always go camping or stay with people when we go away. And I try to get Lawrence to pay at least half.' She lowered the whisk into the chocolate mixture.

'What do you do on your weekend off?' I asked when there was a gap in the noise.

'Study mostly. And try to keep up with this – gesturing round the cluttered room with a dripping spatula.

'She does about six jobs and only one pays,' said a precise little voice behind me. 'Housework, being a mum, counselling at the clinic, the social-work umbrella thing, the thing at the home for teenagers, and she used to do a natural childbirth thing too but she had to give that up.' Nicola sat down opposite and eyed my notebook suspiciously. 'Are you going to put all that in your book?' she asked. Then, when Helen left the room for a moment: 'I would like to correct a false impression,' she said gravely. 'We see our father more often than we stay with him. He tries to see us every day, even if it's only for a few minutes when he takes us or picks us up from school.' And she regarded me severely, red curls bristling. I nodded meekly: I had been warned.

Lawrence arrived just as the cake was being placed in a Tupperware container. A tall forty-year-old in a mustard-coloured suit, he had a big nose, receding chin and wispy greying hair, which together gave him an oddly rodent-like appearance. He seemed irritated, walking quickly with his nose thrust forward. 'Isn't she ready yet?' he asked Helen impatiently. Then, seeing her bridle: 'Thank you for making the cake.'

'Debbie's writing a book about Mum's life,' Nicola piped up. 'What kind of book?' he asked, turning to me and smiling. 'It's about single mothers,' I said. 'And how they cope with all the pressures in their lives.' 'That sounds very interesting,' he said, still smiling.

After he'd gone, Nicola wandered over to the television and turned it on. Curling up on the sofa in a foetal position, she put her thumb in her mouth. 'Don't just put it on regardless,' called Helen wearily, filling the washing-up bowl.

'Great! It's the Surfing Olympics –' Mike bounced into the

room and sat on the floor. 'Look at that!' I did: taut-muscled young men pounding along the beach against the clock, then flinging themselves into the water, leaping like salmon over the waves towards a distant buoy. The sky was blue, the lycra sparkled. "Will one of you please set the table?' said Helen.

'Do they help much?' I asked.

'They make their own packed lunches and I suppose they do the washing-up about once a week.'

Nicola looked up indignantly and slipped her thumb out of her mouth. 'Excuse me!' she objected. 'When you're depressed, we make lunch *and* supper, *and* wash up and tidy our toys.' She turned conspiratorially towards me: 'She goes into her room and shuts the door and reads about *ten* Mills and Boon books,' she said.

'How did you meet Lawrence?' I asked when the children had gone to bed. We were sitting by the empty fireplace and she was darning the toes of Jane's brand-new block ballet shoes so they wouldn't slip when she danced on her points.

'At a harvest supper when I was living in Canberra. It was a big church-based event and I'd been helping decorate the church. Afterwards there was this big meal at Lawrence's sister's house, for all the volunteers. Anyway, he just happened to be staying with her that weekend because he was on one of his "chess tours"' – she had a habit of punctuating her speech with inverted commas. 'After the meal someone turned down the lights and there was dancing and he made a beeline for me – I'd hardly ever been kissed properly before.'

'Was he your first boyfriend, then?'

'Oh, I'd fallen in love a few times, but always from afar. I pursued one man for years. I even wrote him a letter, but he said he didn't think of me in that way. Then I had a chaste sort of "affair" with a man from Sydney, but when I went to visit him there he just ignored me.'

'But Lawrence was different.'

'Oh yes. He was all over me. First we danced and kissed for ages. Then he took me up to the room he was staying in. I

hardly knew what was happening – no one had ever touched me before. I remember saying half-heartedly: "This isn't going to work". Next day he cancelled all his plans and took me to a motel for the rest of the weekend. We just vanished – it sent ripples round the church!' The scandal still clearly delighted her. 'Then on the Sunday evening he brought me an orchid and I saw him off on the plane back to Perth. I remember driving home afterwards. My skin was just zinging from being touched so much.'

'Then what?'

'I gave up my job and moved to Perth.'

'Just like that?'

She giggled modestly at the admiration in my voice. 'No, not really. I'd been depressed for a year before I met Lawrence. I didn't know many people in Canberra when I first moved there. Then I was transferred to a job I hated – as a clerk in the Defense Department. I got some anti-depressants, but I had to stop taking them because they made my skin flaky: horrible, like leprosy.'

I winced: 'That would have made me suicidal.'

'Oh, I didn't mind that so much.' She waved the darning needle airily. 'I was never much of a "God's gift" anyway. I had terrible acne as a teenager, and the fashion then was for long straight hair. I tried to iron mine but it stuck out like a bush, so I just used to tie it back in a rubber band.' I imagined the lonely twenty-four-year-old behind her desk. The ardent young man from Perth must have seemed like the answer to a dream.

'So Lawrence made you feel beautiful.'

'Initially, yes. But then he started trying to influence my appearance. He thought I should look "alluring" so he made me buy tight jeans and a low-cut red evening dress. And he was always nagging me to shave my legs. But there's something in me that rebels against the ideal of how a woman should look. And it didn't seem to affect his sexual urges – he used to demand sex whatever I looked like. I don't know what he'd have been like if I'd tried to look "seductive" as well.'

She spoke lightly, but there was anger in her voice. She pushed the needle into the smooth pink satin and dragged the

thick thread through. 'Were you the first woman he'd been to bed with?' I asked.

'Good Lord no! He'd had two live-in lovers before he met me, and innumerable shorter "liaisons". Actually he had at least six affairs during the first year we were together. It started when I had to go to hospital to have an impacted wisdom tooth out. I found a bloodstain on the mattress when I changed the sheets.' I sensed her cold shock at the sight.

'Did you confront him?'

'Oh, he just claimed he had different moral standards to me and that the sex was a "physical release". It was nothing to do with his love for me.' She spoke mockingly, and we exchanged ironic looks. What about the hurt? What did that have to do with his love for her?

'I felt really depressed after that,' she said, biting off the thread and picking up the other shoe. 'And it wasn't helped by the fact that half my face was temporarily paralysed after the operation and I had to have my eye taped shut because I couldn't blink. I vaguely considered leaving him at that point, but I didn't have anywhere to go. I was unemployed and I didn't know anyone in Perth. And I was stupid, I suppose. I thought I could make him change.'

The next day we went shopping in the rusty green VW Combi. 'I always try to take Nicola with me,' said Helen quietly. 'Lawrence tends to pick on her, and the others have started following suit. It's because of her red hair, I think. He says she reminds him of me. I shudder to think what that implies!' She laughed one of her painful gay laughs. 'Actually, it's more likely to be because she stands up to him. He knows he can't quite control her.'

The Bi-Lo supermarket was an eye-aching mass of red-and-yellow posters. Inside, mother and daughter went into a well-rehearsed ritual, with Helen reeling off items from a list, Nicola darting up and down the aisles collecting them and reporting their prices. These were then tapped into a pocket calculator. Fresh meat, fruit and vegetables went in; whole-wheat cereals, dried pasta, polyunsaturated margarine; teabags,

ground coffee, cocoa-powder, shampoo. And finally diet Coke, chocolate biscuits and tinned spaghetti hoops. 'I have to be careful not to go over budget,' Helen explained. 'But they're each allowed to put one thing on the list.'

We got home just as Lawrence was leaving. He seemed taken aback to see me sitting in the front seat, but waved cheerily as he drove off in his sleek-flanked Audi. As we lugged the carrier bags into the house, Jane came running out and flung herself against her mother, ignoring her load of shopping. 'What's the matter?' crooned Helen, dropping everything and kneeling to take the little girl into her arms. 'Didn't you have a nice party?'

'Half my friends forgot to come!' she sobbed. 'And Dad hadn't got me a present. He said he'll take me to choose something next week, but I wanted to have it on my birthday!'

Helen made a face at me over her head as if to say 'See what I mean?'

'How about if we go to Paulo's Piazza for tea?' she said soothingly, taking off the little girl's glasses and wiping her eyes with her T-shirt. 'And you can choose whatever you like.'

'We come here every other Sunday after swimming,' said Helen happily, sipping her cappuccino. The children had eaten their garlic bread and were over at the ice-cream counter, concocting elaborate combinations of flavours. 'It's not too expensive and they don't mind children.'

'Is it true that the houses are joined together in England?' asked Nicola, sliding a pistachio-and-chocolate-chip creation on to the table. 'And you have to go upstairs to get to the bedrooms?' I nodded. 'The buses are like that too,' I said. 'With upstairs, I mean – not joined together.'

Was this significant? I wondered. Would a society of detached bungalows behave differently to one compacted in the cheek-by-jowl shacks of China or India? Australia had pioneered the suburban lifestyle. It was here that the lawn-mower and folding buggy had been invented. Millions of detached bungalows; millions of detached lives.

I watched with some awe as Mike demolished a mountain of green and pink ice cream. 'Do you do different things when you go to your Dad's house?' I asked when he'd finished upending the steel bowl over his face and running his tongue round the inside rim. 'Well, we've got our bikes there, and there's the computer. So there's those things to do. He takes us cycling to the beach or to the movies. And he's got the pool now, so that's excellent. And we usually get a takeaway – '

'That's because he can only cook about *three* different meals,' Nicola interrupted scornfully. 'So we get pizza or Chinese all the time. He always spends tons of money when we go to his place, but with Mum we have to do things that don't cost much. Like with school lunches. We make our own at Mum's house, but when we stay with Dad he just takes us to choose something at the deli.'

I turned back to Mike: 'Why are your bikes at your Dad's place?'

'Because he bought them. He always gets us bigger presents than Mum because he's got more money and Mum only works part-time. And he doesn't get so tired because he doesn't have to look after us as much as she does.'

'And who's the strictest – your mum or your dad?' I asked, winking at Helen over their eager faces. 'Dad lets us stay up *much* later,' said Jane approvingly. 'But he gets much crosser if we fight or make a noise.' 'And he's much more likely to yell and scream –' This was Nicola butting in again. 'And he likes things tidier than Mum. Before they split up he used to lose his temper a lot – once he put me in the cold shower with my clothes on! Mum just gets sad when we've been fighting a lot and goes and lies on her bed with a book.' Helen smiled and rested her hand briefly on her daughter's flaming ginger curls.

After a frantic scramble for clothes and favourite books the next morning, we dropped the children off at their father's house. Helen was at work for the next two days; Lawrence had the week off, and was taking them to the traditional Easter race meeting. I peered curiously at his new house, an elegant single-

storey Victorian building with tangles of ornate wrought-ironwork around the windows and doors. 'The pool's round the back,' said Mike proudly. 'It takes up almost the whole garden.'

'It's so quiet without them,' I remarked, settling back in the front seat of the Combi after they'd got out. Helen nodded: 'I used to drive round for hours when we first split up, because I couldn't bear to go back to an empty house.' We were on our way to a meeting of what Nicola had called 'the social-work umbrella thing', which consisted of a team of part-time social workers who worked intensively with a small group of so-called 'problem families'. Helen was their supervisor. 'I do three days a week at seventeen dollars an hour,' she said. 'The others get twelve – that's less than a cleaning lady! They're all married to men in full-time employment – they couldn't afford to do the job otherwise. I'm supposed to advise them with the more difficult clients. Nearly all our cases are one-parent families.'

We parked outside a self-consciously designed building: all odd angles and smoked glass. Passing through a series of cheerful modern offices, we arrived at a meeting room full of pale wood furniture where a bevy of middle-aged women were waiting for us. A tea-and-coffee bustle followed, with plates of biscuits and a flurry of 'I shouldn't really' 's. There was lots of good-humoured laughter; expanses of sun-spotted arms; waxed calves trimmed with dainty white sandals; froths of fiercely peroxided hair.

'I've got a great success to report,' said one. 'Della – you know, the one who threw out that violent boyfriend? Well, he asked for his belongings so she loaded a trailer full of goat-shit and dumped it in his front yard!'

'Me too,' chimed in another. 'Remember Cindy, who was so nervous about bringing that rape charge against her husband? I drove past the jail with her last week and she shouted "Hi honey, you're home!"'

When the applause had died down, Helen called the meeting to order. 'I wanted some advice on what to do about Bev,' said a carmine-lipped woman in a tight sky-blue dress. 'She's the one who's deaf from being beaten and sexually abused by her father. Well, she seems to have lost control of her

six-year-old – he's bouncing off the walls with hyperactivity. Then there's the Mackay sisters, as usual – ' they all laughed indulgently. 'Three of the elder kids are refusing school now, and I can't get the mothers to exert any kind of discipline.'

'Have you tried target-setting?' asked Helen. And she went on to outline the beginnings of a programme to help the distraught deaf mother. Knowing how helpless she had felt with her husband, I found it a revelation to see her operating in her professional milieu. Her interventions were intelligent and intuitive; she was clearly very skilled at her job. Yet despite her undoubted professional capability, she seemed personally daunted by their self-assured blondeness: an eager speckled hen in a flock of parakeets. I wondered why she seemed so uncomfortable with her authority, why she felt the need to undermine her position with self-deprecating jokes. Then I remembered what Mo at the support group had said: 'If a woman's husband buggers off, her confidence goes too.'

The group went on to discuss Carol, who'd added a new lover to her houseful of puppies, pet rats and small children. 'I'm worried about his violence,' said a woman with a yacht motif on her white blouse. 'So I've been watching the kids for signs of abuse. Neither of them is toilet-trained and the three-year-old seems retarded. But when they went into foster care last Christmas they made a lot of progress – '

'Must be hard knowing whose poo's whose' – interrupted the woman sitting next to her – 'what with the puppies and the kids!' I laughed with them, but felt uncomfortable. I wondered what Carol would think if she could hear us.

'I have to sort these things or they won't have anything to wear next week,' said Helen, tipping a huge heap of dry washing on to the dining table.

'Don't they keep a set of clothes at Lawrence's?' I asked, thinking of the stock of expensive playthings at his house.

She laughed: 'What – and do the washing and ironing himself? You must be joking!'

She began matching socks and balling them together; sep-

arating greyish underwear into piles; shaking out and folding T-shirts and tracksuits. 'Did he help with the kids when you were married?' I asked. 'He usually got his secretary to look after them if I was unavailable. But she didn't have them very much because I was supposed to be able to manage everything without "unduly impinging" on his life.'

'Did you go out to work as well as looking after the children, then?'

'I just did bits and pieces really. I'd started my social-work training about a year after I moved in with Lawrence, but I fell pregnant with Mike just before my finals. That was when the exhaustion really set in, because I had to do my placement and revise for exams when I was pregnant. And I was seven months gone when I started my first job. In the end I had three children in just over three years,' she concluded with a mixture of pride and resentment.

'Was that intentional?'

'Well Mike was a mistake, because the Pill failed. But he was wanted – they all were. Each time I fell pregnant, Lawrence wanted to rush out and tell everyone straight away, and it was always him who pressurised me into not using contraception. So for five years I was either on maternity leave or doing odd stretches of relief social work in between.'

'How did your employers react?'

'Up to a point they were very understanding. I could take up to twelve months' unpaid leave in addition to maternity leave. But when Jane was born and I had three kids under four, I asked for an extra three months on top of that. But they told me I had to return to work the following Monday or resign. So I added it all up – how much it would cost to keep them in full-time daycare – and it was more than my salary. So I resigned.'

'Couldn't you have gone part-time?'

'There wasn't a vacancy. Actually I did apply to job-share with another woman with small children, but they wouldn't hear of it.'

She set up the ironing board and knelt to retrieve the iron from a cluttered cupboard. 'Those years passed in a haze of

exhaustion – even when I wasn't working,' she said, beginning on a selection of little short-sleeved shirts. 'I had at least one child in double nappies for nearly seven years. And they were all fully breastfed, so there was always one of them sucking at me. I think it was the sheer amount of touching that really tired me out. They all needed cuddling and feeding and bathing, and they used to squabble to get on to my lap. Then as soon as I had a spare moment, Lawrence was there demanding sex.'

'What happened when you said "no"?'

'I was never given the option,' she said bitterly.

'You mean he raped you?'

'At the time I didn't think so, but I'm not so sure now. He used to go on and on at me if I refused, battering me with words until I felt like a piece of meat that's been tenderised with a wooden mallet. If I said I was tired, he'd argue that I couldn't possibly be tired because I'd had however many hours' sleep the previous night, and sex would make me sleep better anyway. He'd use all his logical skills until I'd give in. He allowed me six weeks after each birth. Then I was supposed to be available again.' I winced: more than the pain from episiotomy wounds, it was the calculation that chilled me.

'Did he want to make love often, then?'

'At least three times a day when we first met, then later it reduced to once a day. If I wouldn't do it before I got up in the morning, he'd wedge the bedroom door shut and get his pornography out of the wardrobe. He was always coming up behind me when I was trying to cook, or locking the door when the kids were sleeping in the middle of the day. And if I refused, he'd either argue or go into a great sulk and accuse me of not loving him. I can picture him over there' – pointing to the sofa – 'all hunched up because I wouldn't go and sit next to him while he watched television.'

'He *made* you watch television?'

'He said he liked to have me next to him, but it was just an excuse for foreplay. It meant I never got any time to myself – to read or talk to friends on the phone, or do some sewing. He had to feel I was available, and if I resisted he'd turn it into a huge row. So then I'd have to have sex anyway because he

refused to "go to sleep on an argument". I used to feel there was nothing left of me at the end of the day, because he'd consume every single crumb that remained after I'd finished dealing with the kids.'

The kids' shirts were finished. She picked up a big flowered skirt like the one she was wearing and fanned it over the ironing board. 'Was he ever violent?' I asked, remembering her initial references to abuse. 'It depends on your definition of violence,' she said. 'He never hit me, but he tried to undermine my confidence all the time. You know, continually complaining about the state of the house, or turning his nose up at my cooking, going "Ooh yuk, what's this?" Poke, poke, at some dish I'd spent hours preparing. And holding me responsible if the kids were crotchety when he wanted to take them out. Plus he was always criticising my intellectual capacity, telling me how inefficient and inarticulate I was.'

I looked round the big shadowy room and imagined her in one of her big skirts, her body soft and shapeless from three pregnancies. I could see her standing with her head bowed, like a big flightless bird, as her husband shot his volleys of verbal arrows into her. She had a permanent slight stoop even now: the beginnings of a dowager's hump between her shoulders. The body remembers, I thought, picturing Hua's mother in China with the pigeon chest of rickets; Puni's tiny stunted body in India.

'I felt like I was walking on eggshells,' she said. 'Waiting for the next criticism. And if he was in a good mood, then I had his sexual demands to deal with instead. Looking back, I was depressed solidly from the moment Mike was born until Jane was two. I remember we all went up in a hot-air balloon as a Christmas treat. And I looked down at the countryside spread out in the sunshine – and I felt the depression lift for the first time in over six years.'

'Most of our cases are from this estate,' said Helen. 'You need transport to get anywhere, but the buses are hopeless. And none of them can afford a car.' We'd parked on a hill overlooking a

vast valley of bungalows on the outskirts of the city. It looked idyllic: neat little brick buildings, each with its own garden basking in the golden autumn sunshine. We were waiting for Daisy, one of the quieter women from yesterday's meeting, who'd come to an impasse with one of her clients.

'Stacey's really been trying,' she explained when she arrived. 'But her family are sabotaging the process.' It turned out that twenty-five-year-old Stacey had been a tranquilliser addict since giving birth to her first child at the age of sixteen. By the time Daisy met her, she was a six-stone skeleton who trembled from head to toe: anorexic and agoraphobic, 'popping laxatives, diuretics and Serapax by the handful', with a violent husband, Gary, and two uncontrollable children aged two and nine.

'I put it down to being the unloved child,' said Daisy. 'Her elder sister was the pretty one, and the youngest one was spoilt. So she grew up feeling she was worth less than they were. She remembers her father hitting her for something her elder sister had done and crying "But Dad!" over and over between whacks. Eventually she must have concluded she deserved it – that's how she gets caught up with these violent men. She's been in and out of shelters fifteen times, but the man only has to bring her a bunch of flowers and she's back where she started.

'Anyway, she got herself admitted to hospital a year ago. They took a carrier bag full of drugs away from her and she did cold turkey: shakes, panics, fever, the lot. I was so proud of her. Well, when she was there she met a young man called Jim, who was dying of cancer. He fell for her in a big way, and she spent every day talking to him and wheeling him around in his wheelchair. That's how she got over the agoraphobia – going shopping for him. He helped her start believing in herself, telling her how beautiful she was and begging her to get rid of her dreadful husband. He used to say: "I'm dying – you've got to live for me now".

'And she did. A month before Jim died, she got a restraining order to keep Gary away. She'd never done anything like that before because she thought she deserved to be beaten.' I looked at Helen, wondering what had made her put up with her husband's bullying for so long. 'I went to court with her,' the

social worker continued. 'But they refused to do anything until they'd measured the size of her bruises.'

The house was quiet when we got home, the kitchen littered with the morning's hurried breakfast. This was the pattern of the divorcée's life: a yawning emptiness when the children were with the other parent, alternating with the overwhelming pressures of their presence.

Helen moved automatically among the debris in the living-room, shifting things, piling them up, collecting bundles under her arm. I made tea and cleared a space among the latest avalanche of opened mail on the table. 'The kids told me about Lawrence's girlfriend,' I said, sitting down. 'Was she the reason you split up?'

'Oh, she's just the latest in a long string,' Helen said bitterly, dumping more papers on the unruly heap. 'He likes a certain type: big breasts, long legs. And young, of course. The first one was only a student. Betsy must be about twenty-three. She works in a dress shop.' She opened a cupboard and took out a tin of biscuits. 'I think we deserve these, don't you?'

'Has he always had affairs?' I asked.

'As far as I know he was pretty much faithful when we were first married – right up until Jane was born, really. Though I was probably too stuffed from looking after the kids to notice. Then when Jane was a toddler, he went off "on tour" with the chess club he belongs to. That's when he took up with the student – Brenda. She was in the team too. I was on holiday in Adelaide with the children, and we all picked up *giardia* somewhere along the way. All the way home they were crying with stomach cramps and diarrhoea, and I was frantically trying to get the medicine into them. Anyway, Lawrence seemed to be out a lot after we got back, but I was too worried to care. Then it was our wedding anniversary, so I booked an expensive restaurant. He started hinting at something then, but I was too busy trying to make it a nice evening to take him up on it. Then when we got home there was a phone call from Melbourne saying my grandmother had died.

101

'I'd already been thinking about going to a conference on "The Roots of Violence" at the university there, so I invited myself to stay with some old school friends and caught the night flight. I went to the funeral on the Saturday, and Lawrence phoned me that evening and confessed. I felt really sick – I remember standing in the kitchen with tears pouring down my face and my friends waiting for me in the next room. All I could think of to say was "make sure you go to the STD clinic before I get home" – '

'Did you tell your friends?'

'No, I just flung some cold water on my face and pretended nothing untoward had happened. I suppose I was hoping it was just a hiccough in our relationship. Then when I got home all hell broke loose because we all went down with chickenpox. It was almost surreal, everyone smothered with calamine lotion. Then Mike broke his arm and I had to ferry him to and from the hospital. And in the middle of all this Lawrence invited this Brenda to visit him in bed – '

I was aghast. 'Didn't you object?'

'I was furious, but he absolutely insisted. He said he needed cheering up and the affair was over, so "logically" there was no reason for me to object. The fact that I was uncomfortable with the idea wasn't "logical".'

'So you gave in.'

'You don't understand,' she burst out angrily. 'When he went into "logical mode" my brain used to seize up. He'd go on *ad infinitum* until I was tied in knots like a limp rag.'

'And had he given her up?' She sighed and picked up a chocolate biscuit: 'No, he hadn't given her up. He was just looking for ways of seeing her without me suspecting. He even asked her to babysit the children when we went out. Then one day, when he was supposed to be at some meeting, I spotted him in town with her.'

'Did you confront him?'

She waved the biscuit, scattering crumbs: 'He just made some feeble excuse. Then next weekend I got a phone call from one of her friends, trying to track her down because her brother had committed suicide. Lawrence was at a cricket match, so I

suggested they paged her there – and sure enough, that's where she was. So Lawrence took her home and "comforted her" for the rest of the evening.'

She bit into another biscuit and pushed the tin towards me. Stacey's bruises had been measured by the police. How did you measure Helen's injuries? 'Did you ever think of leaving him?' I asked quietly.

'It never occurred to me at that point: I loved him –' she laughed ironically. 'And I had three kids under seven to look after. No, my immediate response was to haul us off to marriage guidance – typical social worker's reaction! But the chickenpox intervened, so we only went once. Then we were invited to a wedding in Sydney and we both thought it might be a chance to heal our relationship. So I managed to distribute the children into three different households and we had our first weekend alone together since Mike was born.'

She peered into the biscuit tin, hesitating, then reached for another. 'After the wedding reception, we went for a walk around the harbour, and just kept on walking until it was dark. It was a really beautiful evening, warm and clear, with everyone out walking arm in arm with each other. And there we were talking about these really painful subjects, and my high heels were killing me. We must have walked miles that weekend, in between making love at the hotel. Lawrence's idea of a reconciliation was to keep me in bed the whole time – when he wasn't informing me of how stupid I was to make such a fuss about a little "one-off affair".'

I got up and refilled the kettle. 'I tried to let him convince me,' she went on. 'But it was too late really. I didn't trust him any more.'

'Did you tell him it was over?'

She shook her head, cupping her hands round the mug of fresh tea. 'I don't think I knew it myself – though I must have at some level. Because I started making arrangements that I can see were geared to a separate existence. First I signed on at the university. Then I found a part-time social-work job – even though I hadn't really planned to work until Jane had started school. It was only a Grade I post, because I'd taken so much

time off bringing up the kids. And the pay was abysmal – exactly the same as I'd been getting as a clerk ten years before. But at least it took my mind off what Lawrence was getting up to.'

'Was he still seeing Brenda then?'

'No, he'd "progressed" on to another woman by then, and was gallivanting off here, there and everywhere with her. I phoned him up once at his hotel and she answered. We used to have blazing rows about it –' she grinned suddenly. 'Once I threw a jug of milk over his head! Then I reached a kind of turning point that Easter, just after I started my psychology degree. Lawrence was working and I'd taken the kids off on holiday to a house on the beach. I think it belonged to an old woman who'd died, because it was full of brocade furniture and little knick-knacks. It was out of season and the beach was almost deserted. I read all day and the children pottered by the sea. And I remember thinking how peaceful it was without Lawrence there nagging and picking at everything. I think that was when I stopped fighting for the relationship.' She paused, smiling into the mug. 'He moved out six months later.'

Lita – the lodger – came in while Helen was cooking supper. A slim self-contained Filipina of about thirty, in neat navy-blue trousers, she smiled and shook my hand vigorously. 'Lita's been with us for four years,' said Helen. 'Through thick and thin. She's witnessed all the vagaries of an Australian divorce. She even had to pull Lawrence and me apart once when we came to blows.' Lita shrugged noncommittally as if to say 'What else could I do?'

'I thought you said he never hit you,' I objected.

'Well, I was hitting him really. He was taking away all the photograph albums – he said they were his because he'd taken all the pictures. And it felt like he was destroying even the memories I had of our marriage. I just lost control –' She looked at Lita, who smiled sympathetically. 'She was only hitting him on the back,' she demurred. 'Not very hard, but she was very upset – crying and crying –'

'The problem in Australia is people get married for wrong reasons,' Lita said later. 'They choose people because they fall in love. I could never do that. Even if I love a man, I would never marry him if he was unstable.' She pursed her lips disapprovingly.

'What do you mean by unstable?' I asked.

'If he sleep with other woman, or if he is careless with money, or neglect his parents – these things tell you how he will be when he is married.'

There was a sudden commotion outside: bare legs running across the lawn; eager hands flinging the screen-door open. 'Nicola was sick!' cried Jane jubilantly, charging into the room. 'Pooey! Right in the litter bin!' And she dodged behind her mother as Nicola made a lunge towards her. 'It's because she's so greedy,' taunted Mike. 'There were three big boxes of food and she had to try everything, the pig.' Nicola burst into tears and stomped theatrically out of the room. Her elder brother was undeterred: 'Dad gave us some money to bet on the races and I won! But the best thing was the funfair – '

'She insisted on going on the big dipper immediately after lunch,' said Lawrence, sauntering into the room. 'I hope you don't mind me bringing them back early. I'm going out tonight, and tomorrow we've got an emergency meeting at work.'

A day at the university was not the children's idea of a good time. 'Do we *have* to?' wailed Nicola plaintively. 'Can't we stay here – at least Mike and me?' This prompted a chorus of 'it's not fair''s from Jane, stifled by a swift 'You'll do as you're told. This is the only day I can get to the library. You can take your complaints to your father tomorrow.'

The psychology department was in an ugly 1960s building, all flat planes of grey concrete stained with runnels of rust. The children headed off to the garden at the back, while Helen led me to the common room, where people were milling around coffee and tea urns.

'Did you get that grant?' asked a burly bearded man as we sat at one of the tables. 'They only offered me half, so I had to send it back,' said Helen, spooning sugar. 'It was for a church

conference in Chicago on domestic violence,' she explained to me. 'They've estimated there's domestic violence – you know, child sexual abuse and wife battering – in one third of Australian families,' she added. 'And it looks like it's worse in church-going families – maybe because they're more hierarchical than non-religious families. But when the wives turn to the Church for help, the ministers just refuse to believe that the local "pillars of the community" could possibly be batterers. That's what the conference was for – to make them aware of the extent of the problem.'

'You seem to be very interested in abuse,' I commented, and she nodded, fingering her crucifix. 'I think it might be the reason I started this degree in the first place,' she said.

On Sunday, after Lawrence had picked up the children, Helen and I set off towards the south of the city, to a church she'd never been to before. 'I go "walkabout" every Sunday,' she explained as we bowled along the broad empty streets, 'trying to find a church the children will like. They hate the local one – it's all widows and a few elderly couples, and they've never really known how to deal with me. They insist on calling me "Mrs Nugent" on the flower roster. I reckon they think: "No wonder her husband left. She wouldn't take his name and she was forever cavorting off to conferences and leaving him with the children".'

'Why did you choose this church this morning?'

'I just followed a hunch,' she said carelessly, then hesitated a moment, looking embarrassed. 'Actually, it's a way I use to open myself to God.'

'To let Him guide your choices, you mean?'

'Yes –' she seemed relieved I'd understood. 'It allows Him to influence changes in my life – like doing this psychology degree. There were lots of logical reasons to do it – extra status in my work, for instance. But that's not why I did it. It was more a hunch that it was what God intended. Like with my job. It came up just at the right time, when I couldn't stand working at the hospital any more.

'That was the job I took when Lawrence and I were break-ing up – grief counselling for people with cancer or AIDS, or who'd had an abortion, or a breast amputated. After Lawrence left it was just too painful. Everything they said reminded me of what I was feeling – once or twice I even broke down in front of a patient. So when my current job came up, I jumped at it. Now I suspect it's all part of His plan for me to work with battered women. That's what all this has been leading to: my marriage to Lawrence, all this work with single mothers, and now these conferences on violence.

'But it's so painful. It means I'm constantly having to examine things in my own marriage. Like why I stuck it all those years – I recognise so much of myself in the clients I see: the bullying and lack of self-esteem; never managing to get on top of the housework; never daring to throw things away because you think you might need them. I go into houses that are full of old clothes and empty yoghurt cartons, and I know exactly how those women feel.'

We turned down a broad avenue and parked in the shade outside a big Edwardian-style church. A small reception com-mittee of smiling parishioners shook our hands at the door, recognising us as strangers and welcoming us inside.

'Have you always been religious?' I asked as we took our places among the chattering congregation.

'I was brought up Presbyterian, but I didn't really take it seriously until I was sixteen. Then I was sent off with my grand-parents to Scotland – I can't remember why now. It was when we were in St Giles Church in Edinburgh: something in the sermon really rang a bell, as though God was addressing me personally. I expect I was more sensitive because I was lonely and far away from home. Anyway, I got confirmed there, and when I came home I started going to the local church every week.'

'What did your family think?'

'I didn't tell them. It was something private I had for myself. And the congregation really welcomed me, because I was the only person of my age who went.'

I looked at the statues around the walls: a mournful Christ

and a coquettish Virgin, both pointing at their gruesomely exposed hearts. 'How do you imagine God?' I asked, and she laughed: 'I've had a real "clearance sale" of images since Lawrence left. The phrase "Our Father" really started sticking in my throat. But it's hard to forget that picture of a kindly old man looking down. So I've been meditating on the "I am who I am" element of God within me. I believe everyone has a soul, which is a part of God Himself.'

'"Himself"?'

She grinned ruefully: 'I imagine a formless greater power that's interested in me individually. See, I think it's miraculous I'm not in a million pieces. But no matter how far I fall, I never break apart. There's always something there underneath, *inside*, to catch me. And I call that something God.'

'I've been promising myself this for years,' said Helen. We were on our way to the Swan Valley wine-growing region, where some of the local towns were celebrating the new vintage. 'We're staying at the Anglican church, at a village near Margaret River. The minister is the father of a friend of mine, and a whole gang of people go there every year.'

'Why haven't you been before?'

Her jaw tightened: 'No one's ever invited me. I've always been sort of "on the fringes" of this crowd. But recently I've got to know Deirdre a bit better, so when she was talking about going I hinted about taking a day off work so I could come too. Then I phoned one of the others in the crowd for directions. I knew the way already, but I wanted a bit more reassurance that I'd be welcome. Anyway, she said, "Oh, do come" –'

The countryside opened up ahead of us, like a carpet unrolling: finely knotted rich greens and golds, stripes of red and ochre, swathes of swaying soft silver. Soon there were vines on either side of the road: squat green mops strung together with strands of wire; arable abundance as far as the eye could see, but almost no sign of the humanity which created it. Compared to the thronged rural roadsides of Orissa, it seemed a strangely alienated landscape: a factory without walls after the workers have gone home.

After three hours, we arrived at Margaret River. Hay bales and bunting blocked the main road, diverting us through a hinterland of bungalows, where we parked and joined the drift of sightseers towards the centre. Suddenly I was back on the holo-deck of the *Enterprise*, in a weird rural theme park: *Beverly Hillbillies* meets *Crafts for Pleasure and Profit*. A bush band called Kelly's Revenge was *yee-haa*-ing in the main square, with a fiddle-player sawing his elbow like a grasshopper's leg. Beside them the sheep-shearers were in full swing, holding pop-eyed ewes between their legs and peeling them as effortlessly as bananas. We joined a crowd of bright-eyed old women in sprigged frocks, knocking back plastic cupfuls of red wine. Here and there were old men in wheelchairs, abandoned in straw hats to doze in the sun, while younger men with red thighs and videocams recorded the scene for posterity. Everyone was wearing a hat: bush hats for the men, smaller straw confections for the women; while the children charged around in baseball caps clutching candyfloss and day-glo ice lollies.

Whizzing past the wool-classing, log-chopping and saddle-making demonstrations, and giving the barrel-wheeling championships a miss, Helen steered me into a local church hall where there was a quilting and flower-arranging exhibition. 'I used to finance my Christmas presents entering flower-arranging contests when I was a girl,' she told me, as I marvelled at a Wellington boot overflowing with daisies.

When we arrived at our destination later that afternoon, the vicarage was deserted and the projected 'crowd of friends' was nowhere to be found. 'I didn't say when I was arriving,' said Helen brightly, hiding her disappointment by taking me into the nearby church, which had 'Enter ye by the strait gate' etched in stone above the door. As she wandered down the quiet aisle, I picked up a leaflet from a table in the vestibule. In *Motherhood and Homemaking*, I read that 'a family without a true father can be as aimless as a football team without a good quarterback'. *Remember Your Vows* informed me that 'in a Christian marriage, sexual relations should not be regarded as a favour given, but instead as a debt that is owed'.

'This reminds me of where I grew up in New South Wales,'

sighed Helen as we wandered outside again into the autumn sunshine. 'The town was about the same size, surrounded by farmland. With lots of local events presided over by female "worthies".'

We sat down on some sun-cracked wooden chairs under a tree in the vicarage garden. 'Was your mother a "worthy"?' I asked.

'Not really. She was too busy – but she was a wonderful seamstress, and there was always some of her embroidery or quilting on display at harvest festival.'

'What was she like?'

'Very warm,' Helen said quickly, then hesitated: 'No, caring – but not in a smothering way. Yes, competent and caring –' Cold, then, I thought: the child Helen had clearly felt that something was missing.

'Did she go out to work?'

'Before we were born she did. She got her BA, then started work in the local library. Then her mother got ill and she had to stay home to look after her. That's when she met my father. Then after I was born, she got another job running a flour mill and took me along to the office with her. But she had to give up when I was four and my sister Julia was born, then my two brothers – one after another.'

'So you were the eldest – did that mean you were closer to your mother than the others?' An expression I couldn't quite identify flashed across her face. 'Not really,' she said casually. 'I think she preferred my sister to me. They both liked sewing, you see. Then my sister started training as a fashion buyer and my mother was very interested in clothes. But when my mother started teacher-training, after my youngest brother went to school, it was me who had to take over. So I had all the disadvantages of being the eldest, but none of the advantages' – and she laughed that bright, self-mocking laugh I'd come to recognise. 'I used to try so hard to cook things exactly the way she did, but they all used to complain and pick at everything I made.' Poke, poke – just like Lawrence, I thought. It seemed as though her best offerings had been rejected all through her life.

'Did the housework interfere with your schoolwork?'

110

'A bit, but I was a real "goody-goody swot", so I used to study at night when the others were in bed.'

'And were you clever?'

'Not at primary school. I came bottom because the schoolroom was in the middle of a field and I had terrible asthma, so I missed lots of days. They didn't understand about asthma then, so everyone thought I was stupid. I was terrible at games because I couldn't breathe properly, and when people chose teams I was always the last to be picked. When I changed schools it was a revelation. Suddenly I was in the top five every year.'

'What about your father?'

'I remember him as being absent and unreliable. He used to tour the surrounding farms welding broken farm equipment. My mother never knew when to expect him and was always having to cancel her arrangements because he hadn't come home. And she was always worried about money. He never bothered about getting paid until she nagged him for money to go shopping, then I'd hear him whining to some farmer on the phone.'

'Was he violent?' I asked, thinking of her interest in that subject. 'Not physically, no. He was teetotal and he never hit any of us. But I think he was *economically* abusive for subjecting my mother to so much anxiety because he ran his life in an incompetent way. And he was always touching my mother, sitting next to her and stroking her. But she seemed to welcome it, so I assume they had a satisfactory sexual relationship.'

'He sounds all right,' I ventured, curious about the anger in her voice. 'Sounds like he was faithful, didn't booze, didn't beat anyone.'

'Ye-e-s . . .' – grudgingly – 'Sometimes, if he had a job at an outlying farm, we'd all pile into the back of the car and take a picnic. That was fun. But I remember him as being very hot, so I was uncomfortable sitting on his knee.'

The crowd of friends materialised at around five, flinging open all the doors of the vicarage and rushing into the kitchen to check on two enormous pieces of roast meat in a giant two-tier oven. Flushed and jovial, full of noisy banter, they slopped

sparkling white wine into fake crystal glasses, and soon had us organised pulling out the table extension and fetching extra chairs from the nearby Sunday school building. They welcomed us both with an all-embracing Christian *bonhomie*; Helen responded enthusiastically, recounting the wonders of Margaret River and giggling delightedly as they refilled her glass.

Later we went to the Vine Inn, where Kelly's Revenge was wreaking more vengeance. Bush-hatted men with checked shirts and moleskin trousers clapped and tapped their feet in time to the music, while their wives sipped white wine and fingered the glittery bits on their evening dresses. 'Why are the men in fancy dress?' I whispered, and Helen laughed. 'This is how country people always dress to go out,' she said. Then, excitedly: 'Ooh look, they're pulling back the tables. People will start dancing now.'

The couples immediately piled into the open space, leaving me sitting with Helen and her friend Deirdre. 'Let's dance,' she suggested to Helen. 'I'll be the man.' And they galloped energetically into the fray, amidst disapproving looks from the locals.

The next dance was the Drongo, named after a racehorse who never won a race. A woman without a partner stands in the middle, while couples dance mockingly around her. Then the couples separate and the men stand in an outer ring, while the women grab poor Drongo's hand and whirl her around with them. When the music stops, each woman tries to grab a man, and the one who fails becomes the new Drongo.

'I'm always slightly nervous about what'll be waiting for me when I've been away,' said Helen, turning keys and pressing buttons to disconnect the burglar alarm. 'We've had nine break-ins since Lawrence left. Once I saw someone walking along the road with Mike's flute under his arm!'

The house was just as we'd left it: the perpetually draped clothes horse; remains of Nicola's Lego creation; crusted muesli bowls and half-drunk cups of tea. The phone rang, a startling noise in the quiet house. Helen picked it up. 'Oh, hello Jill,' she said breezily. Then, very gently: 'Are you in tears?'

'She was very distraught, so I asked her round,' she apologised. 'She's one of my social workers – a single mother, actually – who's developing a disabled-awareness programme. She says the work's getting her down, but I sense there's something else bothering her. She seems to have "adopted" me as a kind of maternal figure.' The phone rang again. 'No peace for the wicked!' she giggled, delighted to be seen to be in such demand.

'My friend Beth,' she announced, replacing the receiver. 'Inviting me to the cathedral tonight to watch their dress rehearsal. She's in the choral society and her husband's behaved much the same way as Lawrence – he's living with a young student he used to go jogging with.'

The distraught social worker arrived just as the kettle was boiling. Settling me down inside with what remained of her photograph albums, Helen took a couple of mugs out to the garden so that they could talk privately. Surrounded by open books and the beginnings of an essay on the aetiology of depression, I flicked through the old albums at random.

It was all there, documented with brutal clarity: Helen at fifteen, the gauche elder daughter, with her freckles and Brillo pad of red curls, dressed like a middle-aged woman in her cardigan and sensible shoes. And Julia, the pretty younger daughter, with her huge eyes and flawless oval face, petite and poised in strappy sandals. Later photos made the same point over and over. The two weddings were cruel mirror-images. In one a delicate, dazzling Julia was flanked by a freckled square-jawed bridesmaid in unbecoming pink ruffles. In the other Helen beamed in white flounces, effortlessly upstaged by the radiant sister at her side.

I remembered Stacey, the agoraphobic Valium addict on the estate, with the pretty elder sister and the favoured younger one: feeling worthless and unloved, blundering blindly from one violent relationship to another.

'This is so nice,' said Helen, breaking a roll and spreading it with butter. It was my last day, and I'd invited her out to supper at

a local restaurant. 'I never get taken out these days, and I'd never go to a place like this on my own.'

'Why not?'

'People hassle you if you're alone – not that I've ever attracted that kind of attention. I'd just feel uncomfortable.'

'Don't you go out with friends?' I asked, and she sighed: 'A single mother's an odd sort of social unit. You're not invited to couple-type activities. I feel like I've lost a lot of friends since Lawrence and I split up. But it's not just because I'm on my own – it's something about being needy. People are very good at supporting you through a crisis, but that's just twenty-four hours. My crisis has been going on for five years, and I've felt people withdrawing because of it.'

'What about your religious friends?'

She leaned forward: 'I wanted desperately, desperately, to have the support of my faith community through this' – her face contorted with real anguish – 'but they really let me down. There was one couple – Jeff and Mary – who I got to know during my social-work training. He's a minister and she's studying theology. I wrote them a letter, explaining about how abusive the marriage had been. They didn't phone for a week – I was terribly hurt.

'It was the same with Anna and Gordon. They helped a lot when I was battling with Lawrence over the house. I'd gone to a solicitor who thought I should keep the house as compensation for my loss of earnings from bringing up the children. Lawrence had just assumed we'd split it fifty-fifty, so he was furious and started coming round every night and shouting at me. Anyway, it was a miserable few months, and one weekend I just "gravitated" to Anna and Gordon's and ended up staying the whole weekend. But they've withdrawn since then, and now it's always me who initiates things.'

'Why do you think that was?' I asked, and she shrugged: 'I think I must have mistaken their kindness for a deeper intimacy.'

I thought of all those nice people: at the church, at the vicarage; all those kind smiles and warm handshakes, but none prepared to walk that extra mile. 'Of all my religious friends, only Penny's really stuck by me. We used to bottle fruit and make

pickles and jam together every year – her husband's a chaplain at uni. When Lawrence first started having the children every other weekend, I didn't know what to do with myself. I used to get in the car and just drive around, and I often found myself outside their house. They invited me for Christmas the first year and bought me a coffee mug, which I keep on a special hook there. I go there for Christmas every year now: there's me and a priest they know who lives alone. And last year Penny invited an old woman whose husband had just died.' She smiled happily at the memory. Why, then, did I feel so sad?

The food arrived: kangaroo steak (how could I resist?) and fish with little bowls of artistic vegetables. 'What about your non-religious friends?' I asked, slicing into something disturbingly pink and resilient.

'There's Beth, whom you'll see tonight at the cathedral. And Deirdre, whom you met yesterday. Actually, all my closest friends are single women now. Most couples don't seem to want to know.'

She was quiet for a moment, then: 'You know, even though I get depressed and lonely, I think overall I'm happier without Lawrence – more myself somehow. But I miss the intimate side of life enormously. I'd really like to have a close relationship with a man again, but I wouldn't know where to start now. Not that there's exactly a queue of men beating a path to my door!' And as she laughed that brave and painful laugh, I remembered a statistic I'd read somewhere: how divorced Australian women over thirty-five were three times less likely to remarry than divorced men of the same age.

Much later, over coffee, I asked about the children. 'Are you worried about their relationship with Lawrence?'

'I've noticed that they are beginning to see things from his point of view. That's why I can't help pointing out his weaknesses in front of them – I try not to, but I can't always stop myself. Eventually, I expect, some of them will decide that the grass is greener at Daddy's. So I have to find ways of sustaining myself when that happens.'

*

I left her in the dark cathedral, a great vaulted building, pleated with stained-glass panels. In a far pool of light by the altar, a group of men and women were rehearsing. The nave echoed with their good-humoured comments as they turned pages for the next piece of music.

Helen slipped quietly into a back pew and knelt for a few moments, praying. Then she sat, smiling softly in the shadows, as sweet voices soared up into the roof.

Lydia

In Uganda they say: 'A widow must be wide-eyed, resourceful and tough'. This is because, in much of sub-Saharan Africa, a widow does not inherit her deceased husband's property: most of what he owns passes to his nearest male relative. Around one third of families in this region are headed by women, and half of these women are widows. AIDS adds a new twist to the fate of African widows, making them much more likely to be disinherited by their in-laws. One tenth of the population of Uganda is HIV-positive, and 100,000 are now dying every year.

Lydia lives in the rain-soaked southern region, where three-quarters of AIDS deaths occur. Her unfaithful husband died of the disease last year, leaving her to work the farm and raise her four sons by herself. Now she has the disease too. And she's certain her in-laws are plotting to disinherit her four children when she dies.

THE Land Rover lurched like a camel along the cratered road, heaving and tilting, axle-deep, through red puddles. This was downtown Kampala: lumpen 1960s buildings surrounding an island of elegant embassies, all lassoed together by ribbons of potholed tarmac.

Joseph wrestled expertly with the steering wheel, nodding cheerfully to pedestrians in trevira trousers who saluted him, shouting '*Osebeotea sebo!*' through the open window. I was impressed: 'Are they all your friends?' He laughed through his beard, showing the gap between his front teeth: 'I don't know them, but they know me. I was in the Ugandan football team in 'eighty-eight.' Now I was really impressed. 'Ah, it was *nice!*'

117

He shook his head regretfully. 'We travelled to many countries. But the manager kept all the money, so I decided to quit –' And exchanged adulation for the drudgery of driving for Oxfam: a steady job and a steady wage in a country where such things are hard to find.

We were searching for Wellingtons. It was the rainy season, and my feet had been wet ever since I arrived. The shoe shops in the centre had proved disappointing – strappy sandals for high-buttocked city girls. So we headed for the market: an acre of red mud, planted with rusty stalls festooned with flapping plastic sheeting. 'Let me speak,' said Joseph protectively, parking in a puddle the size of a moat. 'I can get a better price.' My gym shoes squelched juicily as I followed him through damp displays of cotton-reels and exercise books.

At the Wellington stall there were no small sizes. Joseph picked up a pair of elevens and sneered at them, brandishing them with mounting disgust until the stall-keeper halved his price. Wrenching off my sodden size threes, I slipped my feet inside the new boots and galumphed back to the Land Rover with as much dignity as I could muster.

The next day was Sunday. After hard eggs and soft toast in the empty hotel dining-room, I donned my Wellingtons and slurped determinedly up the hill to the bungalow that was Oxfam's headquarters. Some of the drivers were there, bending over the open bonnets of their trucks. Waving to Joseph, I parked my umbrella in the porch, shuffled into the empty building, and started to read the heap of background material I'd been given about Uganda.

What emerged was a nation as plagued as Pharaoh's Egypt. Once prosperous, literate and law-abiding, Uganda had been the model of modern Africa – until Idi Amin's coup heralded nearly two decades of civil war. Successive coups brought eventual peace, but not until a generation of young men had been buried and the country's infrastructure destroyed. Then came AIDS, stealthy invader of the arteries of war: creeping along smugglers' routes and multiplying in wounded border towns; travelling inland with lorry-drivers and soldiers. One-

and-a-half million people were now infected, with two thousand dying every week.

After AIDS had come the coffee crisis, decimating the price of the country's major export; then the refugee crisis, bringing a quarter of a million people from Rwanda and Sudan; and finally, last year, the drought crisis, shrivelling the matoke* trees that people had planted between their worthless coffee bushes. I sighed and stared out at the rain. Would plagues of frogs be next?

Turning to Oxfam's project files, I began to read about organisations that supported people with AIDS. It had been sheer instinct that made me focus on AIDS widows. So much had been written about the predations of the disease itself, but almost nothing about how it interacted with the culture that harboured it. I knew widows fared badly in much of Africa – even in normal circumstances. I was concerned that the presence of AIDS would only exacerbate their plight.

'I'm so glad someone is writing about this!' Noerine Kaleeba said warmly, offering me a plate of biscuits. 'When a man dies of AIDS, a huge stigma attaches to the widow. They are often driven out of their homes by the in-laws. Sometimes they are accused of causing the disease by witchcraft – even though the husband probably caught it from one of his girlfriends. I could introduce you to hundreds of women in that situation.'

It was Monday, and I was sitting in the head office of TASO, the now world-famous organisation which helps sick people and their families 'live positively with AIDS'. Noerine was its president, a chubby charismatic woman who founded TASO after her husband died of the disease in 1986.

'The problem is the man's clan,' she said. 'They control the inheritance of his property. So when he dies, they take over the house, the land, whatever. If the wife has sons they can inherit, because they have been born into the clan, but she gets nothing.'

*matoke: Uganda's staple food, relative of the banana; picked green, then peeled, steamed and mashed.

'Are they allowed to get married again?' I asked, mindful of the prohibitions on Hindu widows in India.

'Of course. That's why the clan take everything: to stop them transferring it to another clan. That's how I lost my home – '

'You mean your in-laws threw you out?' I'd imagined it happening to illiterate village women, not to forceful, educated urbanites. Noerine shrugged her plump shoulders: 'I resent it now, but at the time I was too upset about Chris's death to complain. Women who can afford it buy secret houses so they have somewhere to go when their husbands die. But if a poor widow is driven away, what can she do? She has to find food for her children, and finding another man is sometimes the only solution. That's another way this disease spreads. You see, we have a tradition of polygamy in Uganda, so some men have many wives. Or one wife and lots of girlfriends. You know men used to boast if they had gonorrhoea, because it meant they had a lot of women. When the king caught syphilis, people felt proud!'

I decided to talk to the lawyers next. I was hoping to find a widow who was fighting back, trying to hang on to her home. A circuitous route via the Legal Aid Project and Uganda's association of women lawyers – FIDA – brought me eventually to Kataneeba's ramshackle office. It was situated in one of the many clapboard-and-breeze-block mazes that sprouted haphazardly – and unplanned – in the interstices of the town planner's neat grid.

Men hissed and whistled, calling 'How is *muzunga**?' as I hurried through narrow alleys hung with plastic bowls and dead chickens. Women squatted by braziers roasting peanuts, or sold cigarettes singly, fanned out on discarded truck tyres. 'Hold your bag to your chest,' warned Joseph. 'They have sharp knives.'

Up a dark narrow staircase smelling of urine, the lawyer's two tiny rooms perched on the top floor like a tree-house, with

*muzunga: white person.

walls of warped wood and floorboards that creaked and bent under my weight. 'I don't like representing those cases,' said the sharp-suited Kataneeba, waving me to a chair wedged between two brown filing cabinets. 'You have to go out to where the farm is, and it drags on and on. But the widows are so pathetic it's hard to turn them away. It's usually the brothers or uncles who are doing the harassing.' He leaned forward with sudden passion: 'You see, the widow is *nothing* – ' banging the desk with his fist. 'Her husband paid bridewealth for her, so she's his property. A piece of property can't inherit anything. She doesn't even become part of his clan when she gets married – and when he dies she's just something standing between them and the inheritance.'

'Even if her husband makes a will?' He shook his head. 'Some men are starting to do that to protect their wives. But people don't like making wills. They're afraid it brings death closer. The Act of Succession gives the widow the right to occupy the property until she dies. But if she remarries, she loses that right. And she can't sell, because it belongs to whoever the clan names as the heir. And they would never name the widow – even if they choose her son, she can only sell the property if she's made the legal guardian of her own child – '

'Don't they feel any pity for her?' He sighed. 'There must be some in-laws who are kind to the widow. But unless she has an older son to protect her – ' he trailed off, opening his small hands despairingly. 'And I only see the ones who decide to fight. There must be thousands who just run away and we never hear about what happens to them. They find another man, or they start brewing beer or working as prostitutes in the trading centres. What else can they do?'

By the end of the day I was convinced of two things. First, that my intuition about the fate of AIDS widows was correct. But second, that it would be difficult to trace them via lawyers in Kampala. The villages the widows came from were too scattered for me to consider visiting more than a few; and the information was often up to a year old, so there was a danger that the woman might have died of the disease herself by the time I tracked her down.

I would have to start somewhere else. Then I remembered a file in Oxfam's office labelled 'Kitovu Hospital'. The hospital was situated in the centre of the AIDS belt, in the southern town of Masaka. The vast majority of its admissions were people with AIDS-related illnesses, and two in five of sexually active adults in the area were HIV-positive.

'Masaka is like an onion,' said Joseph the driver as we set off for Kitovu Hospital the next morning. 'Every time you peel off a layer you have to cry.'

Rain was dripping through the roof of the Land Rover, puddling around my feet on the floor. Outside, people huddled beneath bus shelters by the side of the road, or plodded, shoulders hunched, holding matoke leaves over their heads. Beyond the outskirts of Kampala, green hills knelt beneath the heavy clouds, accepting the rain; matoke leaves hung flat as nuns' veils, while the lobed umbrellas of cassava swayed like celebrants at a Mass. We passed a convoy of trucks, labouring up the hill with their loads of rain-glossed matoke; and a sign saying 'Equator' in grass as long and lush as young sugar cane.

Despite the downpour, the sheer beauty of the countryside took me by surprise. Death I'd expected, but not this excess of irrepressible life. Morning glories had ribboned every telegraph pole, weaving petticoats of green around their ankles. Tendrils tethered trees to fenceposts, flinging filigree over red termite mounds. Towering like giant dandelion clocks, primeval heads of papyrus crowded the wet valleys, nodding together in eerie conspiracy. And here and there the rampant green was kept at bay by a two-strand wire fence, around a red clay-brick house with a tin roof weighted by rocks.

The sun came out as we approached Masaka, and the road was suddenly filled with movement: barefoot schoolchildren skipping along in the mud, in skimpy uniforms of pink or lemon yellow; men in wet shirts grimly pedalling with leaden bunches of matoke slung either side of their wheels; women waddling in scarf, skirt and cardigan, or gliding like geishas in the traditional long dresses with their puff sleeves and trailing sashes.

The town itself had the air of a groggy boxer: punch-drunk and battered but still standing its ground, fists raised. The war had been fought fiercely here, and the scars were everywhere: roofs and walls collapsed like playing cards; willowherb sprouting from blind windows. A group of beggars, cavorting like acrobats on stumps of arms and legs, touted for money outside the Elgin Restaurant. I caught myself staring at the faces of the younger women in the street, seeking out the 40 per cent who were dying. But they were round as conkers, glossy with Vaseline, as brimming with life as the wet countryside around them.

'Everyone looks so well,' I said quietly, but Joseph shook his head. 'If you know them, you can see,' he said. 'Your friend's jacket will become a bit loose, then he'll get sick with flu or malaria. Then you won't see him any more because he's hiding at home.' I looked again at the cheerful crowds that thronged the cratered pavements, then a movement above them caught my eye. Four huge heavy-billed storks, like pterodactyls, paced the flat roofs above the ramshackle stores, stretching bare grey wattles as they peered over the parapets. Joseph followed my eyes. 'We hate those birds,' he said, with a shudder. 'They break open the rubbish sacks and eat rotten food. Or dead animals from the side of the road.'

When we arrived at Kitovu Hospital a small group of men were waiting outside, squatting by their bicycles. 'They are taxi-drivers,' explained Joseph. 'The passenger sits on the back. If you have a bicycle you are a businessman in this country.'

The breezy Mr Ssennyonga was expecting me. 'Today you can talk to some of our counsellors, then tomorrow we can visit the patients in their homes. Is it okay?' And he ushered me into a sunny room with a crucifix on the wall, where three young women were waiting.

They nodded solemnly as I explained about the book. 'I'm looking for a widow whose husband died recently of AIDS and who's having trouble holding on to her home,' I said finally. 'Do you know anyone like that?'

'Nearly every widow is like that,' said a pretty dimple-cheeked woman bitterly. 'I know one lady with six kids who nursed her husband until he passed away. The clan left the land but took everything else – even the beans from the bottom of the sack.' She paused, frowning. 'But she is very sick now. I don't think you could stay with her.'

'One lady I visit had to move in next to the pigs!' burst out the thin woman sitting beside her. 'A neighbour took pity on her, but it's just a bamboo shack and the rain comes in through the roof.'

'I know a widow who adopted her brother's kids when he passed away,' the third volunteered. 'Now her husband's clan are making problems because they are afraid the adopted kids will take over the property when she dies. That happens a lot – because there are so many AIDS orphans. They go to the grand-mother or the aunt, then the clan makes trouble because the kids are from a different clan. Some women are looking after twenty kids, and no one gives them even one bunch of matoke.'

'How do you stand it?' I asked suddenly, looking around at their eager open faces. There was a long pause. 'It really hurts,' said the thin woman eventually. 'If you counsel someone for two years, you become close to them – and then you have to watch them die.'

'Last year I asked to be put on the maternity ward,' said the pretty one quietly. 'I wanted to see some happiness for a change. But it was the same there – because pregnancy makes this disease worse. So in the end I decided to come back here.'

The next job was to find an interpreter. A social worker with the unlikely name of Bonnie had been recommended by Oxfam, but when we went to the bleak office where she worked, it was deserted. 'I think her brother works at the bank,' someone volunteered helpfully. 'But I don't know his name.' 'She might have gone to Kampala on a training course,' said someone else. At the bank the brother had gone home. 'His sister's moved out now,' called a counter clerk, overhearing my question. 'Maybe you can find her at Mary's place.' Mary's place was unfortunately

not on the phone, but: 'It's the house on the hill,' she said. 'You can't miss it.'

The sound of a hymn, sung in four-part harmony, was sweetening the evening air when we reached the ungainly house at the summit. The singing stopped when we knocked, and eventually a bespectacled middle-aged woman was led down the hall by a shy twelve-year-old. 'I heard you were looking for me,' said Bonnie breathlessly, patting an unconvincing wig of auburn curls. 'What did you want me to do?'

She tutted and shook her head sympathetically as I explained about the book. 'Ah, it's terrible, terrible for those women!' she said. 'If I was twenty years younger, it would be me dying of this disease – I suffered for years with my husband before I left. He was a very handsome man, and he had so many girlfriends – '

My room at the Laston Hotel was next to the bar, and the *en suite* shower seemed to be actually inside the hotel kitchen. If they were washing up, nothing came out of my taps, and the clangings and chattering of the staff sounded unnervingly near as I sat gingerly on the cracked toilet. The floors and walls were bare concrete; the towels stiff and grey. I washed quickly, then sat on the bed beneath a naked forty-watt bulb and began an audit of my body for AIDS entry points.

To my dismay, the deep cracks between my toes were still there – a legacy of Orissa's humidity. I smeared cream and dredged them with fungicide, resolving to keep my socks on when I stayed in the village. My other heat rashes had healed, but I'd cut my finger helping Helen cook in Australia, and the wound was still open and angry. A mosquito hummed in my ear as I applied a new Elastoplast. Experts said you couldn't catch it from mosquitoes, but what if they were just trying to avoid a mass panic? If a mosquito bit me straight after feeding on infected blood, wouldn't that be tantamount to sharing needles? I fished out the repellent and covered my skin with pungent gel.

*

We set off early the next morning, picking Mr Ssennyonga up from the hospital, then up the hill to fetch Bonnie. For a while we headed south towards the border, then turned off down an undulating muddy track into the lush countryside. Here coffee was the main crop, and its spindly bushes lined the road, interspersed with stands of mop-headed matoke.

It was a harrowing morning, spent trailing through mud and wet foliage to sit with sick women and their wide-eyed children, while the same story was repeated over and over: 'I nursed him until the end. It was me who did all the work on the land. Now his brother is telling me to get out of the house.' One woman slept with her goats at night because she was afraid her in-laws would steal them.

Lydia was the fifth widow we visited, but something about the set of her chin, and the elegant way she carried her thin body, told me this was the woman I'd be writing about. Though she was alarmed by the Land Rover churning into the middle of her courtyard, she greeted us with great dignity, kneeling respectfully to the men, then conducting us politely into the main room of her little three-room house.

Though I'd visited four similar houses that morning, I was still shocked by the state of the place. Little toadstools sprouted at the bottom of the wattle-and-daub walls, and the unravelling grass mat on the floor was muddy and littered with red coffee berries. A heavy three-piece suite filled the tiny room, but its crocheted covers were crumpled on the floor, and the seats were strewn with dirty clothes. In a society where a woman's worth is measured by the order in her home, it was this disorder – more than the deep hollows round her eyes – that testified to the advance of Lydia's illness.

I picked up a torn pink shirt and sat down while Mr Ssennyonga launched into introductions. Lydia listened carefully, her hands folded in her lap; after a while, four young boys crept like shadows into the cramped room and clustered protectively around her.

'Are they your children?' I asked her, through Bonnie, and she nodded. A serious nine-year-old in black shorts held out a damp newly washed hand to be shaken. 'Julius is my first-born,'

she said. 'Then Gyavera is six, Bryan is four and Aloysius is two. Julius is in P4 at school, and Gyavera's in P2. They're supposed to wear yellow shirts now instead of pink. That's why their pink things are not mended –' She reached out shame-facedly and took the torn shirt out of my hands. 'I haven't bought the material to make their yellow ones yet.'

'Does anyone help you pay for that kind of thing?' I asked, wondering whether there was a kind brother or new boyfriend in the background. 'I try to manage everything by myself,' she said, bundling the other clothes together and taking them into the next room. 'I pawned the boys' mattress to pay for school fees, but I think I can get it back in two months. My uncle lent me some money last year to start my coffee business. He said I could keep it, but I want to pay him back. I don't want to be in debt to anyone, because they might make it difficult for my children later – ' She didn't say 'when I die', but the words hung in the air.

I wondered how much time she had left. Her eyes were clear and steady above prominent cheekbones; her flowered blouse hung loosely from narrow shoulders. 'Are you afraid someone will take over the farm?' I asked, and she nodded. 'I heard my husband's clan talking at the burial. They said: "How will the widow manage all that land?" And: "What will the children do when she's gone?" I lie awake with my heart beating fast every night. They are so small, you see – how can they protect themselves? I'm afraid the clan will take every-thing.'

'That's why I started with the coffee – because it's some-thing I can do at home. I would get more money making clothes, but you have to sell them at the trading centre and I'm afraid of leaving the house in case something happens – they've already stolen a bicycle. And I think they took the title papers for the land – I can't find them anywhere. So the only time I go out now is to the mobile clinic once a week – and then I give my cousin some money to come and make sure everything's safe.'

'Didn't your husband make a will?' She spread her slender hands eloquently: 'How could I ask him to do that, when he was

suffering so much? But he always said: "I want everything to go to my wife, because she helped me buy the land". It's true – I paid for half of everything.' She gestured out through the open door at the skeleton of a large brick house beyond the court-yard. 'We saved and saved. It was going to be our dream home –' she trailed off.

I turned to Mr Ssennyonga. 'Do you think she's well enough to cope with the strain of having us around for the next week?' He threw back his head and laughed heartily. 'Don't worry! She's got two, maybe even five years if she's lucky. She's still working, and going to the clinic for treatment – ' So I asked Bonnie to explain to Lydia what being in the book would entail – and ask whether she'd be prepared to tell us about her life.

The younger woman listened intently, but before Bonnie could finish she let out a little yelp of delight and clapped her hands. Then she collected herself and turned to me. 'Thank you,' she said haltingly in English. 'I am sorry I English not good. I want to speak you –' And she smiled radiantly into my eyes.

On the bare brown wall behind her hung a photograph of a soulful young man. 'Is that your husband?' I asked, and she nodded. 'Aloysius Waswa*.' She spoke the name reverently. 'He passed away on the second of April 1992.' Just over a year ago. Beside the photograph was one other picture: a line draw-ing of a bearded man crowned with a halo. 'Saint Jude,' said Lydia fondly, and I caught my breath. Saint Jude is the patron saint of lost causes.

Lydia was outside washing the younger children when we arrived the next morning. The sun was shining, and her plan-tation of ragged matoke trees dripped into a litter of decaying leaves. 'We've been working on the farm,' she said, scrubbing at Bryan's feet with a scrap of loofah while he stood naked, whimpering, on a flattened fragment of corrugated iron. 'I give

* Ugandans usually have two first names, a Christian name and an African name. This tends to be unwieldy and confusing in print, so I have used only one.

them each something to do – weeding the beans, planting groundnuts. If we do a little bit each day, we can manage –'

She straightened up and wiped her hands on her skirt. 'I spotted this land five years ago. It was just bush then, but it was near the road and had a good spring for water. We were living in a small room in Kinoni, and we needed more space for the children –' she paused. 'He didn't tell me, but I already suspected my husband was sick, so I wanted a proper place –'

I looked at her proper place: the crumbling little mud house with its rough bamboo thatch; the rickety kitchen shack with smoke billowing through the doorway; the courtyard carpeted with coffee berries drying in the sun; the pig with a festering ear grunting beside the latrine – and the empty shell of her dream home: half-roofed, without windows or doors, just a storehouse for sacks of coffee.

'Did you grow all this?' I asked, pointing to the coffee berries. She laughed derisively: 'You can't make money from growing coffee any more. I buy from other people, then dry it and sell it to the factories. If I had the money, I'd pull up all my coffee bushes and plant matoke instead. You can always sell matoke –' and she nodded towards the dirt road, where a continuous slow stream of men plodded past, pushing bicycles hung with huge heavy green bunches.

'I opened a bank account,' she said suddenly, darting inside and reappearing with a little blue booklet. 'Do you think it's a good idea?' she asked shyly. 'I want a loan to buy a fertiliser-mulch for the matoke – I tried it on a small plot last year and they grew nicely, even when everything else was dying in the drought. But it costs a thousand shillings by taxi and bus every time I go to Masaka to put the money in.' I opened the booklet. She'd made three deposits of three thousand shillings each – and one five-thousand-shilling withdrawal. 'I've added it up,' she said eagerly. 'It would cost half a million to mulch the whole plantation. Then I wouldn't have to worry any more.'

Half a million shillings: I looked at Bonnie. It was an impossible dream, like the big unfinished house with its coffee-strewn floors. 'It would be an awful lot of work,' I suggested gently.

'Only in the first year,' countered Lydia, her eyes shining. 'And I'm still strong. Then the second year I could afford to hire a man. So when I couldn't work any more –' she left the sentence unfinished. 'Then there would always be money for the children – enough to pay for a housegirl to look after them.' She was pleading now, begging us to agree. 'If they go to my mother, they'll lose everything. The clan will just move in and take over.'

'Where does your mother live?' I asked later, as we sat on the grass mat for lunch.

'That side,' Lydia waved vaguely in the direction of Kinoni. 'Near a sugar plantation. She had to move there when I was nine because our house was bewitched. A bee flew up her nose and her face swelled up. She couldn't stop sneezing for three days.'

'Does she live on her own?'

'Oh no.' She looked shocked: no one lives on their own in Uganda. 'She has six grandchildren at home. Four from my brother after he passed away from this disease' – she dared not even utter its name – 'and two from my sister, who passed away when her second baby was being born.' She disappeared in the direction of the kitchen hut, and came back bearing two steaming matoke-leaf bundles.

When everything was ready, and Julius had brought a basin of water for us to wash our hands, Lydia fetched the picture of Saint Jude and propped it ceremonially against the doorpost. Following her lead, we knelt facing the icon and bowed our heads while she chanted a prayer of thanksgiving. 'Do you always say grace?' I asked later, as she pulled open the layers of leaf on the floury yellow mounds inside. 'Sometimes Julius does it – if I've been working hard and I'm too tired to eat. I go to bed and he feeds Aloysius and clears up the things afterwards.' She tore off big pieces from the leathery leaf wrapping, scooping heaps of fragrant matoke on to them and handing them round like plates. Watching the boys pick up hot mouthfuls and dip them hungrily into a small pot of stewed beans, I wondered how they

felt on those quiet, frightening evenings when their mother was too exhausted to pray with them.

'When I was a girl I wanted to be a nun,' said Lydia, chuckling suddenly. 'I thought their white uniforms were beautiful. I even started taking special classes.' She sat back on her heels, smiling. 'God's been good to me,' she said quietly. 'Even though He's taken my husband, He's left me with the strength to look after my children. And He's protected me from loving other men – it's dangerous to love these days –'

Later we drove her to Kinoni. Curious 'visitors' had started arriving, making it difficult to talk, and I wanted to see the place where she had started her married life.

It was like any other trading centre we'd passed along the main road: a meander of tiny tin-roofed stores fronting a latticework of bustling dirt streets. By the time we arrived the matoke market was in full swing, with bicycles unloading on to enormous gleaming green heaps. Teeth flashed as sweat-softened banknotes changed hands. Then the hundredweight bunches were hoisted and strapped on to towering lorries which trundled off, belching smoke and crashing gears.

'My husband used to drive one of those,' Lydia said as Joseph parked the Land Rover. 'That's how I met him. It was when I was doing my sewing course. I was staying at my cousin's hotel, helping out cleaning rooms.' There were several such hotels on the main road, with a bar and beaded curtain at the front, a few tiny rooms at the back, and grand names in wobbly script – 'The Royal' and 'New Excelsior'. Most doubled as brothels, where women with blackened eyebrows slammed beer bottles on the bar to make them foam. It seemed a strange place for the nun-like young Lydia to stay.

'He was sleeping in one of the rooms,' she went on, eyeing Joseph uneasily. 'I think she's embarrassed,' whispered Bonnie, so I gave him some money and he wandered off obligingly to buy bananas from a wooden stall. Lydia smiled gratefully: 'My husband tried to force me to play sex the first time we met. It was when I was cleaning his room – he locked the

door and pushed me on the bed. I fought with him, and he let me go. But later I thought: why not? He was kind and handsome, and everyone else was doing it – ' She laughed ruefully. 'My family were very disappointed when I moved in with him – because I'd been to secondary school and I had my own sewing machine, and he was just a poor man. But I loved him – I didn't care – '

We got out of the Land Rover and walked down one of the muddy back streets. 'That was where I had my sewing stall,' she said as we passed a row of small wooden kiosks. 'He drove the lorry and I made clothes – and we lived over there – ' pointing to a square courtyard bounded on three sides by single-roomed houses, like garages in a row, slung with a cat's cradle of billowing washing-lines. A few women were squatting in front of open doors, cooking over Primuses and open fires. 'We got married here' – smiling, remembering. 'Not properly, with a priest and brideprice. Just a small party with some beers and friends. We didn't want to get properly married until the new house was finished.'

The next day was clinic day, and Lydia had dressed beautifully for her only excursion of the week. Her hair was fluffed out, and long silver earrings dangled either side of her delicate throat. And she'd found a turquoise Chinese blouse from somewhere, which lent her thin body the elegance of a Paris model. Julius wheeled out a heavy black bicycle and squirmed his hips under the crossbar so that his bare feet could reach the pedals, while his mother sat side-saddle on the carrier at the back. The bicycle wobbled as they set off, and his calf muscles strained as he stood all his weight on the pedals. I photographed them like that – Cinderella and her coachman on the way to the ball – then offered Lydia a lift in the Land Rover.

'Why don't you pedal it yourself?' I asked as she got in.

'Women can't ride bicycles!' She was aghast.

'It's not nice,' agreed Bonnie, and Joseph nodded vehemently: 'You would think she was like a man, even if she was pushing it.'

'Is it because she has to put her leg over the saddle?' Bonnie shrugged an embarrassed assent. 'But that means a woman can never take her produce to market – '

Lydia nodded: 'If you don't have a husband, you have to sell your matoke at a lower price to a man with a bicycle. It's the same with the coffee: I have to buy higher and sell lower because of paying the man with the bicycle. When Julius is bigger –' she trailed off, faced again with the intractability of the future.

We set off in silence along the deep rutted road and parked outside the deserted mud house where the mobile team were expected. Munching tiny thin-skinned bananas, we settled back in the Land Rover to wait. 'How did you find out your husband was sick?' I asked after a while.

'He got a skin rash,' said Lydia. 'Big blisters, like a burn on his chest.' Herpes, I thought, remembering a detail from the file at Oxfam's office.

'We call it *kisipi*,' said Joseph from the front seat. 'It means a belt – right across your body. Once you have that *kisipi*, you know for sure – '

'That was in 1987,' Lydia went on. 'Just before Bryan was born. I asked him about it and he confessed he'd been with another woman.' I had known the pain of such betrayals: how much more painful when the betrayal carried the threat of death.

'Oh, I knew he'd had other women,' she continued wearily. 'Two of them even had sons. But that was before he met me. I thought he'd finished with other women when we got married – but you only ever find out about the ones who have children.' She rested her cheek against the glass of the Land Rover window. 'After he told me, I was so angry I didn't want him to touch me. And I stopped cooking for him and washing his clothes. Then he had the cheek to say it was all a lie to make me jealous. But by then I'd found out that the woman had died. So I packed up my clothes and went with Julius to stay with my sister.'

'But you came back?'

She smiled and looked out of the window: 'He came after me, all the way to Kampala, and begged me to come home. He promised he'd never betray me again. What could I do?' She

looked pleadingly into my eyes. 'He was my husband. I loved him. I was carrying his child.'

Soon the other patients began arriving: an emaciated man of about sixty, then two thin women in their best puff-sleeved dresses. 'Why are there so few?' I asked, and Lydia shook her head. 'People think they'll die if they start coming for treatment. When you know you're sick, sometimes you just want to stay at home.'

Suddenly she stiffened and gripped the seat in front. She was watching a young mother, with a baby in her arms, approaching like a sleepwalker down the road in the sunshine. The woman's gaunt flesh seemed to shrink inside the flamboyant furbelows of her traditional dress; the child was like a bald hatchling in a nest: bug-eyed and bone-headed, swaddled in immaculate white baby-clothes.

'My heart hurts when I see a child like that,' said Lydia in a low voice. 'All I can think of is my last-born, and whether I'll be there to look after him.'

'You mean Aloysius has the disease?' I couldn't believe it: he seemed so round and bouncy, full of whinges and giggles, a picture of two-year-old ebullience. 'The tests were negative, but I don't trust those tests. He's had fevers and all kinds of rashes. If a mother has it, her child always dies too.' I tried to reassure her with the facts as I understood them: that only a third of babies catch it from their mothers in the womb. Lydia nodded politely, but I could tell she wasn't convinced.

Just then the Kitovu Hospital Landcruiser arrived, and the patients crowded round the back to receive their free packs of rice and sugar. 'They can't eat matoke once the disease gets hold,' explained Hilda, the pretty counsellor I'd met at the hospital. 'It irritates the intestine, but rice is so expensive – ' Then: 'Would you like to sit in with me?' she asked, offering what I'd hesitated to request.

The main room of the mud house was like a shrine, with tiers of lace-trimmed shelves in each corner, bearing sad-eyed saints and plaster busts of the Madonna among dusty thickets of plastic flowers. Sitting on a low wooden bench in the shadows, I watched as Hilda examined each patient in turn: talking

to them, touching them with the tenderness of a mother.

A stately old widow had brought her grandchild, a six-month scrap of orphaned humanity with chicken ribs and a white-coated tongue. Hilda untied the baby's wool bonnet as if she was unwrapping priceless porcelain. Next came the woman who'd so frightened Lydia: a haunted *pietà*, with her bird-child in her arms. The child stared at Hilda, then blinked his huge eyes slowly, as though the weight of his eyelashes was too great. Both mother and child moved with a vague, graceful lethargy, conserving every ounce of spare energy for a war they had lost long ago.

Lydia was last. Her medical card charted a host of debilitating infections – malaria, flu, oral and genital thrush, diarrhoea, tonsillitis. I noticed she had started coming last July – two months after the death of her husband.

'She's worried about her youngest child, but he tested negative,' I said, hoping to elicit further reassurances. 'Oh, I don't think so,' said Hilda, feeling Lydia's neck. 'He was positive, I'm sure. We tested him three times. The kids are almost always infected.'

Was it true? I looked at Lydia in alarm, terrified she'd understood what we were saying. She was sitting bolt upright, staring at Hilda, obviously taking in every word. 'Can I see his card, please?' I asked, afraid my unguarded question might have robbed her of all hope for her child. Rifling through the box at her feet, Hilda extracted a card. 'Normally we don't even bother to issue a card unless we're sure someone has the disease,' she said, running her eye down the scribbled entries. 'Right, here we are – ' She frowned: 'Test negative – three times. How strange – '

I grabbed it from her, needing to read the words for myself. 'Negative!' I crowed, brandishing the card and beaming at Lydia. 'He's all right!' She looked at me dully, shoulders slumped. She didn't believe it.

Lydia's cousin made us tea when we got back, and we sat sipping companionably out of big enamel mugs. The boys began

to relax, and Aloysius scrambled up on Lydia's knee, while Bryan and Gyavera began crooning a song very quietly together. While Bonnie and Lydia chatted together, I picked up a book lying face-down on the sofa. It was entitled *Yesu Ye Ani?* – 'Who is Jesus?' – and on the flyleaf was a list written in wobbly childish capitals, in English: 'sheets, curtains, bed, mattress, chairs', each with a price beside it.

'Did you write this?' I asked Lydia, and she laughed bitterly. 'That's my husband's writing,' she said. 'One of his stupid lists – things he was promising to buy. He wrote them to keep me happy – then he'd give all the money away. When we were saving for the farm, I looked after the money. But later, when they saw he had a nice place, his relatives were always asking him for things. And he never said no –' Her chest heaved with exasperation: 'He bought a bicycle for his cousin while his own sons slept on the floor without a mattress! It used to drive me crazy –' She paused suddenly, and her eyes filled with tears. 'That's why I loved him,' she said softly. 'I hated him because he betrayed me. But I loved him because he had a warm heart.'

'Did he give money to the mothers of his other children?' She shook her head: 'No – they were both with other men by then. But when we moved here the two boys came to live with us. That was so typical of my husband: as soon as things got better for us, he wanted to share it with everyone else. Richard, the younger one, was sweet. But Michael –' Her eyes flashed with uncharacteristic venom: 'I hate Michael,' she said savagely. 'The clan named him as the heir because he's the eldest – he's supposed to share the farm with my children when I'm gone. But I know they're plotting to get hold of it for themselves –' Her hands had tightened into fists. All the anger she felt – about her husband's infidelities, his death, her own illness – was focused on this one crucial issue.

'Would you mind if I went to talk to him?' I asked cautiously, not wanting to inflame her further.

We tracked down Michael the next day at a trading centre about twenty kilometres away. A thickset eighteen-year-old with

acne, he lived in a tiny room next door to one of his father's sisters, and worked as a lorry-driver for a man who traded – clandestinely – in herbal medicine. He stood sullen and wary as Bonnie reassured him that we weren't there to arrest him. To my consternation, he was calling himself by his father's name – Aloysius Waswa – assuming the identity of successor by the most powerful means possible, placing himself solidly ahead of Lydia's own little two-year-old Aloysius.

His father had arranged the job for him, he said. 'I never knew him when I was a child. But my mother took me to him when I was twelve, and he started paying school fees for me –' 'That's traditional,' explained Bonnie. 'A boy has to know who his clan is.' From then on he'd stayed with his father or with other members of the family, aligning himself firmly with his clan. Richard, the other illegitimate child, had done the same.

He admitted that the clan had named him as the main heir, but said all he'd inherited personally was his father's suit and a pair of his shoes. The property itself was supposed to be shared by all the children when Lydia died. I tried to see it from his point of view. As the nameless child of an abandoned mother, how grateful he must have been to be acknowledged by his clan; how honoured to be named heir. If they told him to hand over the property to them, I had little doubt he'd obey. Equally, if they decreed that Lydia's children should stay, I didn't think this shifty-looking teenager would dare to flout their wishes.

Michael's mother – Nantonga – lived in a nearby village. She'd met Lydia's husband when she was fourteen and he was a young labourer of seventeen, hanging around the bar her mother ran. 'We never lived together, and he didn't give me any money for the baby. So I had to leave him with my mother when I went to find a job. I worked as a housegirl for a bit, then I started brewing beer – ' She looked uneasy; and Bonnie and I exchanged looks: brewing beer often led to prostitution in Uganda.

'Did you inherit anything when Aloysius died?' I asked, and she looked surprised: 'A widow never inherits. We were never properly married anyway, even though he accepted Michael as his son.'

This wasn't the first time I'd encountered this blurring of the boundary between wife and girlfriend. When polygamy had been more widespread, such a confusion was much less likely to have arisen: a man would simply have added each new woman to his existing household, securing her status as wife with a bridewealth payment to her clan. Christianity, with its stress on monogamy, seemed to have created a society of wives and non-wives, married and single mothers – often, literally, of madonnas and whores. But which women were destined to become respectable wives – and which ended up as girlfriends passing from one man to another?

'Why would Aloysius have married Lydia but not Michael's mother?' I asked Joseph as we drove back to the hotel.

He laughed, shaking his head. 'You don't marry that kind of woman,' he said. 'They are good for – for –' he hesitated, looking for the right phrase – 'for going around. But you visit their home and the mother is there brewing beer, and there are lots of men drinking – you don't want your children to see these things. You want someone clean and polite who will cook nicely for your friends.'

'Someone like Lydia?'

'Exactly!' he said, slapping the steering wheel. Then, sheepishly: 'But those women are not always good for the other things –'

Lydia was measuring coffee berries into a rusty petrol can when we arrived the next morning. 'There should be four cans to each sack,' she explained. 'I always check to make sure.'

'And do they ever cheat you?'

'No –' she looked confused for an instant – 'but it's best to be sure.' And she returned to her task, alone in the middle of her courtyard, grim and dogged, trusting no one.

Minutes later it started to rain, and the two older boys came running to help her scoop the coffee back into the sacks and haul them into the unfinished house. 'Why aren't they at school?' asked Bonnie sharply, suddenly the social worker.

Lydia looked abashed. 'It's raining,' she said, gesturing half-heartedly at the sky. But I didn't think that was the real reason. Nor was it because they didn't have the right school uniforms; nor because she couldn't afford books and pencils. It occurred to me suddenly that they were not at school because Lydia needed them with her at home: not just to help with the work, but because she was frightened and sick and lonely. And, young though they were, they were the only people she could really rely on.

The day passed, grey and showery, with patches of hot sunshine that made the ground steam. The little family worked steadily at their various tasks regardless of the weather: faces freckled with raindrops; feet spattered with red mud. Lydia knelt beneath a matoke tree, peeling a bunch of the banana-like fruit for lunch. Her only concession to the weather was a man's mustard cord jacket – her dead husband's – whose sleeves hung down over her thin wrists, heavy and dark with rain. When I suggested she sheltered for a while, she laughed dismissively. 'This is small rain,' she said shortly.

She'd seemed restless and agitated all morning. Now her hands moved like lightning, slicing and cutting, while I stood watching in my Wellington boots and umbrella. 'I want to talk about Michael,' she said suddenly – in clear English – laying down the knife and looking me straight in the eye. So that was it: she'd been worrying about what he and his mother might have said to us the previous day.

Bundling up the peeled matoke in fresh-picked leaves, she led the way back towards the house and closed the door carefully so that the boys couldn't hear. Then, when Bonnie and I were seated, she composed herself with characteristic grace and firmness: knees together, hands neatly clasped in her lap.

'Michael has an evil heart,' she began. 'I knew that from the beginning when he stayed with us in Kinoni. We had a housegirl with a bad scar on her face – and he used to tease her and make her cry. And when he moved in with us here, he used to just sit in the corner and stare at me when I asked him to do anything –' and she mimed a sulky teenager, pouting non-chalantly with his arms folded. 'Then he found out about my

husband's other woman, and his attitude changed towards me. He started smiling and being helpful, and talking to me. He said he liked the older women in Kinoni; that he got excited looking at their legs. Then one night after I'd gone to bed, he came into my room and started touching me under the blanket. I was asleep, so I didn't realise what was happening. Then I woke up and he started begging in this horrible wheedling voice. But I screamed at him to get his hands off me – ' She paused: 'Of course, I was more attractive then,' she said. 'Not thin, like this –' holding out her arms with a look of disgust on her face.

'Did you tell your husband?'

She heaved a big sigh: 'I didn't dare. We weren't getting on very well, and I knew Michael would deny it – or say it had been my idea – ' Her hands clenched. 'He thought I was available, you see,' she said angrily. 'Because he knew my husband had another woman. Anyway, after that he started talking to the clan about me – telling them I wouldn't let my husband give them any more money. He's the one who turned them against me.'

Telling us about Michael had released something in Lydia. She was excited – gay, even – welcoming us like old friends when we climbed down from the Land Rover the next morning. Her mood was infectious, and the younger children began doing handstands, half-dressed, dangling their tiny genitals, chortling and tumbling on top of one another in the warm mud.

It was a beautiful day: clear and blue, with steam rising softly from the rich leaf litter beneath the matoke trees. The coffee boy came, a bulging sack slumped like a drunk over his bicycle. The matoke man arrived soon after, and Lydia sold him two bunches, then dispatched Julius with the money to buy sugar and paraffin for the lamp. Then she dragged the grass mats from the house and began gathering the white mushrooms that had sprouted from the floor and walls in the wake of the rain – then unearthing potatoes, picking bitter tomatoes, and standing on tiptoe to reach purple passion fruit down from the vine: a wraith-like Eve in her Garden of Eden.

Later in the afternoon, when the matoke men were rattling home on unladen bicycles, Lydia touched my arm and pointed to a house in the distance. A lorry had pulled up, and a man was swinging down from the cab. 'He's been away for three weeks,' she said. 'I always think of my husband when I see that lorry come home.'

'Did he work right up until he died?' I asked, and she sighed: 'He wanted to give up, but I persuaded him not to. It was nine months after we'd moved here. Suddenly he had this pain and diarrhoea, and started vomiting before every meal. He got thinner overnight – everyone noticed. He was terrified, but I made him go to the clinic, and while he was away I got the children together and we worked really hard on the farm to prove we could grow our food. When he came back I showed him what we'd done, and we had a long talk.

'I said: "We have to think of the children now" – so he decided to try and finish the big house before he passed away. He hired eight men and started building, and I opened a kiosk by the road selling bread and matches and things to tide us over while he wasn't earning. But when the walls were finished, we ran out of money to pay the builders. So he had to try to get a job again. But he had a rash on his hands by then, and everyone in Kinoni knew he was sick. So he took a bus to the lake to try there – ' Her eyes filled with tears: 'It was terrible. He got a fever when he was there, and huge blisters all over his legs. There was no one to look after him, and when he got home all the skin had come off and he could hardly walk. That was the end really – he didn't try again after that.' She smiled crookedly, wiping her eyes with the back of her hand. 'I'm sorry I keep making you talk about these things,' I said, touching her wet hand. There seemed to be so many tears in my book.

Supper was a subdued meal: it was later than usual, and the children were tired. The lamp-flame danced their shadows, like puppets on the wall, as they reached sleepily for fistfuls of matoke.

'Do you have a husband?' asked Lydia, and I took out the photograph of Bill in his old donkey-jacket. She wiped her hands carefully and took it from me, leaning close to the lamp

141

and studying it. 'You must miss him,' she said eventually. Then: 'Did you have a big wedding?' I explained that we'd had a private ceremony, on a hill in Scotland, where we'd exchanged rings. She nodded. 'When my husband was dying, we decided to get married properly – even though the house wasn't finished. He couldn't walk further than the latrine, so I had to get the priest to come here. He gave him the last rites at the same time.'

'Do you mind talking about his death?' I asked, and she shook her head. 'I want to tell everything,' she said firmly. 'And do you mind the children hearing?' She looked surprised. 'They were here all the time. They saw everything,' she said.

We finished the rest of the meal in silence. Then, when Julius had piled up the pots and taken them outside, and Bryan had come round with a basin for us to wash our hands, Lydia sat calmly back on her heels and began talking.

'He was in so much pain those last days, and too weak even to go to the latrine. I used to roll him over so he could go on matoke leaves, then I'd wash him and throw them away. Then one night his stomach swelled up and the pain was so bad he couldn't sleep. He just curled up, shivering and holding his stomach, crying that he wanted to go to hospital. So I decided to go to Kitovu to get them to come and fetch him, but he hung on to me – he was so scared of being left alone – ' Big tears filled her eyes and began to drop silently down her cheeks, streaks of gold in the lamplight.

'I told him I was going to get help, and I ran to a neighbour's house and asked them to send a message to the clan. Then I found someone to take me to Kinoni and got the first bus to Masaka.' I glanced at the boys: anxious Julius with his big serious eyes; Bryan and Gyavera with their arms clasped around their knees; Aloysius, dozing, clutching the front of his mother's blouse. What did they remember of that night?

'At Kitovu Hospital I had to queue for ages – then they said it was too far to send an ambulance. They just gave me a prescription for some painkillers. But before they opened the pharmacy, they gave us all a lecture about AIDS. I didn't hear anything – I just sat there holding that piece of paper, thinking that my husband might be dying. Then when I got to the pharmacy there

was another huge queue and my heart started pounding – all I could think of was him begging me not to leave him alone.

'Anyway, I got the medicine and waited for the bus. And when I got off in Kinoni, someone came up to me and asked if it was true that my husband had died. That was when I started shaking. I tried to answer but I couldn't speak, but when I got home and saw all the people there I knew it was true. His sisters had come from Kinoni – they said he'd died at eleven o'clock, when I was queuing up for the medicine – ' She untucked her blouse and wiped her eyes on the hem.

'You know the worst thing? They didn't know about the matoke leaves, so they lifted him up over a bowl. It must have been so humiliating for him, and Julius said he was screaming with pain. Then he asked to be taken into the big house to die, but they said it was too dirty. But if I'd been there, I'd have sent the children to sweep it and make it nice for him – '

'I'm sorry – ' Poor Bonnie, translating, couldn't go on. Fumbling for a handkerchief in her bag, she mopped beneath her spectacles. My eyes were brimming too, and my throat ached with suppressed sobs. Looking at us both, Lydia began laughing through her tears. Then, fired with sudden energy, she scrambled to her feet and called Julius to fill a basin of water. 'I want to wash,' she said in English. 'Then I want to talk.'

Bonnie and I exchanged anxious looks. 'Let's stop now,' I suggested. 'We can carry on tomorrow.' 'No, please.' Lydia was adamant. 'I want to talk.' She took a towel and a clean blouse from her bedroom, and went outside in the dark. Ten minutes later she reappeared, shivering and smiling. 'The kitchen fire's out, so the water was cold,' she explained cheerfully, rubbing her thin arms.

I shrugged helplessly at Bonnie: 'What would you like to talk about?' 'The clan,' she said, with a determined tilt to her chin. 'I want to tell you what happened at the funeral rites.'

'The funeral rites are after the burial,' Bonnie explained. 'It's when the clan decide who inherits the property. The heir is dressed in barkcloth and given a spear and knife to hold.

Then the *moojwa* drum is played and the names of the ancestors are read out – right up to the person who passed away. It's a very important ceremony. All the relatives are invited – there can be hundreds of people there, and the clan have to brew beer and make a canopy for everyone to sit under. Then they discuss how the property should be divided up. In the old days we had the funeral rites immediately after the burial. But since this disease, people wait until two or three of their relatives have passed. It's too expensive to do it every time.'

She translated for Lydia, who nodded: 'It was nine months before my husband's funeral rites, because they decided to do his brother and his uncle at the same time.' I digested this for a moment: so the clan had lost three male members in less than a year. If the others had been as assiduous in their obligations as Lydia's husband, it must have been a devastating economic – not to mention emotional – loss to the dependent members of the extended family.

Lydia waited patiently while I scribbled this thought down, then embarked on the rest of her story. 'They started trying to take my things the day after my husband was buried,' she began. 'His brothers and one of the uncles decided to make a list of everything in the house. So I went to the RC' – 'That's the local councillor,' Bonnie explained – 'and he told them they mustn't touch those things. They went away then, but they'd revealed what lay inside their hearts. That was when I really started to worry that they'd try and take the farm away from my children.

'Anyway, nine months later they sent a cousin to tell me the date of the funeral rites. They wanted to hold the ceremony at my place, because it was during the drought and they didn't have enough matoke. They told me to prepare the beer and all the food, and they would bring two cows to kill. I thought it was very strange, because Kinoni is far from where they stay, and everyone would have to travel. So I went to visit them six times to make sure all the details were correct. Then I started to prepare everything. Then, on the morning of the ceremony, they sent a young boy to tell me they'd changed their mind and were having the funeral rites at their place instead!' Her chest

heaved with anger, and her eyes flashed in the lamplight.

'Why did they change their mind?' I asked, somewhat mystified as to why she was getting so worked up.

'You don't understand,' she said impatiently. 'They'd planned it from the start! It takes six days to brew beer and prepare everything, so they must have decided at least six days earlier. But they didn't tell me until the last moment, because they wanted to keep me out of the way. They knew I couldn't leave the guests I'd invited to my place – ' she clenched her fists and the sinews stood out in her neck. 'All his other wives were there – I was the only one who didn't go!'

'What would you have done if you'd been there?'

'I'd have said that I'd paid for half the farm with my own money, that if they wanted my things they had to pay for them – ' She crumpled suddenly, as if an electric charge had been switched off: 'Oh, I don't know. There were five hundred people there, and usually it's only the men who speak. But maybe if they'd seen me there, with my children – ' She sighed, and the sound came from very deep inside her. 'Anyway, it's too late now. They came round a few days later and took away the cupboard and the Primus stove. And they told me they'd named Michael as heir, and showed me a paper setting out all the arrangements for the property.'

She got up and disappeared into her bedroom, returning with a dog-eared document endorsed by several witnesses and the local councillor. After I'd read it I looked at Lydia: 'I don't understand. It says here that your children will get the land – with Richard. Michael gets a different piece of land altogether. It's all written down here and signed. Why are you so worried?'

She took the paper and folded it carefully. 'I don't trust them,' she said simply. 'Why did they name Michael as heir? Why did they prevent me from coming to the funeral rites? When I'm gone, all they have to do is tear up this paper – '

It was gone two by the time we lay down to sleep. The boys had gone to bed hours ago, curled up on a filthy makeshift mattress made from knotted rags. Bonnie took off her skirt and shoes,

wrapping herself like a pupa in a blanket on the sofa, her head on her handbag. Despite my protests, Lydia insisted on dragging her mattress out of the bedroom for me and wedging it in the small space between the furniture on the sitting-room floor. 'I'll sleep here,' she said firmly, laying a blanket on the bare wood of her single bed. 'I'm used to it – this is how I slept when my husband was ill.'

I lay down on the dead man's mattress, and she blew out the lamp. With the door shut and no windows, the room was pitch dark. I stared up into blackness, listening to the night's noises: Bonnie snoring softly by my feet; the boys snuffling and sighing; little scratchings and scufflings as rats and crickets scavenged in the corners. Every so often one of the boys would wake in the next room and I would hear him fumble his way towards the basin, then there would be a trickle of urine, and a warm earthy smell would mix with the smells of mud and mushrooms and damp matting.

Lydia was awake too. I could hear her shifting her body on the hard wood, drinking from the enamel cup by her bed. Once she lit a match, and I heard her writing something with a biro I'd lent her. Later she began to cough, stifling the sound with the blanket. I thought of her working all day in a rain-soaked jacket; of the goose-pimples on her arms after she'd washed. Then I felt the unmistakable sensation of a flea beneath my breast, and wondered who else it had bitten that night.

I woke up to hear the door being dragged open, and saw sun-light flooding into the room. 'It's late!' called Lydia gaily. 'Everyone else has already had their breakfast.' I looked at my watch: it was ten past seven.

Julius brought me a basin of water and I pulled off my T-shirt to examine my flea bites: several runs of red lumps, like footprints wandering over my torso. Bonnie grinned and pointed at them. 'You've found a friend,' she said, disentangling her extraordinary wig from the cropped grey curls underneath. It consisted of a six-foot-long string hung with auburn ringlets, like some bizarre Christmas decoration, which she shook out

then re-coiled around her head, anchoring it firmly with large black kirby grips.

Refreshed but itchy, I stepped out into a glorious morning. The sun was like a kind hand, drying the tears of the previous night. The sweet scents of crushed leaves and clean earth filled the air, mingled with wood-smoke from the cooking fire in the kitchen hut. Flocks of bright finches whirred from bush to bush, and a haze of gauzy insects hung in the dappled spaces among the matoke trees.

Julius appeared from the direction of the spring with a canister of murky water on his head, while Gyavera scrubbed at last night's dishes with a loofah. 'You have good children,' I said to Lydia, as she swaddled peeled matoke in its parcel of leaves ready for steaming. She smiled and nodded. 'How many children do you have?' she asked, then looked stricken when I explained about my infertility. 'I will help you get a baby,' she said decisively. 'After breakfast I'll take you to my friend. She treats all the women in the village.'

The woman was tall and sturdy, with a confident breezy manner. Her mud house was perfectly swept, plain and brown, with a few utensils hanging from the beams. She rolled out a grass mat, and we all knelt while Bonnie and Lydia went through the genteel rigmarole of introductions.

'I've cured lots of women with this problem. I'll give you something now to open your passages, and something else to take to England to make you strong.' With that, she knelt upright and led us in a short prayer, then took me outside to her dispensary: a tiny thatched mud building with a huge wooden pestle and mortar by the door. This she filled with green leaves, which she pounded to a pungent pulp. Then she filled the bowl with water, stirred it to a greenish soup, and handed it to me to drink.

After a shower and a long night's sleep at the hotel, I woke feeling marvellously refreshed. Bonnie and Joseph seemed to share

my mood, and the journey to Lydia's house was relaxed and light-hearted. I was so grateful to have had them with me for the past week: Joseph's thoughtful good humour and Bonnie's indignant compassion had made them perfect guides and companions. I said as much and they responded in kind, saying they'd enjoyed being involved in such detailed detective work. We bowled along, munching bananas, basking in our mutual admiration.

There was a crowd of visitors milling around outside the house when we arrived, and my heart sank slightly at the thought of all the introductions and politenesses I'd have to endure. Leaving Joseph with the Land Rover as usual, Bonnie and I made our way through the people and into the little house to find Lydia.

She was there, kneeling, dressed in a traditional black-and-white furbelowed dress, and all the available seats in the room were filled with people. They were staring at her, but she was oblivious to them. Her hands were clasped and she was rocking to and fro, nodding her head violently in time with the prayer she was chanting. Little Aloysius was whimpering on an old woman's lap, but the older boys just knelt beside her, staring with huge frightened eyes. While I was watching, Julius turned and looked at me, an expression of utter desolation on his face.

Lydia spotted me a moment later, and her movements became more violent. She started singing a hymn, forcing out the words tunelessly, almost shouting, flinging her upper body from side to side. Then she stumbled to her feet and grabbed the picture of Saint Jude from the wall, clutching it to her breast and pushing her way towards where I was standing at the door. I backed away, thinking she was going to hit me, but she just sang louder at me, bent almost double with the effort.

The press of people divided to let her out into the sunshine and she charged into the courtyard, still wildly singing, then picked up handfuls of coffee berries and began flinging them at their curious faces. They backed further, laughing, and she came after them, shouting and flinging coffee, then lay full-length on the ground and rolled, limbs akimbo, like a horse. 'She's saying

we have come to help her,' whispered Bonnie. 'She's telling them to leave her alone. Now she's thanking Saint Jude for bringing us to her house. She thinks it's because of him that we chose her. But she's talking a lot of rubbish too. I can't understand all of it – she's very crazy – '

I tried to think logically but all I could hear was a voice saying 'Your fault, it's your fault'. All I could see was her fragile body, being jerked like a puppet by the madness inside it. Whatever gripped her seemed strong enough to snap her neck like dry grass.

'Can we take her to a doctor?' asked Bonnie. 'I'll explain where we're going and make sure there's someone with the children.' I nodded gratefully, then forced myself to walk over to Lydia and help her up from the ground. She calmed down as soon as I touched her, relaxing against me as I put my arm around her and walking obediently to the Land Rover. God, she felt so insubstantial in my arms: like a hollow thing with the life sucked out of it.

Bonnie followed a few minutes later, accompanied by an old woman and a younger man. 'This is Lydia's mother, and her brother,' she explained. 'They want to come with us. Her aunt's going to stay with the children.'

As soon as the engine started, Lydia put her head on her mother's shoulder and fell into a deep sleep. 'It started last night, when she was praying,' said her brother quietly. 'She began shouting strange things, then at about two o'clock she ran down the road and banged on the councillor's door to wake him up, shouting that he hadn't been fairly elected. He found someone to stay with her, then cycled to fetch us. Julius said she hasn't eaten or drunk anything since you left yesterday – ' He paused and glanced at his mother. 'We thank you for helping her like this,' he said.

Helping her? If only he knew. Was it helping to force her relive the worst days of her life? To make her dwell on her husband's infidelity, on his relatives' duplicity; to make her focus repeatedly on her fears for the future? Not to mention the anxiety of simply having us around: worrying when we'd like to wash, what we'd like to eat –

An age later we arrived in Masaka, and Bonnie guided Joseph down a side street to a small pharmacy with a surgery upstairs. 'I know this doctor – he's the best in town,' Bonnie assured me, and hurried up the stairs to charm her way to the front of the queue.

We were soon led into a small room painted in salmon-pink gloss paint. A big, jovial man with plump hands led Lydia to a chair. She shook her head violently to all his questions, like a child in a tantrum, denying that there was anything wrong. He placed a thermometer in her armpit and turned to me. 'She is suffering from malaria,' he announced. 'The fever often affects the brain in these patients – she does have AIDS, doesn't she?'

I nodded: 'Will she be all right?'

'Oh, yes,' he said, reaching for a prescription pad. 'Just make sure she takes these, and she'll be fine in a few days.'

'What are you giving her?' I asked suspiciously, as the list began to extend alarmingly – to four, then five different items. 'Largactyl for the craziness, and something for the side-effects of the largactyl. Two different kinds of malaria drug, in case she's picked up a resistant strain. And paracetamol because she's sure to have a headache later.' Now I was alarmed: surely largactyl was a drug for schizophrenia? If the craziness was caused by the fever, why did she need an anti-psychotic drug as well? And what was all this about side-effects?

'Does she have to have largactyl?' I asked nervously. 'Couldn't she just have a sedative to calm her down?' He stared at me in disbelief – obviously no one had ever questioned his expertise before: 'Would Valium be acceptable?' he asked sarcastically, and fitted a needle to a syringe of pink fluid.

The effect was dramatic and terrifying: Lydia lolled like a rag doll, her mouth open. I rounded on the doctor: 'You didn't have to knock her out! How are we going to get any liquid into her now? She hasn't drunk anything for twenty-four hours – she must be dehydrated because she's had a fever –' He looked at me with silent hostility, then took a bottle of Fanta from a drawer in his desk and, heaving Lydia's unconscious body into a sitting position, started pouring foaming orange

liquid into her mouth. It dribbled out again immediately, pouring over her chin and down her neck as she slumped forward. He tried again, hauling her upright so that her head fell backwards and her mouth gaped open. She made a weak attempt to swallow, and more liquid trickled down her neck.

'Stop it, please!' I begged. 'She can't swallow.' I had visions of the foul orange stuff seeping into her lungs. If she was too sedated to cough it out again, it could fester there into pneumonia. AIDS sufferers were particularly prone to lung infections – if she developed pneumonia, she could die. And it would be because I had insisted on the sedative. The room started to recede as this newest nightmare began to take shape in my mind. If she didn't cough, she could die and it would be my fault. Realising I was about to faint, I sat down and put my head between my knees.

Bonnie put her hand on my shoulder. 'He says it's only temporary,' she said gently. 'She'll come round in a few minutes.' I raised my head and stared at Lydia's crumpled body. While I was watching, she started to grunt a little, then to cough up sticky orange ooze. I dropped my head and started to weep.

Amal

One quarter of Middle Eastern families are headed by women, but the stigma of single motherhood is so strong that most try to attach themselves to the household of a male relative. In Egypt, where 23 per cent of women are divorced, a woman living alone is assumed to be sexually promiscuous. Going out to work has similar moral connotations. An Islamic wife's place is at home, so women constitute only one tenth of the workforce in Egypt. This leaves the single mother with some stark choices: begging from relatives, putting her reputation at risk – or getting married again.

Amal has tried every option. Thrice divorced, she admits that she married her last two husbands to end the sexual harassment she experienced as a single mother. She and her two teenage daughters rarely leave their tiny Cairo flat. With no man in the house, they must be above reproach at all times.

'IMPOSSIBLE!' Sameh threw up her hands; her whole body tensed with exasperation. She wiped a film of perspiration from her forehead and chewed furiously on her chewing-gum. 'Even the police are intimidated – in-*tim*-i-*dat*-ed – from going to those quarters.' Like a diminutive sergeant major she barked her words, punctuating them with little karate jabs of her plump hands.

'But if I can't go to a village, and I can't go to a poor urban area, where *can* I go?'

'We understood that you wanted to interview the woman – not live in her house!' Sameh flapped cool air down the front of her blouse and shifted her sturdy bottom restlessly on the

edge of the sofa. 'You must understand,' she continued. 'These fundamentalists, they can annihilate – an-*ni*-hi-*late* – anyone who enters their territory. You can't find even one taxi to take you there!' She turned to her companion for confirmation. 'We thought you could interview the woman here,' agreed Zaineb agitatedly, stubbing out her sixth cigarette and shaking another out of the packet.

'Here' was Zaineb's parents' book-lined apartment in Cairo, in the sticky heat of afternoon. Sameh and Zaineb were to be my interpreters for the next two weeks. Sameh, a nutritionist, could manage only a couple of days before she went off on holiday. So Zaineb, a psychologist, was going to take over in the run-up to the Eid festival.

They belonged to a group which produced a newsletter on women's issues, but I soon discovered that their contact with ordinary poor women was limited to volunteer stints at a clinic on the edge of one of the more genteel working-class 'quarters'. 'Perhaps we could find a single mother through the clinic?' I ventured. 'If she knew you, perhaps she wouldn't mind taking us to her home?' '*Im*possible!' Sameh burst out again. 'You cannot – can*not* stay with a poor woman! There is no tradition of grass-roots working in Egypt. Upper-class people do not go to the working-class quarters. They would think you were a government spy.'

I tried another tack: 'What about someone you know really well? Your maid, for instance?' I knew that domestic workers – everywhere – were often single mothers: no woman would accept the abysmal wages unless she was desperate. 'At last she has understood!' Sameh opened her arms in mock triumph, as though I were some dimwit child who'd finally learned to tie her shoelaces. 'Tomorrow we will make an interview with Zaineb's maid, who is a widow. After that, you can decide.'

'And will I be able to visit her home?' But I already knew the answer: '*Im*possible!'

I sighed and leaned back in my seat, trying to collect my thoughts. Downtown Cairo crawled past the taxi window in a

haze of dust and fumes. Between high-rise slabs of glass and marble the traffic was almost stationary, a panting amphibian, glinting and snarling in the sun. Women scuttled along the pavements in twos and threes, hobbled in their high heels by long dust-coloured gowns. Many wore white scarves, pinned beneath their chins. Others were bolder, in scarves smothered with bright flowers. And here and there I spotted a froth of permed curls, a daring swirl of calf-length navy-blue pleats. The men walked more slowly, pacing their territory in pastel robes and heavy watches, dusty leather shoes.

Everything was dusty, and everything was being constantly polished. Men with hoses stood in every side street, sluicing cars and café windows, even the pavement itself, creating a sludge of thin mud that clung to the hem of each passing jellabah. Shoeshine boys staked out every alley in a perpetual battle against the grime.

Suddenly the taxi-driver stiffened and wound up his window. Signalling me to do the same, he reached over from the front to lock both rear doors. I stared at him in alarm, and he nodded his head towards the large mosque up ahead. The doors had opened, and a flood of white-robed figures were pouring out. In three minutes the street was full of black-bearded young men, talking animatedly in small groups, crowding round the bus-stops, striding through the traffic in search of empty taxis.

I shrank back against my seat, terrified that any eye contact would be interpreted as a challenge. Though my hair was concealed with a patterned scarf, I knew my freckles and blue eyes would immediately identify me as a foreigner. Hemmed in by six lanes of traffic, the taxi crept inexorably onwards. We were soon surrounded by a press of white robes. I could hear the men shouting at each other over the roofs of the cars, see them gesticulating out of the corner of my eye. It was like being buffeted by a white breaker in the sea. The car began to rock and I froze, waiting for the windows to smash, for angry hands to drag me out into the street.

The driver revved the engine nervously, and the crowd stepped back, slapping the roof and bonnet as we inched forward. And suddenly we were through, and the wall of seething

white was behind us, leaving us to inch forward through the hot soup of pollution.

Back at the hotel, yesterday's breakfast tray was still languishing in the corridor and my sheets were in a heap outside my door. I'd been bullied into coming here by a suave man at the airport, who'd flashed his government ID and stuck to me like a limpet until I was seated in an overpriced minibus. 'Cairo is the safest city in the world,' he assured me. 'But with our recent troubles' – he coughed modestly – 'we want our European guests to feel welcome.' At the time I'd felt cosseted, but I soon realised that this 'welcome' meant herding every Western visitor straight into his uncle's minibus *en route* to his cousin's hotel. The fundamentalists' bombing campaign had decimated the tourist industry: we were a rare and precious commodity.

Normally I would have found this amusing. Now it just depressed me, adding to the sense that I was surrounded by greed and hostility. From the moment I'd stepped off the plane, male eyes had followed me everywhere, raking over my clothing with naked curiosity. Each time I paid for anything, there was a belligerent demand for *bakshish*. Almost every taxi I'd taken had set off on a deliberate detour.

Having done research in both Jordan and Morocco, I knew this degree of predatoriness was not general in the Arab world. True, I'd had to cover my arms and legs in those countries, and restrict my movements to the daylight hours; but I had always been treated with courtesy – and with as much generosity as anyone has a right to expect when travelling among poor people. Egypt felt different: avaricious, misogynist.

The next morning I went out and bought a scarf: a voluminous white scarf identical to the ones worn by the more conservative women. I pinned it under my chin, but I looked absurd: a parody of Islam. So I knotted it at the back of my neck under my hair. In my black jacket, ankle-length black skirt and flat gym shoes, I looked like one of the nuns who had taught me at

school. Sweaty but demure, I walked to one of the main shopping streets, where Sameh was going to pick me up in her car.

She was late, and I began to feel uncomfortable. Men were scowling disapprovingly, or staring with arrogant invitation in their eyes. Women nudged each other and looked away when I tried to smile at them. At last she arrived, lurching along near the gutter in a tiny red Lada. She laughed uproariously when she saw me. 'You think you are a good Muslim woman!' she said. 'But you are too *chic*! This black and white – it is too stylish. You must look ugly – *ugly* – with colours like mud. The men can see your throat, and this little gold chain. They suffer from sensory deprivation, so these things become very erotic.' She snapped her chewing-gum and veered out into the traffic with a wild crashing of gears.

She drove like she spoke: in staccato bursts, stabbing the horn, paddling brake and accelerator in random succession. 'Myself, I absolutely *re*-fuse to wear a scarf,' she declared, tossing her short hair and shaking a fist at an innocent lorry-driver. 'It has become *ri*-diculous. When I was at university, we were wearing miniskirts and no sleeves – *mi*niskirts!'

The Lada leapfrogged round a corner, narrowly missing a herd of sheep waiting unconcernedly at a set of traffic lights. 'They've been brought in for Eid,' Sameh explained. 'They will be killed before dawn. Next week, you will see – Cairo will become full of animals!' The car zigzagged like a demented water-flea through the traffic, and skidded to a halt outside Zaineb's parents' apartment.

Their maid, Sunsun, was tall and stately in a floor-length housecoat and slippers. But when I discovered where she lived, even I had to concede to the 'impossibility' of visiting her home. The Imbaba slum area was an acknowledged nerve-centre of fundamentalist activity. 'If they see a woman without her jellabah, they throw acid on her legs,' remarked Sunsun mildly, leaning against the wall and lighting a cigarette. 'Last month an American woman was stoned for taking pictures.'

'They have been paddling in sewage there for years,' said Sameh, curling her lip in disgust. 'That's why the men are so

angry. Fundamentalism is just working-class protest in a coat of Islam.'

'Are there many women without husbands in Imbaba?' Sunsun coughed juicily and took a long drag on her cigarette: 'There are six in the building I live in. Most are divorced, but two are waiting for their husbands to come back from Hallib.' She snorted derisively: 'They will have to wait a long time – when a man gets money, he gets a new wife.'

'Hallib is the oil states,' explained Sameh. 'Saudi, Kuwait, Bahrain – the wages are twenty times inflated – *twenty times* – so there are four million Egyptians working there.'

'How do the wives manage on their own?' I asked.

Sunsun flicked ash: 'If he's away, she'll wait for him to send money. Then try to borrow from his relatives. Then if she hears nothing, maybe she'll make an affair with another man to get him to support the children. But that's difficult, because her husband's brothers will be checking with the neighbours, to make sure she's faithful.'

'And if her husband wants a new wife?'

'He'll beat her till she leaves the apartment,' she said simply. 'Then she'll have to go back to live with her family. Otherwise people will assume she's a whore – that's why my daughter's living with me. And she can't go out to work because people will gossip about what she's doing when she's out. It's all right for me, because I'm old now – '

'Please try to think,' I begged Sameh later. 'Isn't there any way we can visit an ordinary bit of Cairo? Don't you have an uncle who owns a factory, or a distant cousin who's a builder – I don't know!'

Watching that familiar tide of impatience flood her face, I wanted to scream. I could see the i-word forming on her lips. Then she hesitated: 'I wonder if Youssef – '

Youssef turned out to be a communist. Retired owner of a sweet shop, he had co-ordinated the most recent election cam-

paign in Waily, an area of Cairo Sameh described as 'popular' – something halfway between slum and bourgeois and therefore – presumably – only halfway 'impossible'. To my astonishment, I discovered that Sameh was a communist too, and had helped in the campaign. 'I detest the disfigurement of our economy,' she explained, grinding the poor Lada's gears. 'We're all in the Party – Zaineb and her parents, and her ex-husband. Zaineb's been trying to interest me in women's issues, but I believe that economics is funda-*men*-tal.'

It was the following day, and we were jolting erratically down an eight-lane roadbridge over the Nile. 'Youssef is a guardian for women without husbands. Many old men take this role. Women need them if they have no brothers or fathers to speak for them, or escort them to the police station or the beach – anywhere they will be vulnerable. He might know someone we can visit, but I'm very dissatisfied about this.' She swerved and wiped the sweat from her upper lip. 'The fundamentalists are active in Waily also –'

By now the traffic had thinned, and our surroundings had changed dramatically. Goats pawed at charred garbage heaps, and a stench of burnt fish filled the air. 'That's the fish market.' Sameh wrinkled her nose. 'They burn rotting intestines to vanish the flies. The government passed a law to move it out of the city, but the owners just ignore. It's the same with the lead factories – ' She jabbed a finger at a thicket of belching chimneys. 'We all have rheumatism and headaches from lead poisoning.'

The factories were surrounded by slums: acres of formless brown shacks, roofs piled high with old tyres, tin buckets, splintered planks – the depressing debris the poor must accumulate because one day something might come in useful. Further on were the vertical slums: ten-storey blocks of flats, festooned with fluttering washing-lines, and balconies alive with chickens and goats, or boarded with tin and patched ply to make another room.

Waily, when we reached it, was different again. Obviously middle-class, it consisted of a warren of narrow unpaved streets winding through terraces of three-storey buildings. Tiny cafés nestled between open-fronted vegetable stalls and haberdashers

with bolts of material layered like chocolate gâteau. I glimpsed hairdressers through dark doorways, and tailors bent over giant black treadles. Sameh parked behind a drowsy donkey and hurried me through crowds of leisurely shoppers to a booth where a small apple-cheeked man was puffing on a giant hookah.

He embraced her warmly and launched into animated chatter, while I endured an unending series of double-takes as each passer-by registered the red curls beneath my innocuous white scarf. 'He likes to talk,' apologised Sameh when he paused for breath. 'But he says there are hundreds of divorced women here. Of course the husbands don't take the trouble to divorce them properly – they just beat them until they leave the house. There are four he knows well. One works as a maid – her husband is a drug addict who married a rich belly dancer.' I raised my eyebrows. 'Oh, belly dancers are millionaires in Cairo!' she declared. 'Teachers and doctors are paid nothing, but you get *millions* if you are a plumber or a dancer.'

'Can we visit her?' I braced myself: the ten-thousand-dollar question. Youssef shook his head and broke into another flood of Arabic. 'She's away in her village for Eid,' Sameh reported finally. 'He knows another woman who attacked her husband with a knife when he married again, but she is visiting her mother's house. Then there is a widow who had a heart attack – ' This was driving me crazy: 'Isn't there anyone we can see?'

She turned back to Youssef, and he was off again: smiling and gesticulating with the hookah's mouthpiece, rattling on nineteen-to-the-dozen. 'Well?' I couldn't stand it. 'Her name's Amal,' said Sameh at last.

Amal lived on the third floor, up a narrow concrete staircase above a fishmonger's and a hairdressing salon. A soft-looking pillow of a woman, she exclaimed with delight to see Youssef, who embarked on another torrential monologue as she conducted us into a small spotless sitting-room with doors opening on to a tiny balcony overlooking the street. Soon two teenage

girls sidled in, gawky and big-nosed, proffering glasses of steaming cerise cordial. Dressed in pastel nightdresses, like their mother, and open-toed slippers which slopped dreamily along the concrete floor, they made me feel that we were disturbing some eternal siesta.

Without interrupting his flow, Youssef smoked two cigarettes and picked his way through a dish of yellow beans. Amal listened with a sweet smile on her heavy features, nodding and adjusting the folds of her white scarf. She was fat, with the kind of flesh that moulds itself into lush billows, like wax falling from a cream candle. Her dimpled arms cradled great untidy breasts; her thighs surged sideways over the spindly cottage suite we were sitting on.

After a while I touched Sameh's arm. 'What's he saying?'

'He's talking about her illness. She was hospitalised last month for diabetes. I see women like her all the time at the clinic. They are obese and hypertensive, and they eat terrible food.' She sighed with frustration. 'You give them a diet, but they ignore. They never make exercises and they don't take their medication. It is *involutional* anger. The man makes a hard hand when he is angry – ' she balled her small fingers into fists. 'But the woman must be passive or her husband will divorce her. So she boils with hypertension.'

'Can you ask if she knows other women with her illness?' Sameh leaned forward and put her hand on Amal's arm, and the big woman bowed apologetically to Youssef, then turned her gentle dark eyes towards us. 'She says the hospital ward was full of people like her. All with uncontrolled diabetes like her, all divorced, all obese and hypertensive – '

'Would she mind telling us a bit about her marriage?' Amal listened carefully, with her head on one side, then spoke for a long time in a low voice. 'She's been divorced three times,' reported Sameh. 'And she was pregnant each time. So there are three fathers and three children: a son who is married and lives with his mother-in-law, and the two girls we have seen. She says she loved her first husband, but the other two were bad men. She married them because it was impossible to survive without being married. Her brother's wife didn't want her with them,

and she could not find an apartment. The landlords think divorced women make affairs with men and paint the building with a bad reputation. She says she is ashamed that she married for a roof on her head, but she is proud that she did not become a prostitute – '

I smiled as sympathetically as I could, and Amal shrugged her soft shoulders resignedly. 'How did you get this place?' I asked.

'I moved here with my third husband when we got married,' she said in Arabic. 'I paid the rent and the deposit, but he put the lease in his name because he was ashamed for people to know his wife was paying. Then when I was pregnant, he decided he didn't want me any more, so he started beating me every day to make me leave. But Youssef said there was a new law that allowed a wife to stay in the home when her husband has divorced her. I knew it was my only chance of finding somewhere to live, so I refused to leave –'

Sameh was becoming increasingly agitated as she translated, wiping her upper lip and tapping her feet as though she was about to run from the room. 'What's the matter?' I asked. 'She's telling how he was kicking her abdomen to abort the baby. You know these women have really suffered,' she said, a note of anguish in her voice.

'How long did this go on?' I asked, and Amal shrugged: 'Weeks, months – I don't know.' 'Did you go to the police?' She smiled her slow sweet smile: 'My husband was a policeman,' she said. 'So did he leave of his own accord?' Amal nodded shyly towards Youssef: 'I asked Youssef and some other neighbours to help me, and they forced him to put my name on the lease for the apartment. After that he gave up. But he took all the furniture with him – even the things I paid for. It was completely empty when he was finished. But I didn't care. I had a place to live and I didn't need him any more.' She opened her arms and gestured proudly around her little domain, and I sensed that every stick of cheap furniture, every plastic mat and nylon lace curtain, had been acquired with agonising slowness over the intervening years: saved for and selected with the utmost care.

Sameh broke into my thoughts. 'They repealed that law in

'eighty-five,' she said. 'It gave women some security so the men in beards could not allow it.'

'Could you ask if she'd be willing to be in the book?' I asked. 'And whether us coming here would cause any problems for her.' Amal laughed when she heard the question, and Sameh turned helplessly towards me: 'She's crazy! She says she's had every kind of problem we can dream of, so there is nothing any-one can do to her now.'

'We must not spend too much time there,' Sameh said grudg-ingly as the Lada stop-started through the traffic afterwards. 'And we must *d*e-sist imm-*e*-diately there is trouble. And of course you can't stay there at night –' I nodded happily, not really listening, as it began to dawn on me that Cairo had not proved impossible after all.

Amal greeted us with a broad smile the next morning and her eighteen-year-old daughter, Jasmin, sat us both down and wafted burning frankincense on a tray around our heads, chant-ing a greeting prayer from the Q'ran: 'May Allah protect you from the envy of others'.

They were preparing a traditional breakfast for us, the kind that's usually eaten at the weekend. I followed Amal to the kitchen: a tiny room, little more than a cupboard, where she was frying chips and felafel patties over a Calor gas ring. Like the sitting-room, the kitchen was sparse and spotless, with a cold tap and a sink, a few utensils hanging from hooks, and a shelf for beans and flour. There were three other cramped rooms: a hall-cum-living-room where the television and fridge were kept, and two bedrooms with brown nylon curtains over the doors. This plethora of small rooms – each with a specific function – was typical of middle-class homes, Sameh told me later. Curious, I asked to go to the toilet, where I was faced with an ordinary flush toilet, plus a confusing array of jugs and small hosepipes – including one in the toilet itself – for cleansing dif-ferent parts of the anatomy.

When the food was ready, Jasmin carried a folding table into the sitting-room and set out the dishes one by one: glistening fried whole green peppers, brown beans in a thick sauce, sliced cucumbers and a salty curd cheese, plus the hot food and huge rounds of home-baked flatbread which we tore up and used as spoons. It was all delicious, and I said so. 'My mother taught me,' said Amal, looking pleased. 'She had to cook for other families after my father died, so she became very skilled.'

'How old were you when he died?'

'I was five, so my mother must have been about thirty. He was a policeman, but he never took advantage – he used to change out of his uniform even if he was just going out to buy apples – ' She smiled fondly, remembering. 'Before he died we were so happy. Everyone knew us and we had meat every day. After he died everything changed. His brothers made my mother move out of Cairo, to Tantah where they lived. They said it would be easier to look after her there, but it was really so they could cheat her out of her inheritance.'

I closed my eyes for a moment, as the familiar story began to unfold: the vulnerable widow, the avaricious in-laws: it could have been Lydia talking in Uganda. 'She didn't want to go, but they threatened to take us away from her if she refused. Then they made her sign a paper giving up all claims to my father's property. She couldn't read, so she didn't know what she was signing. And she couldn't write, so she just made a mark with her thumb – that's why they wanted her away from Cairo, because they knew her friends would have told her what it said.'

She turned suddenly to Jasmin and spoke in an angry, passionate voice. The girl hung her head sulkily like a big colt, and played with her heavy hands in her lap. 'She's telling her to go to literacy classes,' reported Sameh. 'I think this is a big argument between them. She says if her mother had been able to read, their whole life would have been different.'

Amal sighed: 'My mother never recovered from what they did to her. She used to cry all the time, saying the same things over and over, about how they'd cheated her and what a good man my father was. My elder sister left home before my father

died, but my brother and I tried to comfort her. He used to hold her hand while I brushed her hair, but I don't think she noticed we were there.

'We were staying with my uncle, in a back room, but he threw us out as soon as she signed the paper. We didn't have anywhere to go, so an old man invited us to stay with him. He lent my mother money to buy flour and beans, and she started cooking bread and *foule* for people who lived nearby.' She touched the folds of flesh in the region of her stomach: 'For nine years that was all we ever ate!'

'Don't you feel angry?'

She shook her head. 'Allah avenged us,' she said simply, reaching for more cheese. 'One of the brothers went blind, and the other was poisoned by witchcraft – his wife put menstrual blood in his food, and he vomited until he died.

'Later on people started asking my mother to do their washing – she had to agree because they were buying her bread. But she was so ashamed – she used to go before sunrise so no one would see her doing that work. In those days everyone used potassium and bleach, and it was so strong it made your hands bleed. I used to help her, and I remember I was crying with the pain of it one day, when a man saw me and said he'd give me a better job. He told me to meet him at his factory –' she hesitated – 'I was so innocent!' she burst out. 'He pushed me against the wall, but I kicked and struggled, and he had to let me go. Then he took some money out of his pocket and showed it to me, saying: "You're just a servant, a nothing – I could buy a hundred girls like you".'

'How old were you?' I asked. 'Thirteen,' she said.

There was a sudden commotion outside: masculine voices cheering, car horns blaring. Pulling my scarf low on my forehead, I slipped on to the balcony to investigate. In the street below was an open-backed lorry piled high with furniture, with young men perched on the top or clinging like footmen to the tailplate, singing and banging drums. More men hung out of a cavalcade of battered cars, shouting triumphantly at passers-by. 'It's a wedding,' said Sameh, tugging me back inside. 'The husband is taking the dowry to the new apartment. He's supposed

to provide the big things, and the wife's family give sheets and curtains and kitchen things.'

I could sense the pride involved in such a display: few things could have demonstrated more clearly the ethic of man as provider. 'Was it like that when you got married?' I asked Amal as I sat down again. She smiled and shook her head. 'When I married my first husband we moved straight to Aswan after the ceremony, so he read out a list of things he promised to buy instead. It was different with my other two marriages. No one really bothers with the dowry for a divorced woman.'

'How old were you when you first got married?'

'He first approached my mother when I was twelve, but she sent him away because she thought I was too young. He kept pleading with her for two years, and she eventually gave in. It was after that trouble with the man in the factory – she thought being married would protect me. So she got a forged birth certificate saying I was sixteen.'

'Weren't you scared?'

She laughed, throwing her head back: 'Oh no – I was excited! It meant I could wear a bra and lipstick like a woman, and walk arm in arm with my husband in the street.' Her eyes flashed, and she flirted her fat shoulders in a parody of the preening teenager. 'A woman came and removed my body hair and painted hennah on my hands and feet. And I had a lovely white dress and a lace veil – '

At that moment something made me glance at Jasmin. The girl was staring at her mother with real anger in her eyes.

Preparations for Eid were beginning in earnest now, with carcasses hanging like misshapen pale fruit outside every butcher's, and herds of sheep jostling pedestrians off the pavement in the streets. Once I saw a cow in the back of a pick-up, its chin resting stoically on the roof of the driver's cab. In the warren of narrow streets where Amal lived, the smell of dead meat hung like a warm cloud, drowning the stench of traffic and chimney fumes.

We were greeted by a hive of activity when we arrived the

next morning. The curtains had been taken down, and the furniture was piled up in the sitting-room. The rugs were rolled up on the balcony, where five parallel washing-lines fluttered with brown lace. Every balcony in the street was similarly laden, and the air was full of coloured fabric billowing out above zigzags of bunting.

Amal dismantled part of the furniture tower and rubbed her knees ruefully through her pink nightdress. 'I've been scrubbing floors all morning,' she said, urging us to sit.

'Would you like us to come back later?' I asked.

She shook her head: 'No, please – it's good to have someone to talk to. Nothing happens here. We eat breakfast, then maybe I'll do some washing; then eat again, and sleep. Or I'll sit on the balcony with Jasmin if it's not too hot. Later maybe someone will come to buy some clothes – or Jasmin will cut their hair. Then we'll watch television until it's time to eat.' She smiled. 'We live quietly,' she said.

'Don't you ever go out?'

She shook her head: 'If you are divorced, people gossip about everything you do. My younger daughter, Samira, goes to school, but she always comes straight home. And once a week I go to the bazaar to buy the clothes I sell here, or over the road for vegetables. We're staying at home over the Eid holiday so people will see that we are a respectable family – otherwise no good man will want to marry my daughters.' I looked around the apartment, with its four little rooms, and it began to feel very small indeed.

We were interrupted by a knock on the door. Three heavy middle-aged women came in, dressed in grey jellabahs and bright scarves. Sameh stiffened. 'If they ask, I will say I'm a doctor bringing medication,' she whispered. 'And you are my colleague.' The three women sat down close together, smiling and fidgeting so self-consciously that it became obvious they were far more interested in me than in the nightdresses Amal was bringing out to show them. They hardly looked at the slithers of red and purple nylon she laid in their laps, but glanced pointedly in our direction, clearly willing Amal to introduce us.

Attack being the best form of defence, Sameh began to

hold forth in what I assumed to be her normal bedside manner: brusque volleys of rapid-fire instructions, accompanied by much frowning and finger-pointing. 'I am informing them about diabetes and obesity,' she explained, as they cowered in their seats. 'Now I will give them a *régime* – a list of foods they should avoid, like sugar, bread, Coca-Cola, cheese, all fried things – ' And she wrote out a long list in Arabic and brandished it under their noses, pointing accusingly at each item.

Amal heaved a great sigh. 'This is the same list the doctor gave me,' she said. 'But how can you make a meal without bread? And what do I do when people visit? You have to give something sweet to drink.' Sameh began to wax lyrical on the virtues of fresh salads and fruit. Seizing their opportunity, the three women got hurriedly to their feet and fled.

'Is that how you make a living – selling clothes?' I asked after they'd gone.

'They prefer to look at these things in private,' Amal explained. 'So I buy wholesale and make maybe one pound profit for each one. But it's difficult – because people don't pay all the money at once, or they want credit. Last night I had to go out at midnight to get my money, because the woman hid when I went in the morning.' She sighed: 'People will talk – but what can I do?' I thought of Jomuna in India, and the problems she had extracting payment from her customers.

'Did you work when you were married?' I asked.

'In my second two marriages, yes – I think they only married me because I had my own money. But Hassan, my first husband, wouldn't allow me to work – ' smiling proudly. 'He liked me to stay at home and keep the apartment nice, then he'd bring meat and fruit in the evening – ' I could only guess how heavenly this must have seemed to the teenager whose childhood had been spent living on leftovers. Then her face clouded: 'My mother came to stay soon after we moved to Aswan. She was coughing and had a fever – then one morning I woke up and she was dead. She was thirty-nine. I think she was waiting until she was sure I was happy – '

168

'And were you happy with your first husband?'

'Oh yes' – heartfelt, smiling again. 'He gave me money for housekeeping and I saved a bit every week until there was enough for a fridge and a fan. We used to sit on the balcony playing cards, just him and me. For three years I was the luckiest girl in the world.'

'And then?'

'Then he fell in love with a girl with blue eyes, like you –' she touched her face sadly – 'much more beautiful than me. Her parents thought he was rich because he was a car mechanic, so they invited him to visit. They didn't care that he was already married to me.

'He could see I was jealous, but he told me not to be silly. Then we were invited to a wedding at their place. I didn't want to go, but a friend said I should make myself as beautiful as possible so he would love me again. So I curled my hair and bought a new dress, but I knew he was looking at her all the time. A few weeks after that he sent me to Cairo to help with his uncle's funeral. He married her while I was away.'

'Without telling you?' My shock must have been evident, because she laughed and patted my arm, as though I was the one who should be comforted. 'He was a handsome man,' she said, as though this explained everything. 'Women always loved him. He married five times, and they were all virgins.'

'When did you find out he was married?'

'He wrote to his sister, where I was staying, asking her to keep me there for another month. But I was suspicious, so I threatened to burn myself with kerosene unless they let me leave. My brother-in-law travelled with me, and when the neighbours saw us they started screaming. I panicked then, and rushed up the stairs to bang on the door. His new wife opened it, wearing one of my nightdresses – '

I could scarcely imagine a more public humiliation. 'When I saw her, I fainted,' she said, laughing again at my stricken expression. 'When I came to I was in a neighbour's house and Hassan was there, telling me it was all a mistake: her family had tricked him into marrying her by leaving them alone, then accusing him of raping her.'

'So what did you do?'

She sighed, and her big body shuddered: 'I decided to stay. I thought if I was kind and quiet, and didn't complain –' She looked down, embarrassed: 'I hoped he would let me stay.'

'Is that usual?' I asked Sameh. 'It's legal,' she said. 'Under Islam a man can take four wives if he asks his first wife's permission. But these days it's too expensive to pay for more than one. It's cheaper to throw away the old one. Under Islam a man does not even have to give a reason for divorce: he just says "I divorce you" three times and it's over.'

'Did Hassan agree?'

Amal nodded. 'It worked for a while. I slept on the floor in the sitting-room, and he'd spend one night with each of us. And I tried to make her like me by doing her make-up and lending her my clothes.' She ducked her head again in embarrassment: 'I even sugared her pubic hair so she'd be beautiful for him in bed – '

'How long did you live like that?'

'Only six months. Then I started being sick, so Hassan took me to hospital. He was frightened it was because I was sleeping on the floor. But it was because I was pregnant. That was the end really. His new wife said she'd go back to her parents unless he divorced me.'

Just then there was a sound of ululation outside. Jasmin rushed excitedly into the sitting-room and pulled me by the hand on to the balcony. Another truck was passing below, more sedately this time, with a load of laughing teenage girls, clapping and singing in a nest of quilts and pillows. Jasmin nudged me, indicating that this was for a wedding as well. 'Come inside!' Sameh hissed. 'Do you want to get us all shot?' Then, when I was safely seated once more: 'You know that first husband was a psychopath! He didn't even let her keep the dowry! It's supposed to be a wife's security in case her husband divorces. But he said she could only keep it if she went to live with his sister. And she refused – of course! – ' She threw up her hands. 'She would have been like a servant again! But she still loves him, even though he left her with nothing. Because he was kind to her once, she idolizes him for ever!'

Sameh had become more and more agitated as the day wore on. Now she was perched stiffly upright, ripping tiny bits of skin from around her nails. Amal, by contrast, was sitting calmly: legs crossed at her plump ankles, smiling gently as we ranted on her behalf.

'So where did you go after the divorce?' I asked.

'To my brother in Cairo. But his wife made so much trouble I had to leave. So I went to a cousin, then to my elder sister, but they were both too poor to support me and I couldn't work because my belly was getting so big. Eventually I got a bus back to Aswan and begged Hassan to take me back. But he wouldn't even let me into the house. He said it was impossible because his wife was pregnant too. Even when I sat on the steps and cried, telling him he'd turn me into a prostitute, he just closed the door in my face.' And left her sitting there, on her own doorstep: seventeen years old and eight months pregnant.

'I banged on the door, but he wouldn't open it. I was crying so much I was nearly sick. Then the old man who lived next door invited me in. He said: "I would hate my daughter to be treated this way". So I stayed with him, and my son Wahid was born there three weeks later.' She spoke with such affection of the old man who'd befriended her that it was a moment before I realised the import of what she was saying. She had moved in next door to her husband. She must have seen them every day; watched them playing cards together on the balcony.

'These interviews have been very paining for me,' said Sameh afterwards, in a subdued voice. 'I have never sat in a poor house before. In the clinic I just ask a medical history and give a prescription. But she can't even afford medication to control her diabetes. So all the little infections will become big from feeding on the sugar in her blood, and then she'll die a stupid death.'

Zaineb, the other interpreter, took over from Sameh the next day. 'Don't worry about these,' she said, wafting her cigarette

over her black leggings as she opened the door. 'I've got a nice long brown skirt to change into before we go.'

Without Sameh's twitches and tension, the atmosphere in Amal's apartment changed completely. She and Zaineb relaxed immediately into a gentle dialogue, and the three of us pored over faded pictures in a photograph album: Amal as a teenager in the late 1960s, with bare arms and a knee-length dress – soft and luminous, like an out-of-focus Jackie Kennedy. 'That was just after my divorce,' she said. 'There – can you see? The eyes are sad.'

'Do you have a photograph of the old man you lived with when you had the baby?' I asked. She sighed and shook her head. 'He's dead now,' she said. 'But he was like a father for four years. When my son, Wahid, was old enough to be left, he got me a job as a nurse-assistant for a doctor he knew. It wasn't much money, but it was better than being a servant.' She mimed scrubbing laundry and I winced, remembering her bleeding hands. 'Then I had to leave, because he was having affairs with his patients and I was afraid he'd make advances to me.

'So I went back to Cairo, to my brother's. I thought he'd let me stay if I got a job. But his wife refused to look after Wahid when I was working. So I had to leave him with other people. My sister had him for a year, then a neighbour for a few months, then I took him back to the old man in Aswan. It was the same when I had Jasmin – the worst thing about those years was being away from my children. I don't think they've ever really forgiven me.'

'What kind of work did you do?'

She smiled ruefully: 'Oh, lots of things: tailor's assistant, shopgirl, different factories. But it's difficult if they know you're divorced. One shopkeeper said I could only have the job if I'd have sex with him.' Her face hardened for a moment: 'I could tell you so many stories like that. It was because I wasn't a virgin – even though I was living with my brother, they assumed they could have me –'

'How old were you by then?'

She shrugged: 'Twenty, twenty-five, thirty – it made no dif-

ference. The only time I was safe was when I was married. It's impossible to be a woman on your own. That's why I married Gamel. Once, when I was working in a textile factory, the owner followed me into the laundry room and locked the door. When I struggled he was surprised! I stayed away for two days after that and he came and begged me to come back. He said he was "just testing my morality" –' Zaineb sniffed with disgust and I shook my head; then we all burst out laughing suddenly at the crude stupidity of the man.

'That's what decided me,' said Amal. 'I'd been refusing marriage proposals for eight years, so I just accepted the next one. Gamel worked at the factory and he seemed kind – and he was five years younger than me, so I thought he'd be simple and honest. We went to the Islamic minister with my brother and a few friends and out to the cinema afterwards, then I moved into his apartment. That was when I found out he was married – he even had children with her! She was away staying with her parents, so he just moved me in instead.'

'But that's exactly what happened to you!' I exclaimed.

She looked ashamed: 'I kept thinking about how she must feel, but by then it was too late. And four months later I was pregnant with Jasmin. He never planned for me to have a baby –' I began to suspect that he'd probably married her for sex: she would still have been in her twenties at that time, plump as a plum, with her son conveniently lodged elsewhere. 'He forced me to go for an abortion, but we couldn't find a doctor who'd do it. So he decided to take his wife back –' And she spread her arms as if to say 'What else could I expect?'

'So you went back to your brother?'

'For a while, yes. But I had to leave when the baby came, so I found a little two-room apartment and took the baby with me to work. I hated seeing her on that dirty floor, but what could I do? It was good in some ways, though, because it shamed Gamel. Everyone could see how he'd treated me. That's how I got him to give me some money for the baby – the other workers came to the police station with me and they made him sign a paper promising me six pounds a month.' She gave a little nod of satisfaction, then sighed: 'But then I had to send

the baby to my sister, because when she started crawling it was too dangerous with all that machinery – I hardly saw her until she was six years old.' As if on cue, Jasmin slopped into the room in her slippers and went to sit on the balcony. 'She's a good girl,' sighed her mother. 'But she feels she's been neglected. My sister didn't bother to send her to school and her father's never shown much interest in her.'

'How did you meet your third husband?' I asked, and was surprised to see tears on Amal's cheeks. 'I feel so ashamed,' she whispered, hanging her head. 'My relatives think I must love sex to have married all these men. But I just wanted a place to live and peace from being approached all the time.' She wiped her eyes: 'I lost the apartment, you see. The landlord had only let me have it because he wanted to have an affair with me, so when I refused he said he needed it for his son.' She spoke wearily but without bitterness, and I remembered what Sameh had said about the consequences of suppressed anger. 'So I went back to my brother again, but this time his wife threatened to divorce him if he let me stay.'

It was so unrelenting: the harassment, the homelessness; the brave battle for her precious reputation. The very thought of it exhausted me. I thought of the rich belly dancer with men at her beck and call: what a relief it must be to have no burden of morality to carry. I closed my notebook: it was enough for one day.

The noise outside had been increasing as we'd been talking: radios blaring, cars hooting, people shouting and laughing in the street below. We'd had to close the door to the balcony to hear ourselves speak. To change the subject, I began to ask about Eid. It turned out to be an Islamic version of a familiar Old Testament story. Ibrahim (Abraham in the biblical version) had two wives. Sarah, the first, was an Israelite. She proved infertile, so he took another wife, Hagar, an Arabic woman who bore him a son named Ishmael.

Soon after the birth, Ibrahim had a dream in which an angel commanded him to sacrifice his son to Allah. Satan tried to persuade him to ignore the dream, but Ibrahim resisted and cast seventy stones at Satan to send him away. Then, just as

he was lifting his knife to kill his son, the angel substituted a young sheep for the child: Ibrahim had proved his obedience, and the sacrifice was no longer necessary. That is why an animal is slaughtered at Eid, and why ritual stone-throwing is an integral part of the observance of the millions of Muslims who congregate at Mina, near Mecca in Saudi Arabia, every year.

The story didn't end there, however. Years later the infertile Sarah had a son of her own – Isaac – and insisted that her husband acknowledge the baby as his heir and drive Hagar and Ishmael out into the desert, where they wandered for many years.

'The Israelis believe it was Sarah's son, Isaac, who was to be sacrificed,' said Zaineb, laughing. 'And Muslims believe it was Hagar's!' I was more interested in the second part of the story: the discarded wife wandering in the wilderness. I thought of Amal and her children, discarded by one man after another, moving from back room to back room, searching for a place to call home.

'You know I identify with so much of what she says,' said Zaineb unexpectedly as we walked down the narrow stairs. 'I also got married because it was so difficult to live as a single woman – even for an intellectual working at the university! This was years before these crazy fundamentalists. I'd gone to meet my boyfriend late one night and the police arrested me as a prostitute because I was on my own. My boyfriend came to vouch for me, but because we weren't married, that only made it worse. I had to get a lawyer to get me out in the end. We got married the next day.'

Walking to the bank that evening to change a traveller's cheque, I heard what sounded like a riot coming from round the corner. I pushed my fringe under my white scarf and went to investigate. The noise was coming from the cinema: it must have been the first night of a new movie, because a crowd of at least five hundred people were pushing to get into the foyer. Some intrepid

young men had even shinned up the outside of the building and were strutting about on the flat roof. Below them was a huge poster of a man and woman kissing, their eyes closed in a paroxysm of bliss, their lips blanked out by the censor's white paint-brush.

I'm afraid I laughed aloud, a dangerous gesture for a lone woman. A hundred pairs of male eyes swivelled towards me, and four eight-year-old boys detached themselves from the crowd and zigzagged after me as I hurried along the pavement, jostling each other until they'd caught up. Then one grabbed my skirt and declared, in perfect English: 'I want to fuck-fuck with you!' Without thinking, I whirled round at them, hissing as loudly as I could. They scattered like gutter kittens, while the men who were watching smiled indulgently.

Later I wondered what man had taught those few words to that boy. It was like handing him a truncheon: 'This is how we keep women under control'. And it worked: the sniggers and curious looks, the shouted comments and whispered compliments – all ensured that I returned to my hotel room as soon as darkness fell, obedient as any good Muslim woman, while the men's city pulsed and throbbed into the small hours.

The next day was Islam's one-day weekend. The small café opposite Amal's apartment was crowded with men in their best jellabahs: sucking ruminatively on hookahs or playing backgammon with theatrical flourish. Young boys darted between the tables bearing trays of black coffee, or knelt at the men's feet with the inevitable shoeshine box. Outside, in the street itself, more boys careered past on new bicycles, shouting as they swerved through the parade of strolling families. I looked for the little girls and spotted one or two, pinioned in pretty layers, trotting demurely behind their parents.

Upstairs in the apartment Amal's two daughters were in their Sunday best: identical black leggings and T-shirts with 'disco a go-go' in orange cursive on the front. Their hair was freshly done: Jasmin's black curls pinned up above her long mournful face; Samira's tied in a mousy pony-tail at the nape

of her neck. They paced restlessly as caged lionesses around the apartment: from television to kitchen to balcony and back again, slopping their flipflops on the bare floor.

'They look so different from one another,' I remarked.

'Samira's father was quite fair,' Amal explained. 'She's lucky to have inherited his colouring.' Then, quietly: 'I'm glad that's all she did inherit – of all my husbands, he was the cruellest.' I raised my eyebrows, and she sat forward conspiratorially. 'My third husband was a very sexual man,' she said in a low voice. 'Even when he was beating me every day, he still wanted sex in the evening. He didn't care whether I responded or not.'

'Why did he beat you?'

She shrugged: 'Money – it was always about money. He thought I had money saved, so he beat me on my wedding night to make me say where I'd hidden it. When he found out there wasn't any, he beat me again. Then later he'd beat me when I asked for money to buy food – but he was a rich man!' Her chest heaved with rare indignation. 'He had two jobs, you see – policeman and minibus driver. He used to sign on at the police station, then go off in the minibus for the day. That's how I met him: I used to take his bus to the factory every day. Then one day he saw me walking along the street with a friend, so he told all the passengers to get off so he could give us a lift home! It was very romantic – ' She shook her head at her own folly. 'If someone is kind to me, I'll do anything for them,' she sighed. 'Anyway, I was living with my brother at the time, and my sister-in-law was threatening to divorce him unless I left. I knew it would be impossible to find a place of my own, so when Ali – that was his name – asked me to marry him, I agreed.' Her eyes filled with tears, and I noticed again that it was shame – for having married for security rather than love – that upset her: far more than the cruelty and hardship she'd experienced.

'He was a mean man,' she said, patting her eyes with a white handkerchief. 'He only gave me a pound a day for food – but the smallest chicken cost ninety piastres in those days, and you had to try ten butchers to find one that size! Once I found some money he'd hidden under the mattress and I put it on the

table – so he beat me and only gave me fifty piastres the next day. I had to go begging to my friends for bread and beans when he was spending hundreds of pounds on hashish and women!' I saw that, to Amal, her third husband's tightness with money was a far worse crime than the daily beatings and unwanted sex. Likewise, she had nothing but good to say of her first husband, despite the many ways in which he had betrayed her: because he was generous with money while they were married. In a society where women are forced into dependence on men, a husband's ability and willingness to provide for his wife was clearly his most important attribute.

'Where were your children when this was going on?'

'He promised I could have them with me, but it was impossible. I couldn't let them see how he was treating me, and I would never have been able to feed them on a pound a day. That's what made me so determined to keep the apartment. If he'd been kind to me, I'd have left after the divorce. But I knew it was my last chance to get somewhere to live. So I let him beat me and beat me, until Youssef and the others made him sign over the lease. Now I'll never have to get married again.'

She smiled the tired smile of someone who has come to the end of a long journey. 'I'm happy now,' she said. 'I know I worry about Jasmin and Samira, and I'm depressed about being ill all the time. But I'm so grateful to Allah for having given me this place.' Out of the wilderness, I thought, into a tiny claustrophobic haven.

It was a day for visiting, and local women took advantage of the opportunity to take a good look at me. Amal's business boomed as they bustled into the sitting-room in twos and threes and sorted through her wares, holding lurid flimsies up to the light and fingering their slippery folds. There were two types of garment: opaque long-sleeved pastel nightdresses for daytime, and seductive chiffon confections for the night.

When the customers had dispersed, Jasmin came and sat beside her mother, shaking out the pretty jumble of garments and folding them reverently. Amal laid an elaborate black lace

negligée lovingly across her vast lap: 'You have to buy lots of these things when you are first married,' she said nostalgically. 'And you must wear them all day so visitors think you have just stepped out of the bedroom.' She smiled at Jasmin, but the young woman scowled and slouched out of the room. Five minutes later she had resumed her moody pacing: balcony, television, kitchen; balcony, bedroom, television.

Just then Samira rushed in from where she'd been sitting on the balcony. 'It's Wahid!' she announced excitedly. 'In Mohammed's apartment over the street!' Peering out through the doors, I saw a puny young man with a wispy moustache sitting smoking with an older man who was fiddling with a large ghetto-blaster.

At the mention of her son's name, Amal's face came alive: 'Wahid? Does he have the baby with him?' She made to get to her feet, then slumped back in her chair again: 'He won't come here,' she said in a dull voice. It turned out that Wahid was visiting his uncle – Amal's brother – who lived in a second-floor apartment just across the street. Until that moment I hadn't realised he lived so near, though in retrospect I should have known that her reputation would not have allowed her to live alone outside the jurisdiction of a male relative.

I was curious: 'You mean he'll visit his uncle but stay away from his mother?'

'It's that wife of his,' said Amal sadly. 'She's afraid he'll give me money if he comes here, so he avoids even walking down this street. My brother's wife's the same – she thinks I'm always begging my brother for money.' It was inevitable, I supposed, this lack of solidarity between women. When men are the only source of income, women have to compete for each crumb of the patriarchs' cake. But it meant added isolation for the women excluded from the feast.

'I never even speak to my brother,' Amal went on. 'So she can't ever accuse me of begging. I've vowed never to ask either of them for anything again, even though I paid for the dowry for Wahid's wedding.'

'I thought he was supposed to pay – '

'He didn't have any money saved. And I thought if I

bought the furniture, and gave them this room to live in – ' she trailed off. 'I had it decorated specially,' she said, gesturing at the beige sprigged wallpaper; the flowers picked out in white on the brown pelmet above the window. 'I thought if he moved in here, men would stop bothering me. And people would know Jasmin and Samira came from a decent family.' She sighed, and her whole body heaved with weariness.

'That's them on their wedding day,' she said, pointing to a framed photograph on the wall: of a weak-mouthed young man and a round-faced girl wreathed in white tulle. 'She's standing on a box,' she added, and smiled at my startled expression. 'That's why I chose her for him. I knew no one else would want a short girl with no breasts, so I thought she'd be grateful. But she was always complaining about being bored. And she never did any housework, even though I was working at the factory every day. In the end we had a huge fight and she went back to her parents.'

'And Wahid went with her?'

Amal shrugged resignedly: 'I think her parents promised him some money, I don't know. So he took all the furniture and moved out.'

She hauled herself heavily to her feet, unable to resist a peek over the balcony. 'The worst thing is not being able to hold my grandson,' she said.

'There's one thing I don't understand,' I said as we sipped coffee later that afternoon. 'Why do men bother you, if they know your brother lives just across the street?'

Zaineb and Amal exchanged looks. 'They assume you are willing,' said Amal. 'And if you are willing, they know you will keep it secret. After Wahid moved out, the owner of this building used to come and knock on my door in the middle of the night. He claimed he'd come for the rent, but I knew why he was really there. Then when I kept refusing to let him in, he began spreading rumours.

'A neighbour told me he was telling people that my brother was really my lover! I was so angry – next time I saw

him in the street I ran downstairs, shouting at him to stop telling lies about me – ' She grinned suddenly. 'Then I threw my shoes at him, I don't know why!' I laughed, imagining the scene: the irate woman in her pink nightdress, hurling flipflops at a startled moustachioed man. 'Then some men in the café started beating him up. They said it was their duty to defend my reputation. After that he was so ashamed, he sold the building and moved to another part of the city.' She crossed her plump arms, a satisfied smile on her face.

Soon afterwards, as we were saying goodbye, a new sound rose above the tumult in the street below: insistent drumming and the *tish* of cymbals; men's chanting interspersed with loud cheers. Hiding behind Jasmin on the balcony, I stared down at what appeared to be a green birthday cake, complete with lighted candles – on a chair in the middle of the road. The men had linked arms at shoulder height and were circling like Greek dancers. Every so often someone would toss money into a box – hence the cheering.

'It's henna,' said Amal, coming to lean on the balcony beside me. 'For painting the bride's hands and feet. The girl who lives in the next building is getting married tomorrow.'

'Are you going to the wedding?'

Amal shook her head: 'We haven't been invited.' I was about to ask why when Jasmin turned abruptly and rushed back into the apartment.

It was the day before Eid, and Cairo was swarming with animals: trotting busily down the shopping streets, crammed bleating in trucks, peering stupidly out of the rear windows of saloon cars. Men were out in force with their hoses, pissing arcs of bright water over their precious cars. The reek of meat was now tangible even in the middle of the city, and the promenaders were out in force, sauntering *en famille* past the shuttered shops.

'They'll be fasting today,' said Zaineb. 'And there'll be prayers on the radio all day. We'll have to be careful – ' It was the first time she'd reminded me of the dangers: without

Sameh's constant stream of warnings, I'd almost forgotten about the fundamentalist presence in Amal's neighbourhood.

Amal opened the door, looking pale and exhausted. 'It's my knee,' she gasped, limping into the sitting-room. 'I've been polishing the floor for tomorrow – ' She pulled up her night-dress to reveal a huge puff of pale flesh above a perfectly hair-less calf. 'It swells up whenever I kneel for too long – or stand for any length of time. That's why I had to stop doing factory work.' She kneaded it with plump fingers. 'I fell down getting off a bus. The doctor said it would have healed if I'd had it treated immediately, but there was a rush on at work and the owner wouldn't let me take time off. I was his best worker, you see – ' she smiled proudly. 'I looked after twenty weaving machines: mending broken threads and fitting new spools. No one else could manage more than eight.'

'Is that how you paid for Wahid's dowry?'

She nodded: 'I worked from seven in the morning till ten at night. In the evenings I was so tired, I had to sit on the floor to cook. Anyway, after I hurt my knee I kept working for three days until it went blue and swelled up to the size of a water-melon. Eventually I couldn't stand the pain any more, so I went to hospital and it was put in a plaster. When I went back to work three weeks later, they'd given my job to someone else. It was the first time I'd been away in ten years!'

She subsided back in the chair, patting her face with a handkerchief. 'The doctor says my weight makes it worse, but I can't diet – ' she waved a tired hand at the plate of beans Jasmin was putting on the table. Food was the high point of their uneventful existence: planning it, preparing it, eating it. Food – and clothes that would never be seen outside the walls of the tiny apartment.

'Is that why you started selling clothes?' I asked, and she nodded. 'I began selling a few things at home. But the profit was so small, I decided to go to the Export Processing Zone in Port Said to buy the things. There was a minibus going from this street, and some of my neighbours clubbed together and raised five hundred pounds to lend me.' She leaned forward: 'I wanted to start a proper business, you see. So we went to Port

Said and I bought the clothes – a huge parcel of things, really cheap. Then, when I was waiting at Customs, a man offered to take my parcel through a back office so I wouldn't have to pay duty. I refused, but then I found I didn't have enough money to pay the Customs man, so I left the parcel with a friend while I went to borrow a few more pounds from someone else on the bus. And while I was gone the man told my friend that he was going to take the things back to Cairo for me. She'd seen me talking to him, so she thought it was all right – '

I put my head in my hands. She was such a soft, sweet person: was that what made these men prey on her? Or was it simply that she was a single woman, a sitting duck? 'I was so shocked I couldn't even cry,' said Amal quietly. 'I kept thinking of the people who'd lent me the money. I think that's when this diabetes started – '

We were interrupted by a knock on the front door. Jasmin answered it, and a group of four women trooped in and stood around while she organised them on to an array of folding chairs in the hall and switched on the television. 'They've come for beauty treatment,' explained Amal in a tired voice. 'Everyone wants to look their best for tomorrow.'

'Does she earn money doing it?' I asked.

'Yes, a bit – I don't know how we'd manage otherwise. But she got much more when she was working at the hairdresser's downstairs. He tries to stop people coming up here to her, so she only gets customers on holidays.' One of the women had taken off her scarf, and Jasmin had draped a towel round her shoulders and was parting her hair to dab black dye on the roots.

'Why did she stop working at the hairdresser's?'

'That was her father's doing. I wanted to hire a private tutor to teach her to read, and I knew he had his own factory now. So I asked him to increase the money he was paying to support her. He said he'd give her a job instead, but when she went there she said it wasn't a decent place – all the girls were flirting with him. So I told him I wouldn't allow her to work there and he was so insulted, he forbade her to work at the hairdresser's. Now he says he wants her to live with him – and he'll

tell the court I'm an unfit mother for allowing her to work with men. It's revenge: he doesn't really want her – it's just because I insulted him. So now I'm taking him to court, too, for the extra money. But I daren't let her work outside the house until it's sorted out.'

She shifted her bad leg and groaned. 'It all happened just after I hurt my knee,' she said. 'It was a bad month.' I put my hand on her good thigh and squeezed. She smiled and laid her head briefly on my shoulder.

Later, drawn by gusts of laughter, I went to join the women in the hallway. An old Hollywood movie was flickering unwatched on the black-and-white television, with booming Arabic dubbed over. The dyeing was finished and the woman was sitting with her head swathed in tinfoil, while Jasmin worked on another woman's face. With a length of cotton clamped between her teeth and stretched between her two hands, she seemed to be smoothing the skin on the woman's cheeks. But when I looked closer I could see that she was using the natural twist on the cotton to pluck tiny hairs from the skin, whipping the taut thread over cheek, forehead and upper lip until the skin was completely depilated.

Soon I had been pushed into a chair and Jasmin was smiling mischievously down at me. 'Here – ' the women were giggling, pointing at their upper lips, indicating that this was where I needed the treatment. Someone handed me a mirror and I peered into it, trying to see myself through their eyes. Sure enough, in a certain light you could see a slight down of pale hair. 'You see?' they crowed triumphantly, then stood aside while Jasmin bore down on me.

It was excruciating, a thousand pinpricks like the tingle of electric shocks. 'And what about your cheeks?' Zaineb laughed as I rubbed my poor red mouth. 'To attract an Egyptian man, you should have your whole face done. And your arms, and legs, and pubic hair – '

'What, allow someone to do that between my legs?' I shuddered at the thought.

'No, we use sugar for that. You melt it with lemon juice into a sort of pad, and the hair sticks to it.'

'I don't even shave my legs,' I confessed, pulling up my skirt. The women backed away like vampires from a crucifix, and one volunteered to fetch the sugar there and then. 'They want to know if you're married,' said Zaineb, grinning. 'They can't believe a man would want you. Here we think that body hair is masculine and unnatural for a woman.' She stretched out her arm. 'It's time I was done again,' she said, as I squinted at a microscopic spattering of fine dark hairs. Yet Semitic women are the most hirsute of all races. Was this obsession with depilation a response to that hairiness – or just another way of filling those empty hours at home? Or was it because Egyptian men found any hint of masculinity in a woman too threatening?

'That's why women are circumcised, too,' remarked Zaineb later, when Jasmin's customers had gone home. 'People think the clitoris is something manly.' She translated what she was saying and Amal shuddered: 'It's so ugly! Your husband would find you repulsive if you hadn't been cut.'

'How old were you when it was done?' I asked. 'About nine, I think – before I started my periods. My mother knew I was terrified, so she said we were going shopping. She took me into this house and there were four women waiting to hold me down – I felt so betrayed. There weren't any painkillers in those days – they just took the razor and *cut* – ' she made a swift to-and-fro sawing movement. I winced, wondering to what extent this betrayal undermined the solidarity between Egyptian women.

'Poor Jasmin – the woman who cut her didn't use enough painkiller. I'll never forget her screams –' she shook her head as if to rid her ears of the sound.

'Does she blame you?' I asked, remembering the anger I'd surprised so often on the older girl's face.

Amal heaved herself forwards, grunting with pain. 'She knows I've done my best for her,' she confided quietly. 'But she's had so many disappointments lately – this fight with her father; being stuck up here all the time. And last month a boy asked if he could marry her. I've never seen her so excited! But when I

started asking about him, I discovered he'd been lying: he said he earned two hundred a month, but he didn't even have a job!' She spread her arms helplessly. 'I couldn't let her go to a man like that.'

'But she was upset.' It was a statement rather than a question. I'd seen Jasmin gazing longingly over the balcony at the wedding preparations below. 'She thinks she's ugly,' explained Amal. 'Because she's dark-skinned and flat-chested. She doesn't think anyone else will ever want her.'

My heart went out to this lovely horse of a girl, with her big feet and thick ankles, preparing other brides for other weddings. Amal put her hand on my arm. 'The henna, last night,' she said. 'It was for the girl he decided to marry instead.'

She slapped her swollen knee suddenly, viciously. 'I don't care about this pain,' she said. 'I just pray Allah will keep me alive long enough to see my daughters happily married.' I thought of Amal's own mother: dead at the age of thirty-nine, weeks after the marriage of her last daughter. And I remembered what Sameh had said: 'All the little infections will become big from feeding on the sugar in her blood, and then she'll die a stupid death.'

The girls had disappeared into their bedroom while we were talking, and emerged in another two identical outfits: black calf-length skirts this time, with black-and-white spotted jackets.

'I brought them months ago,' said Amal. 'But I've been keeping them hidden until now.' The girls blushed as we admired them, looking at the floor and swaying their shoulders shyly. I noticed that their feet were bare. It didn't matter, of course: they wouldn't need shoes for the next few days. They wouldn't be leaving the apartment until the Eid holiday was over.

Maria

(TRINDADE, BRAZIL)

*One in three Latin American women breaks up with
her husband before her children have left home.
Many are divorced or widowed, but an increasing
percentage are women who never married the fathers
of their children.*

*These unstable 'consensual' relationships are com-
ing to replace formal marriages in much of the
region. Brazil is no exception. One-parent families
quadrupled between 1960 and 1987 – from 5 to 20
per cent. Such families are twice as likely to be living
below the poverty line as two-parent families.*

*With her irrepressible grin and purple hotpants,
Maria works as a prostitute in the Bar dos Vaqueiros
– the Cowboy Saloon – in a dusty frontier town deep
in the drought-parched north-east. People are twice
as poor in the north-east; babies twice as likely to
die. Only four of Maria's eight children are still alive,
and since the drought hit, few cowboys are willing to
pay for her services.*

I christened him the honey man. Tall, unkempt, his trousers
belted with string, he was trying to sell honey to the owner
of the café. The honey was in two smeary Coke bottles sealed
with wads of rag; they glowed amber as he extracted them from
the pockets of his dusty black overcoat. The café owner shook
his head with great courtesy and the honey man walked off
down the crowded street, tongues flapping from his lace-less
shoes.

Trindade was full of such people that morning: the hat
woman wringing her hands in the middle of the road; the pig
man with his barrow of slops – refugees from the parched farms

that surrounded the little town. It was cattle market day, and for a few brief hours the only cash there was in this drought-starved region would circulate like pigeons startled by gunshot, then settle again in new pockets.

The influx had begun before dawn, and I had lain half awake listening to the clatter of hooves, the roar and rattle of trucks, as the cattle were driven to the dark marketplace. The cavalcade continued as I sat down to breakfast in the open-fronted café: sun-seamed cowboys on lean horses behind herds of bony heifers; dented pick-ups with five farmers in the front seat, each with a dried-up milk-cow to sell. And the empty three-tier pantechnicons of the big dealers, thundering imperiously past the motley procession.

The street children materialised as soon as my food arrived: the small ice-cream boy with his big front teeth; the tall shoeshine boy with his scowl; and two beautiful girls with grubby T-shirts, squatting staring at me from the pavement. The waitress picked up her broom and swept them good-humouredly into the gutter. They were back minutes later. Not begging: just watching while I ate.

We'd arrived late the previous night, after a twelve-hour bus journey from Recife, the coastal capital of north-east Brazil. It had been my interpreter Tarciana's idea to come here. 'People are always writing about whores in Recife,' she'd said with a sneer as I'd outlined my original plans. 'The pimps, the pederasts, the sex tourists – these are clichés now. But it starts in the country-side. People can't survive, so they move to a little slum in a little town like Trindade. Then they graduate to a bigger slum in Petrolina, then an even bigger one in Recife. Then they are ready for Shangri-la – São Paulo and the biggest slums in the world!' And she'd thrown back her head and laughed her big open laugh.

I'd hesitated about abandoning Recife. After all, I'd chosen it precisely because I wanted to challenge those clichés. I wanted to write about prostitutes as single mothers rather than sex objects. True, a minority of prostitutes had no one to care for but themselves. But everyone I'd spoken to who'd worked in Brazil's slums confirmed that most prostitutes had families to support.

'And Trindade is in the middle of the Sertoes,' Tarciana had gone on. 'Sertoes people are prouder and wilder and poorer than anywhere else in the country. They have spent generations in the bush, herding cattle and growing corn and beans.' 'But will we find prostitutes there?' I'd asked doubtfully, and she'd laughed again. 'If we go to Trindade, I'll take you to the *Bar dos Vaqueiros* – we can talk to the whores who go with the cowboys after the cattle market.'

The Cowboy Saloon? How could I resist?

'Shall I give her my cake?' I asked later, nodding towards the younger of the two girls, who was still staring up at me from the pavement. 'Sure,' said Tarciana casually, leaning back and stretching thick thighs encased in psychedelic lycra. I beckoned the child over and handed her the slab of sweet cake. But instead of eating it, she broke it in two and shouted down the street to the older girl, who came darting back through the crowds. They went into a huddle to share out their booty, then turned back towards me wreathed in smiles.

After breakfast we set off for the market. There was no need to ask for directions. Everything that walked was going the same way: down the potholed main road, past the supermarket and the petrol station, then right at the crossroads and straight on past wide sandy avenues lined by terraces of one-roomed stucco houses. I spotted a sow trotting solemnly round the roundabout, observing the Highway Code with two clockwork piglets.

We crossed a piece of waste ground where men were haggling over horses, spurring and reining them in until they reared, snorting through flared nostrils, then galloped through a wilderness of thornbrush and plastic bags. Beyond them were the sad men selling bicycles: a thicket of chipped paint and rusted spokes. 'There's no work here, so I went back to the farm to see if it had rained,' said one. 'I knew it was hopeless, but I missed my wife and kids so much. That's why I'm selling my things – to get the bus fare to go to Petrolina – '

'I call them the widows of drought,' murmured Tarciana.

'Thousands of women left on dead land while the husbands go off looking for work. I can't imagine what their lives are like – at least here the water's delivered once a week.'

We made our way to the cattle pens: an acre of dust churned up by a thousand milling animals. Men with wads of cash and huge stetsons moved among them, while anxious farmers prodded their drought-dulled charges with spikes, goading them into spurious shows of vitality. Every so often a bull would wheel round in fury, surging through the dense pack of bodies, and the men would scatter, laughing uproariously, while cows mounted one another in alarm. Tough stuff; men's stuff: lorries revving and reversing in the dust; animals hauled kicking and bellowing up the ramps. I saw the honey man on the outskirts proffering two smeary bottles.

'There's the *Bar dos Vaqueiros*,' said Tarciana, pointing. 'We should talk to the owner before it gets too busy.' We walked over to a bare open-fronted room with a dented stainless steel bar along the back wall. Frantic accordion music was pouring from the speakers, and three couples were jigging energetically around the dance floor, clasped groin-to-groin, doing something between a foxtrot and a fast polka. Men were ranged along the walls, leaning with glasses in their hands or sitting laconically on metal chairs. Others clustered round the bar, where a bullet-bodied woman was flicking lids off beer bottles.

We caused quite a sensation as we walked to the bar: Tarciana in her baggy army surplus jacket, me in my ankle-length Indian skirt. Checking out the other women, I could see why. Glossy thighs in tight hotpants were the thing, topped with something skimpy in stretch cotton. So we weren't prostitutes, and we certainly weren't cowboys: the bullet-bodied woman slapped the bottle-opener on to the counter and came out from behind the bar to investigate.

Her name was Zenaida, and she was the owner of the bar. 'I'm like a mother to the girls,' she said when we were settled in a back room. 'They get the men to buy beer and I lend them money if they don't get someone to go with. But business is terrible

since this drought started. The men come, but they don't spend anything.' She smoothed her coiffured curls with a much-beringed hand, and tugged her T-shirt down over corrugations of flesh. 'You can stay as long as you like,' she said when Tarciana had explained about the book. 'But this is the only day the bar's open. There's no money in Trindade any more, so there's no point opening the rest of the week.'

We took up residence behind the bar, perched on high rickety stools in the corner. This gave us a front-row view of the proceedings, while setting us somewhat apart from the working women. It also meant we were prominently displayed against a backdrop of beer bottles and holy pictures. In a complete reversal of my situation in Egypt, I'd have been more inconspicuous if I'd worn less.

The approaches began almost immediately, and Tarciana had to spend most of her time explaining to insistent bleary-eyed farmers that we didn't want a drink and we hadn't come to dance: we were researching a book and had come to talk to the women. But the word eventually got around and the women began to drift over, one by one, to our corner.

Antonia came first. In her rolled-up T-shirt and frayed white shorts, she was one of the wildest with the men, pressing chubby thighs against theirs and drinking from their glasses. 'We hitchhiked from Ouricouri this morning,' she said, nodding towards a frizzy-haired woman in red shorts. 'We go from town to town, depending on where the men are. It's two months since we were here, but it's even worse than last time – I don't think anyone's been with a man yet. And you have to try harder because Zenaida likes the men to go with her girls. It's better in Ouricouri because the plaster factories are still working and the lorry-drivers have regular money – ' Did she have any children? 'Just a boy – my daughter died when she was two. He stays with a neighbour while I'm travelling.'

I asked which were 'Zenaida's girls' and she beckoned to Yvonette, a pretty, angular woman with short curls and hoop earrings. Her sharp little face was etched by three knife scars from ear to chin. 'A jealous woman,' she said, flicking her cheek with quick fingers. 'If you go to a new bar and the men like you,

sometimes the older women go crazy.' And children? 'Two boys, plus a miscarriage and an abortion,' she said in the same matter-of-fact tone Antonia had used to describe the death of her daughter. 'They stay with my mother, when I'm working, and I look after the little ones when she's busy.'

Wriggling her bum to the music, a younger girl sashayed over in a baggy T-shirt with 'Rebel' scrawled across her tiny breasts. She was sixteen, she told us, and started selling sex after she lost her virginity – they all referred to this, poignantly, as 'getting lost' – with an older man two years ago. This seemed a frequent route into prostitution: 'getting lost' in their early teens, then being thrown out by angry parents or simply gaining a reputation for being seduceable and drifting with the tide.

'My father threw me out when I got pregnant,' said a jaded-looking woman in a white ra-ra. 'But when my mother died, he took me back to look after the other children.' Now he was unemployed, and she was the only one bringing money into the house. 'But I always insist on a condom,' she said, with a scornful glance at the others. 'Though it means less money. Fifty thousand's the usual rate, but with a condom it's only twenty-five. I could get more money begging.'

I turned to Tarciana: 'Fifty thousand – how much is that?' She shook her head in disbelief: 'One beer, or two Cokes. Or half a drum of stinking salty water from a truck.' Yet this last woman had been the only obviously unhappy prostitute we'd met so far. Despite the slim pickings, the others radiated ebullient energy and a kind of careless *bonhomie* that seemed to be only partly inspired by the alcohol.

The last woman we spoke to – Maria – typified this spirit. Flaunting vast buttocks and quivering thighs, she'd been on the dance floor most of the time we'd been there: being tugged laughing from man to man – or simply dancing alone, shimmying her shoulders suggestively with her eyes closed and arms stretched out like a sleepwalker.

'Raw sausage has been my life since I split up with my first husband,' she said cheerfully. 'But I'll have to retire soon because I'm getting old. That's why I wear gold combs in my hair – to distract the men from the wrinkles.'

'How old are you?' I asked, guessing maybe thirty-five, thirty-six.

'Twenty-six next birthday,' she said, screwing her face into a grotesque hag caricature. 'But I was an early starter – I "got lost" when I was fourteen and had my first child the next year.'

She'd come behind the bar to talk to us, and began slopping generous measures of *cachaça* into thick glasses for the punters. 'I've had eight children, but four died,' she said, levering beer bottles open. 'That's nothing,' she added, laughing at the expression on my face. 'My mother had twenty-four and lost fourteen.'

Things began to quieten down at four, and by five only tyre tracks marked the place where the cattle had changed hands; and these soon disappeared too, blurring then dispersing in the wind, and tumbling with empty cigarette cartons out across the flat treeless landscape.

We wandered back slowly through the side streets, past terraces of flat-roofed houses: each no bigger than a garage, each with an oil drum outside, gaping empty for the water lorries. Smudge-faced toddlers pottered happily along pavements that doubled as front rooms, with men lounging in baseball hats, smoking, and women squatting to chop onions or strain couscous into the gutter.

'This is where the Sertoes miracle happens,' said Tarciana. 'No one here has any money, but almost everyone will eat tonight. Look – ' pointing at an old woman carrying a battered pot. 'She'll be taking some terrible stew to her daughter's house. Then maybe she'll take a handful of charcoal back home. Everything gets shared out – even the kids. If someone can't look after their kid, they'll give it to another household to bring up. There's no such thing as a childless woman in this region: if you want a baby you can always find somebody to give one to you.'

She grinned suddenly: 'People think that's why we're talking to whores. Apparently a French couple were here a few

months ago and they took a newborn kid home with them.' I swallowed: it had crossed my mind.

We spent the next few days scouring the town for signs of prostitution, wandering along the sandy roads with an escort of street kids, hanging out in deserted bars that were little more than front rooms.

'Talk to the fat lady,' advised one of the town's two taxi-drivers. 'It's the last house past the football stadium. That road used to be full of whores.' He drove us out into a sand-coloured countryside, where there was a long terrace of houses, marooned among cacti like a broken-down train in a remote siding.

The fat lady was no longer fat: her swathes of skin held only the memory of the flesh they once contained. 'There used to be bars all the way from the centre of town,' she said sourly, sucking on a brown cigarette. 'But they've all closed down. Only poor men come here now – married men cheating on their wives. And all they bring is a loaf of bread for the kids, maybe a few chicken wings if they're lucky.'

We followed a rangy young woman next door, and sat on a pink sofa that smelled of urine. It was the only furniture in the two-roomed house. 'I sold the rest to buy food,' she explained, hoiking a breast from her blouse for a naked toddler. Several other women crowded in after us and knelt beside her on the floor, suckling or wiping the noses of their various offspring. One scabby cherub sat in a spreading puddle: her teenage mother mopped it resignedly with a green cardigan. 'We can't wash anything,' she said, chucking the wet cardigan into a corner. 'There's a man who buys a drum of drinking water for us sometimes, but if you want to wash you have to walk two kilometres to the reservoir. And the water's so salty everything's stiff when you've finished.'

I asked about their husbands, their children. Apart from one widow, the rest had all 'got lost' at an early age, and had had a series of brief or violent relationships with men which had left them with an increasing number of children. Unlike 'Zenaida's girls', none referred to herself as a prostitute: their

hand-to-mouth lives seemed to lack even that degree of coherence. Without money to buy water to wash, they were ashamed to walk the streets, let alone display their bodies in a bar. Instead they occupied what seemed to me a more degrading niche: not as low-status whores, with some bargaining power, but as no-status mistresses whom men wouldn't even pay to have sex with.

The next morning found us walking again towards the *Bar dos Vaqueiros*. The open front was barred by a metal grille, but I recognised Maria coming out of a door round the side.

'I've been doing Zenaida's washing,' she explained, lighting a skinny roll-up. 'She pays me to clean the bar too, but that's only one day a week now – ' Tugging a frayed crotch-high denim skirt down over her big backside, she led us to her house, in a row of one-room houses a hundred yards from the saloon.

'Is this where you bring the men?' I asked as she unlocked the rough wooden door. 'I wouldn't insult my neighbours,' she said, frowning disapproval. 'Anyway, your home is your own place – you only invite your lovers and friends.' She gave an ironic bow. 'Welcome to Maria's Palace!' she cried.

It was tiny – scarcely more than ten by ten – but charming. A single bed heaped with parrot-patterned cushions took up one wall. On the concrete floor, in lieu of a rug, was a length of scuffed red velvet. A rickety shelf unit delineated the 'kitchen' corner containing a brazier fashioned from an empty petrol tin, plus a bag of charcoal. The rest of the space was taken up by a folding table and two metal chairs, a pottery water jar covered with a cloth, and a saucepan rack laden with shiny pots like a silver tree. The walls were bedecked with paraphernalia: a cracked mirror and a muslin bow; framed pictures of mythological saints; images of Elvis and Bowie (as yet uncanonised). Like a magpie, she'd decorated her nest with pretty gewgaws: a row of empty shampoo bottles on a shelf; plastic flowers in a jam jar; plaster cake decorations nailed above the bed.

'Who lives here with you?' I called as she nipped next door to borrow a spoonful of live charcoal to start a fire.

'Ruberlanio and Wesley, my two sons – and Zilda, my friend,' she said, arranging the coals and blowing them into a flame.

'Where are they?' I asked, wondering how they all managed to sleep on the little bed.

'The boys spend the day with my mother because she has children the same age. And Zilda – ' she paused, and her face darkened. 'We're not getting on very well at the moment.'

'What about your other children?' In the bar she'd said that four of her eight children were still alive.

'I gave them away,' she said. 'Carlos, the eldest, is with his father's mother. She was on her own and she wanted a boy to help her – so he begs with her by the bus station. He used to come to get money from me after the cattle market, but I haven't seen him lately, so I expect they've gone to Petrolina – '

'Don't you mind not having him with you?'

She smiled sadly, tipping coffee and sugar into a pan of water: 'In the beginning, yes. But that was years ago – he's nearly thirteen now. Anyway, I hated his father by then – ' I raised my eyebrows in query. 'He went off with another woman,' she explained, then grinned suddenly: 'I'm so untidy – I found two husbands, then I lost them both!'

'And the other child?'

'Rubenfilio – ' now she was sad again. 'I loved him best of all my children, because he looked like my second husband. But he'd promised his mother she could have him.'

'What happened to your second husband?' I asked.

'He tried to stop a fight in a bar and someone shot him by mistake.' The coffee was ready, and she poured it into two polished tin cups. 'The same thing happened to my father,' she went on. 'Except it was a knife instead of a gun. That's why my mother started in the bar: it was the easiest way to get money.' So her mother was a prostitute too. I looked at Tarciana and she grinned: we'd found the woman we were looking for.

'Did you know what kind of work she was doing?' I asked.

'Oh yes – ' Maria seemed surprised at the question. 'A neighbour looked after me when she was working at the bar,

and I used to go there to fetch the money to pay her. I remember being so proud seeing her there surrounded by men. She was always so pretty and sweet-smelling – not like the other kids' mothers in their dirty old clothes. And I was never hungry like the other kids without fathers.'

'Were you her only child at that point?' I asked, and she shook her head, laughing. 'My mother started even earlier than me! She got married at eleven and had her first baby at twelve. I'm the oldest one still alive, but three died before I was born. Then after me she had three more before my father was killed. I think she must have been nineteen then – ' Her forehead wrinkled as she tried to calculate: 'Yes, because she was sixteen when I was born and she had one a year – ' I added it up myself: seven children by the age of twenty. 'My youngest sister died just after my father did, so there was just me and my two brothers when she started going to the bar.'

Just then a grim-faced woman appeared in the doorway, a leather belt slung casually over her shoulder. She stared curiously at us, then helped herself to the dregs of the coffee. 'We're in luck,' said Tarciana. 'This is the mother. She's come looking for one of Maria's kids – she sent him on an errand and he hasn't come back yet. That's what the strap's for,' she added. 'This is one tough lady.'

The older woman took a roll-up from behind her ear and squatted to light it from the fire. The sun glinted on her gold earrings: at least twenty studs massed along each pinna, precious scraps of past glory. Now her body was like an empty sack: soft and sunken under her pink sundress, breasts and belly hanging tiredly like burst balloons. I had to remind myself that she was only forty-two years old. 'Of all my children, Maria gave me the least trouble as a baby,' she told us, leaning against the wall after we'd exchanged greetings. 'But when she started growing up, she was worse than all the rest put together. They expelled her from school for fighting, then she "got lost" with her boyfriend when I was out shopping!'

'That was my first husband, Luiz,' Maria explained. 'He pestered me for three days non-stop. I was fourteen and really shy because I had to stay at home looking after the kids all the

time. So I was flattered that he wanted me so much. But Mother found out and sent me packing – ' She grinned affectionately at her fierce parent. 'That was because you didn't tell me!' objected the older woman hotly. 'You didn't show me proper respect.'

'Did you get married?'

Maria shook her head: 'I say "husband" because we lived together and had children. But we never got married – after I "got lost" there wasn't any point.' She reached up and unhooked some strips of dried fat from a washing-line over the brazier. The flies feeding there buzzed around her head as she handed it to her mother. Tarciana shuddered surreptitiously: 'They're practically eating garbage,' she said. 'It's all part of the miracle of the Sertoes.'

I wanted to meet Maria's children, so we followed her mother down the wide street and round the corner to her house. Naked but for the pink dummy round his neck, three-year-old Wesley was digging in the dust with assorted children of a similar age. He came scampering over when he spied Maria, and she ruffled his curls absent-mindedly. The delinquent Ruberlanio was still nowhere to be found, so Maria's mother looped the belt ostentatiously over the open door. I eyed it suspiciously. 'There are so many, it's the only way she can control them,' said Maria with a grin.

'I've never taken those pills,' said her mother proudly, rolling a tiny screw of tobacco in a torn piece of brown paper. 'So I don't have that sin on my conscience. God knows I'll accept however many children He sends me.'

'But He takes so many away – ' I objected, looking at her poor sagging belly, thinking of the fourteen she'd lost. 'How can you bear it?'

She sat down on a stool and tugged a small tousle-haired girl on to her lap. 'In the beginning it was like a big wound in my heart,' she said, searching the child's scalp automatically for lice. 'Then I started to get used to it. Most of them were only a few weeks old anyway, so I didn't have them for long. But when this one's twin died' – putting a wrinkled hand on the child's bare shoulder – 'I was like a crazy woman, screaming

198

and trembling for weeks.' She paused and looked up, pain in her eyes. 'I was looking forward to raising the two of them together, you see –

'Here's my husband Mañuel,' she said suddenly, nodding towards a bandy-legged man hurrying down the middle of the street. 'He's got another wife and family on a farm out there' – waving vaguely towards the colourless horizon – 'but he hasn't been home since the drought started.'

'Does she know about you?'

'Yes – she was furious when she found out. But that was fifteen years ago. Now I see her every month when she comes to collect her share of his pension, and I give her clothes for her grandchildren when mine grow out of them – '

The man arrived, slightly out of breath. He nodded to us before rounding on his wife. 'Where have you been?' he demanded angrily.

Maria giggled. 'He's so jealous!' she whispered. 'He sends the children to follow her and make sure she's not talking to other men. She retired ten years ago, but he still doesn't trust her.'

The door was locked when we arrived at Maria's house the next morning. 'She went out drinking late last night with Yvonette,' said her next-door neighbour. 'They won't wake up 'til lunch-time.'

So where were the children? With their grandmother, I assumed – unless the mysterious Zilda had returned to look after them. I began to see that these additional sources of child-care freed Maria to go out whenever she chose: it was her earnings, after all, that helped to support the whole edifice. While she was young and attractive, her job was to earn money, not to wipe bottoms. She had done her share of childcare as a girl – helping to rear her own siblings while her mother worked. And she would doubtless do time again with her own grandchildren – as her mother was now doing – so that her daughters-in-law would be free to earn an income.

*

'Cholera, malnutrition, violence against children – these are the things I'm concerned about.' A passionate young denim-clad woman banged blue folders on to her desk as she spoke. We were in the local health office, trying to find some statistics on infant deaths.

'So far we have only eight cholera cases in Trindade, but this is just the beginning. It has *exploded* in Ararapina and Ouricouri. It's because of the drought – poor people can't wash, and they can't afford to buy clean water to drink. And the malnutrition – ' she threw up her hands in despair. 'We see children of six who look like two-year-olds. In the countryside they are feeding them on cacti!'

'What about AIDS?'

'Only one case, but without proper tests it's impossible to know. And there's a tradition of anal sex here, because the girls want to preserve their virginity – I hate to think how many are infected. Sex starts very early, you see, because girls are trying to get a husband. There are practically no jobs for women, so there's enormous competition for men. Lots of men have families with two different women.'

She spoke with weary disapproval. But it was beginning to make a tragic kind of sense to me. Like the sharing of charcoal or childcare, the sharing of men was all part of the Sertoes miracle, which allowed five hundred people to survive on resources that would keep barely fifty alive elsewhere. And I thought of Cairo, where everyone scrabbled to hang on to their own small slice of the cake. Far from a collapse of society into chaos, I felt I was witnessing, in the Sertoes, one of the most intricate juggling acts in the world.

We tracked Maria down eventually after lunch, in a small bar round the corner from the *Bar dos Vaqueiros*. She was sitting at an oilcloth-covered table in a back room, opposite a red-eyed drunk who was slopping Coke and beer together into tin cups with a wavering hand.

'To my liver!' cried Maria, toasting us with the foaming brown brew. 'Come and join us – even the flies drink beer in

this town.' And she shooed away the black swarm that was paddling in the spilt liquid.

'Were you here last night?' I asked, and Maria nodded. 'Usually we just stay in and make cigarettes, but Yvonette wanted to go out to look for her boyfriend. We couldn't find him, so we came back here and a man with a bottle of cognac found us instead. But there was no money in it – he just wanted to drink. That's how I did this – ' waving a thumb with an angry-looking cut on it. 'I fell over on my knife.'

'Do you always carry a knife?'

She shrugged plump shoulders: 'You meet some strange people in this job. I've been lucky so far, but you never know – '

As if to emphasise the point, Yvonette appeared in the doorway, her hair in curlers and her three knife scars livid in the sunlight. She was brandishing a piece of paper. 'There's bingo the day after tomorrow,' she announced, sitting down and gulping from Maria's cup. 'First prize is a beautiful red sofa!' She hugged the paper to her skinny chest: 'I'm going to win, I can feel it in my bones.'

'But it won't fit in your room,' Maria objected.

'Then I'll rent a *casa grande* and lie there on my sofa, sneering at you in your little hovel – '

'What are the other prizes?'

'A bicycle, an electric food-mixer, a juicer – '

'The bicycle's for me!' cried Maria. 'I'll ride up and down with my bum in the air, driving the men mad with desire –' She pranced round the room, her bottom protruding. Mesmerised, the drunk made a sudden lurch towards her and fell on to the floor. She hauled him to his feet and plonked him back on his chair as though he were a sack of potatoes.

They went on to talk about the weekly lottery. The woman who collected the bets was outside, so we all trooped over to Maria's house for her to find her money. 'I always back number eighteen,' she said, unlocking the door. 'It's represented by the pig, and I love spicy sausage!' 'Raw and cooked – ' shouted Yvonette, unlocking another door three houses down.

Maria laughed, then her expression hardened. Following her eyes, I found myself looking at a tall young woman standing

on the other side of the wide street. Dressed in regulation hot-pants and a striped T-shirt, she was staring belligerently at us, winding a strand of long dark hair round her finger.

'Is that Zilda?' I asked, and Maria nodded grimly. 'She moved out yesterday, after you left.' 'How long had you been living together?' 'Nearly five years – but I'm tired of her sulking every time I talk to anyone. And she's so mean! Last week she won eighteen thousand on the lottery but kept the three thousand I lent her to bet with.'

We sat down and Maria whisked round the room tidying up: arranging the parrot pillows in an artistic heap, straightening the red velvet, carrying the bowl of piss to the communal latrine. As she was lighting the brazier, a ten-year-old girl appeared and dithered uncertainly in the doorway: I recognised her as one of the many children we'd seen at Maria's mother's house. Without pausing for thought, Maria unhooked a carrier bag from a nail and gave her half a loaf of bread.

'I used to get free bread,' she remarked, dropping a piece of the flyblown fat into a pan. 'My first husband was a baker – he used to say that was the only reason I married him! But it meant there were always women flirting with him at the bakery. That's how I found out he was having an affair – I'd gone there to get some bread and found them at the back of the shop.' She shook the pan, and a smell of beef dripping filled the room. 'It was just after my eldest daughter died. I still had Carlos at home, and Marcus was still a baby – ' So she'd lost her daughter and her husband within a few months of one another.

I flashed her what I hoped was a sympathetic look, but she was laughing again. 'I nearly killed that bitch!' she said proudly. 'Dragged her into the street and started tearing her hair out – '

'Did it frighten her off?'

Maria snorted: 'In a way – he ran away with her to Salvador the next week! He told me he was starting a bakery there and he'd send for us when he'd found a place to live. But after he'd gone I discovered she'd been hiding at the bus station and had slipped on to the bus when I wasn't looking.'

'What did you do when you found out?'

'Oh, screamed, cried, got drunk' – carelessly – 'then moved in with my mother.'

'Is that when you started working at the bar?'

'No-o –' She hesitated, stirring frazzled fat thoughtfully. 'I don't know why not. Maybe because my husband was the only man I'd had – maybe I wanted to be faithful to him –' She shrugged: 'Anyway I decided to find a respectable job, so I started working for Zenaida. Just as a maid – you know: cleaning, cooking, washing. Then my son Carlos got run over by a jeep, so I wrote to my husband to ask for help with the medical bills.' She added a bowl of soaked couscous to the fat, and began chopping some blackened pieces of dried meat on the table.

'He must have regretted leaving us, because he sent the money straight away, plus the bus fare for us to come to Salvador. The other woman had gone by the time we got there, but the house was still full of her things and the neighbours said he'd told her to leave just an hour before we arrived.'

She laughed suddenly: 'I was one month pregnant when he left, so I had the new baby with me. You should have seen his face! To begin with he thought I'd had an affair. Actually, I don't think he ever believed it was his baby, because he was always suspicious of me after that. I remember one day we were out walking and a man shouted that I was too much *pirau* for one man –'

'*Pirau* is anything especially tasty,' Tarciana explained.

'He was really angry!' Maria smiled. 'And that night when I was asleep, he took a big knife and hacked off all my hair!' She mimed him sawing at her curls: 'I looked horrific, like a witch. So next day when he was at work I tied a scarf round my head, then packed up the children and came home to Mother.'

'Just because of that?' Compared with what she'd been through up till then, it seemed a strange reason to leave.

'I wanted to teach him a lesson.' She jutted her chin. 'He was always playing around, but if a man even looked at me he'd go crazy! I should have known better – he didn't even bother to write. I found out afterwards that he moved the other

woman straight back in as soon as I'd gone. Then a month later he sneaked back into Trindade and took Carlos back to Salvador to live with him.'

'So you were left with two children – Marcus and the baby you had after he left the first time – '

'Patricia,' she said quietly, and I realised, with a jolt, that I hadn't met either of these two children. That meant – 'They died soon after he took Carlos,' she said. 'A woman had put an evil eye on Marcus when he was three months old. He was holding his own bottle and she picked him up and said "Look, he's feeding himself". After she left he started vomiting and he was sick off and on for the next two years until he died.'

'And Patricia?'

'She got a fever when her teeth started coming through – ' She knelt on the red velvet and began rolling a cigarette. 'One day I had three children, then six months later they were all gone.' She lit the cigarette in the brazier and inhaled deeply. Flies floated lazily in black halos above our heads. For once she wasn't able to summon a bright comment to chase the dark memories away.

'Then one day I heard my husband had come back to Trindade and was living with his mother. Until then I was just working at Zenaida's during the day and sitting in at night looking ugly and feeling miserable. But when he didn't even bother to come and see me, I decided I wouldn't be miserable any more. I wanted to show him I didn't care, you see. So I got all dressed up in my best clothes and joined the other girls at the bar.'

A police car whizzed by as we turned the corner into Maria's street the next morning. 'You missed the fight!' she said excitedly as we joined the crowd milling around in the middle of the road. 'They beat up the man who lives in that house over there, then dragged him off to jail – '

'What did they arrest him for?' I asked.

'They didn't say. Stealing, I expect. He used to steal from everyone when he was here, but he went away a few months

ago – someone must have seen him come back and reported him to the police.' She pushed open the unlocked door of the man's house, and we went inside. Its two bleak rooms were empty except for a small table, a guitar and a few clothes in a cardboard box.

Maria picked up a dirty shirt between two fingers, then dropped it distastefully back into the box. '"Thief" is the worst word in the world,' she said meditatively. 'Even worse than "murderer". If you steal things no one trusts you and you don't have any friends. I never saw anyone come to visit him, not even his family.' I could understand that: stealing must seem like a sacrilege to a society that survived by sharing. Maria shuddered: 'You should have seen the way they attacked him: hitting him on the head over and over. It'll be even worse when they get him into that jail. It's far out in the bush, so no one can hear what goes on.'

She walked into the rear room of the dingy house and unbolted the back door. It opened into a little alley leading to the communal latrine. She came back in and switched on the light – a forty-watt bulb hanging from a tangled brown flex. 'I could put my bed here,' she murmured. 'And a curtain in the doorway to separate it from the kitchen –' She spun round suddenly, her arms outstretched: 'It will be the new *Palacio de Maria*!'

She rushed off to stake her claim with the landlord and returned ten minutes later, grinning from ear to ear. 'He says I can have the keys tomorrow!' she crowed, leading us into the bar to celebrate. Remembering her liking for spicy sausage, we'd brought two long red *wursts* along with us, and some loaves of fresh bread. Maria laughed with delight when she saw them, grabbing them and making lewd thrusting gestures, then bearing them triumphantly off to be sliced on to the griddle.

While they were cooking, she took my hand and led me down a short dark corridor. 'This is the room we use,' she said, opening a door next to the latrine. I peered into the grimy blue-washed room: there was a bare bulb and a single bed without a pillow. It was about as inviting as a station waiting-room.

'What was it like that first time?' I asked as we sat down

again at the kitchen table. Maria laughed: 'I was so pathetic! The men were going crazy because I was new and pretty. But I was too shy to go with any of them. So I kept flirting and dancing and getting them to buy me drinks – Zenaida said afterwards that I drank three litres of green *cachaça* trying to make myself go through with it! I was so drunk she had to put me to bed, but she offered me a job as a barmaid because I was so good at getting the men to buy beers.

'Next day I got as far as one of the bedrooms. But the man's penis was so big I was terrified. So I went to the toilet and when I came back I told him my period had just started. I thought he'd be put off, but he just grabbed me and said "Doesn't the cow have an anus?"' She laughed again, shaking her head. 'I ran out of there as fast as I could! It was three months before I finally managed to put horns on that cheating husband of mine.'

'Did you get drunk that time too?' I asked, topping up her tin cup. She shook her head: 'No – I fancied him. He was a regular in the bar, so it was like he was a proper boyfriend. And he was so good in bed' – wriggling her shoulders appreciatively – 'it felt strange to be taking money from him.'

Standing in the doorway, Yvonette kissed her fingers like a gourmet chef. 'When the man's tasty, this is a great job,' she said. 'You don't mind how long he takes. But if he's ugly or smells bad, then it's *vapt–vupt* – in–out!'

'I charge them less, then tell them to hurry because I've got a pan on the stove!' said Maria.

'Do you take your clothes off?' I asked, trying to visualise these brisk businesslike couplings.

Maria shook her head firmly. 'I never let them see me naked,' she said. 'I just pull up my skirt or take my shorts off and lie down –' She squared her shoulders and mimed lying stiff as a board: head turned to the side, eyes tightly shut. 'And I never let them kiss me, or use any position they wouldn't use with their wives.'

Yvonette wrinkled her nose: 'Yes, that's too degrading. They can find another woman if they want that –'

'And if they get angry?'

Maria flicked her hand dismissively: 'Oh, they act tough, but we can wrap and unwrap them like bonbons.'

The sausages reappeared, fragrant red discs piled high on a plate. We ripped up the bread and ate with our fingers. 'What about when you're pregnant – do you stop working?'

Yvonette laughed: 'That's the best time! It excites them – I made millions when I was pregnant. They think it saves them from catching a disease from you, because the badness will go to the baby instead of to them.'

'But you might catch something from them – '

Maria shrugged philosophically. 'I've been lucky,' she said.

'Do you use a condom?'

She made a face: 'They give you worms in your fanny. And the men hate them, so they pay less. I refuse to go with anyone for less than it costs for a kilo of meat – '

She licked her fingers and went over to a radio perched on top of the huge refrigerator. The room was flooded suddenly with the lilting music of Bahia. 'The woman singing this is a notorious lesbian,' remarked Tarciana. 'The Brazilian word is *saponiera*, which is someone who makes soap.'

'Why soap-maker?' I asked, but she didn't know.

'Maybe it's because they rub together,' suggested Maria. And she performed a lascivious hand-washing mime that had us all spluttering with laughter.

'Which do you think is more natural? Two women making love or two men?' she asked me, suddenly serious. I began framing some glib answer about love, then realised what a cop-out that would seem to a woman who made her living from sex. I tried again. 'I think anything's natural if both people want it,' I said. 'What – even men mounting each other like cattle?' Maria screwed up her face in disgust. 'I think the way women love is much more beautiful,' she said.

It was bingo that night, and Maria scoured the street looking for someone to lend her enough water to wash with. Dressed in a clean T-shirt, she hung a crucifix from one ear and squirted cheap scent in the general direction of her armpits. Yvonette

appeared, posing and pouting, revealing an acre of silken brown skin beneath her halter-top. 'Oh sofa! You are mine tonight!' she cried as we set off together, four abreast, for the centre of town.

Bingo in Trindade was like a cross between a pop concert and a football match. Everyone with enough water to wash in was there, parading in their best clothes beneath the floodlights and jostling for seats in the open-air amphitheatre. A disc jockey presided, sidling round a huge red sofa that dominated the small stage, chattering and making jokes between blasts of pop music while bingo-wallahs sold grids of numbers to the punters. Then, just as he called the Brazilian equivalent of 'Eyes down', and five thousand pencils were poised in anticipation – it started to rain.

The town laughed and turned its face to the sky. Big drops plashed on to five thousand bingo cards. Then the lights fused and we were plunged into darkness.

We sat for a while, gasping and wiping the drops from our faces, then ran for shelter, hiding our damp cards under our clothes. 'They call this a green drought,' said Tarciana as we walked back to the hotel. 'Enough rain to make the grass sprout, but not enough to save the corn and beans.'

The water lorries arrived the next morning: trundling down the streets like yellow elephants, rusty and dripping, reaching into the empty oil drums with grey trunks. And each neighbourhood, when they'd passed by, was like the sea's edge when the waves have receded: popping and scuttling with sudden life – toddlers paddling, men shaving, women kneading bowls of suds between their knees on the pavement.

We met Maria carrying two brimming plastic buckets from her mother's house. 'They don't deliver to us until later,' she gasped as the water slopped on to her bare feet. She led us to her new house, where the doors and shutters were wide open and the sun flooded in. Unable to sleep, she'd been up since first light, sweeping then washing the room in water in which big crystals of sea salt had been dissolved. 'The devil hates salt,' she

explained. 'I burned sulphur too, to frighten away bad spirits.' She picked up a jar of slimy vegetation and flung the contents into the street: 'This plant protects against the evil eye, but it's obviously been working too hard!'

The activity at the *Palacio de Maria* was a magnet for everyone in the street; they took turns leaning through the window or against the doorpost to comment on her new abode. Maria picked up the piece of packing case she used as a shelf, and banged a couple of bent rusty nails into the wall to secure it. Like everything else she'd hung up, it was slightly crooked. She saw me surveying it and cocked her head comically at me. 'It's like my life, isn't it?' she said cheerfully, and tipped a plastic bag of cosmetics out on to the bed. 'All these bits of lipstick wouldn't make even one whole one,' she laughed, twisting out a blunt cerise stub to demonstrate; then she piled them inside a fresh bag and squatted to stow it in the cardboard box that served as a bedside table.

There was a sharp ripping noise as her denim skirt divided along her thigh. She stood up and tugged the frayed edges together. 'It's those pills,' she said ruefully. 'I was never this fat before. Men like a round arse, but this' – slapping her bum affectionately – 'is ridiculous! They gave me headaches, too, so I feed them to the flowers instead.' True to her word, she took a foil packet from the plastic bag and popped a small green pill into a jam jar of tradescantia. 'I'll get some different ones from the clinic tomorrow.' She waved her hand vaguely.

'What would you do if you got pregnant?'

'Go and find that nurse again, I suppose,' she said. 'Though I don't know where I'd get the money. I only paid her a fifth of what it should have cost last time.'

'Last time?' She hadn't mentioned having an abortion before.

'My eighth baby was a "child from the streets",' she explained. 'I mean he didn't have a father like the others. It was about two years after I'd started working in the bar – that's why I had to get rid of him. I didn't know the father, and I knew it would hurt me to have to give him away. So I drank coffee and paraffin – ' She shuddered: 'That's why I don't drink coffee

now. I can't forget the taste of paraffin in my mouth. Anyway, when that didn't work, I went to this nurse and she stuck a thin rubber tube up inside me and when she took it out the next day I started bleeding.'

'Did it hurt?'

'A bit – ' wrinkling her forehead, trying to remember. 'It was a boy – the size of my hand, all skinny and red. I never gave him a name – ' she paused. 'Afterwards I started bleeding so badly I had to go to hospital. I told them I'd had an accident, but they knew what had happened.'

'Abortion's illegal in Brazil,' said Tarciana. 'But if you've got the money it's easy to get someone to do it for you.'

By late afternoon the move was almost complete and Maria was hanging her pictures, arranging them informally at different heights with the care and confidence of an interior designer. 'These two sacred hearts are to protect the house – ' picking up two stucco busts of the Madonna and Jesus, each with anatomically unlikely hearts spouting yellow flames on the outside of their garments. 'And Saint Luzia' – a glum-looking icon holding a pair of eyes on a brass plate – 'stops you getting eye infections.'

Some of the images were familiar from my Roman Catholic upbringing. But others had a magical, fairytale quality: the mermaid Madonna, for instance, or the naked wild man of the woods covered in hair. 'The *candomble* religion is a mixture of everything,' Tarciana explained. 'Mostly Christian and African beliefs, with a bit of herbalism and voodoo thrown in for good measure.'

'And Buddhism too?' I asked, watching Maria place a small plastic Buddha on the shelf with his back to the room. Tarciana shrugged: 'Bowie, Buddha – they're all icons,' she said. 'He's turning his back on bad spirits,' Maria explained, stooping to arrange ornaments on a little metal trolley in the corner: jam jars of protective plants; a manic plastic rabbit; an antelope's foot and a hollow bull's horn.

The horn kept toppling over on its side. 'It reminds me of

Ruben, my second husband,' she commented, righting it with a mischievous smile. 'He said he couldn't get it up for any other woman. He tried a few times, but it was hopeless, so in the end he just used to masturbate when he was away.' She collapsed on to the cushions and rolled a cigarette.

'I keep meaning to do that,' she said lazily as I flicked through a dog-eared leaflet with a Madonna on the front. 'It's nine days of prayers to Our Lady. Maybe I'll start tomorrow – ask her to send me the rent for this place. It's a hundred thousand a month and Zenaida only pays me three hundred thousand. Last year I could get that in an afternoon, but the men don't want to pay for it any more.' She sighed suddenly. 'If Ruben was still alive, I could stop working. Then I could have my children with me all the time – '

'How did you meet him?'

'At the *Bar dos Vaqueiros*. He was one of my regulars, and gradually we fell in love.' She smiled dreamily, blowing smoke. 'I didn't really know about pleasure until I met Ruben. He just had to stand beside me and my legs would start trembling. And I wasn't ashamed of him seeing me naked – he used to follow me into the washroom and lick me when I was trying to wash. And when he was drunk he was even sweeter – ' She hugged herself, remembering, then sighed: 'I wish I'd "got lost" with him instead of my first husband – then we would have had more time. But he was killed five years after we met. Now all I've got is Ruberlanio to remind me of him.

'I didn't even go to the funeral. He used to sell hammocks at all the markets around the region, so I'd gone to stay with my grandmother while he was away. When I got back it was all over.' She relit her cigarette and smoked in silence for a while. A stiff-legged sparrow hopped in through the doorway looking for crumbs, and she kicked absently at it with her bare foot. 'I took a candle to the grave that afternoon, and that night I dreamt we were in the bar and he was leaning against the wall laughing down at me. Then we were making love by candlelight, and I realised that his penis was white and cold inside me and I knew he was dead.'

She bent abruptly to rub the cigarette out on the floor, and

I thought I saw tears glisten briefly in her eyes as she threw it out of the window. 'A few months later my first husband came round and tried to seduce me. It used to drive him mad seeing me with Ruben, so I suppose he thought he'd get his own back. Anyway, he got me drunk one night and we had sex. Then as soon as he'd finished he said "Now I've filled you too" and he walked out and never came back again.' She laughed suddenly: 'He was right, too – because I found out I was pregnant with Wesley. I started back at the bar the next week.'

It was growing dark, and the doorways opposite began to light up one by one. Maria shuddered suddenly and rubbed her arms. 'With all this talk of death, I'll be scared sleeping here on my own tonight,' she said.

'I'll stay if you like,' I offered. At first she was taken aback – 'Rich people never stay in this kind of place' – but when she saw I was serious, she seemed relieved and began dismantling the bed to give me one of the two mattresses. It was then that I noticed the word 'Zilda', etched in cigarette burns on her inner thigh.

I had to go back to the hotel to fetch my sleeping-bag, and I walked back alone with it under my arm. The sky seemed enormous, full of stars; the town very small, just a faint sprawl, like a grey spider in a black desert. As I neared Maria's house I saw a tall figure in white shorts watching me from the shadows.

Without Tarciana to translate, my communication with Maria was reduced to inane grins and gestures. She lit a stub of candle and showed me where to wash: in a kind of anteroom to the communal latrine, with a hole for drainage and a curtain threaded on a string for privacy. The latrine itself was another hole, beside which hung a plastic bag full of torn-up litter for wiping with. It seemed that the principle of sharing worked here, too, for it was as clean as it's possible to keep a place that's used by up to twenty adults and children.

When I came back, she locked both doors and unhooked a pink bowl from the wall, plonking it ceremonially on the floor and indicating that this was what she used during the night.

Dressed in T-shirts and knickers, we settled down to sleep. Once I woke up to hear her pissing long and vigorously into the bowl, then lighting and puffing on the cigarette she'd rolled ready before she went to bed. As I was drifting back to sleep, I wondered where Zilda was sleeping tonight.

I got back to the hotel the next day in time for what Tarciana called the 'street kid carnival': the sudden materialisation of hopeful ragamuffins that occurred the moment the cafés and food shops opened. Maria was spending the morning cleaning Zenaida's house, but in the afternoon she was back in the little bar with Yvonette and an old man in a battered stetson.

She was in an ebullient mood, welcoming us as old friends and demanding beer. 'I've been like a mad ostrich today,' she declared, wriggling an arse clad in red hotpants. 'Rushing round with my bottom in the air – ' She broke off suddenly, spotting something in the street. The next thing I saw was Zilda sprinting past the doorway, with Maria in hot pursuit. I rushed out in time to see her fling a knife at Zilda's fleeing heels. It missed her by inches and slithered sideways in the dust, from where Maria retrieved it and thrust it angrily down the front of her shorts.

'She was trying to break down my door!', she gasped, subsiding on to a stool, dark circles of sweat under her arms. Yvonette retrieved the knife and placed it out of temptation under a cloth on the sideboard. 'I hate knives,' she said. 'Look what that's done to me –' And she held out trembling hands for us to see.

Maria took a roll-up from behind her ear and gave it to her friend by way of a peace offering. 'I'm a *pomba gira* today,' she said apologetically. Yvonette smiled shakily. 'It's because you're wearing those red shorts,' she said.

The *pomba gira*'s a female spirit entity in the *candomble* religion,' Tarciana explained. 'Very sexy, very mischievous, very powerful – and she always wears red.'

'Zilda really knows how to upset me,' Maria said agitatedly, pouring more beer. 'Last year I was arrested for knifing her in the leg.'

'What were you fighting about?' I asked, and she opened her arms helplessly: 'Jealousy, always jealousy. She was slapping my face in the middle of the night because I'd stayed too long with some man – even though she knew that was where the money came from! After that I started going to Ouricouri and Ararapina so she didn't have to see it.' She sighed: 'I can understand it, I suppose. I hated her going with men too. That's why I started paying for everything: so she could look after the children for me instead.'

I looked at Tarciana. 'They're lovers, aren't they?' I said. Then, with a thud of dismay: 'Do you think we're to blame for all this?'

Tarciana laughed shortly: 'Probably. Buying her beers, paying her all this attention. Zilda probably thinks we're gay too.'

'And staying the night – ' I put my head in my hands. What other conclusion could the poor woman draw?

Yvonette's entrance, with two heaped plates of fried sausage rings, distracted everyone for a while. 'What do people think about your relationship with Zilda?' I asked Maria when she'd calmed down a bit.

'My mother was furious when she found out. Lots of people disapprove. But my friends just accept it. And we're not the only ones – there are hundreds of women like me in Petrolina. And some here in Trindade too – '

'But you loved Ruben – '

'Oh yes, more than anything!' Her eyes shone suddenly. 'When he died I vowed I'd never love another man. Then I met Zilda – ' She smiled and shook her head. 'She was so sad and crazy, I just felt sorry for her to begin with. She used to live out on a farm somewhere, but her mother died when she was fifteen and her stepfather started to beat her, so she ran away. I remember seeing her in the bar sometimes, or stumbling around drunk in the streets. Then one night I saw her clambering up on to the roof of an empty house. She had a heap of cardboard there that she was sleeping on – '

'So you took pity on her – '

'I said she could come and stay with me. But she was crazy'

214

– rolling her eyes – 'really crazy. She used to have these nightmares about a devil killing her – she'd wake up screaming. That's why she drank so much – because if she passed out she wouldn't have that dream. Sometimes she'd get so drunk she'd start shaking and hearing voices – that really scared me. So I took her to Doña Elena.'

'Doña Elena?'

'The healer who discovered that the evil eye had been put on my son. She's famous for curing infertility, so people come from all over to see her. Anyway, she washed Zilda in salt water and prayed over her, then said if she didn't stop drinking she'd die.' Maria laughed bitterly: 'But when she gave up drinking it was even worse. She was so frightened of dreaming that she'd keep us both awake all night! And there was all this jealousy on top of that – No,' she sighed regretfully. 'I've got to get her out of my heart.'

It was getting dark, but she hadn't switched on the light; the sky glowed like mother-of-pearl through the open window. 'This Doña Elena,' I said quietly. 'Where does she live?'

Maria directed us to the other side of town, to a big barn of a house with shadowy rafters towering above a warren of little rooms lit by single swinging bulbs. It was swarming with activity: children charging up and down, women wandering in and out carrying knitting, a pot of food, a newborn baby. A huge colour television boomed garishly in the front room under the long-suffering gaze of a life-size Madonna statue.

We were ushered into a back room whose walls were completely covered with framed images of strange saints. Doña Elena was sitting in state beside a small table loaded with bottles. She wore dark glasses over blind white eyes, which flickered in contrast to the curious stillness of her big body. Grabbing my arm, she pressed me on to a low stool positioned between her knees, keeping me imprisoned there, her heavy hands on my shoulders, while Tarciana explained about my infertility. Then she began barking curt questions – about my menstruation and the various medical treatments I'd received

215

– and kneading my arms and hands, and running her fingers over my face and torso.

After a while she appeared to go into a trance, sweating and whispering rapidly, as though the flicker of her eyes had spread to her lips; and the pressure of her hands increased until she was sweeping them roughly down my body as though to rid it of some clinging shroud of spiders' webs. Though the night was cool, I found I was sweating too, and my skin began tingling in the wake of her hands.

Then she stopped suddenly and shook her hands in convulsive movements at the floor, wiping and shaking them to rid them of the invisible shreds of badness. 'Do you believe in the Holy Spirit?' she asked abruptly. And I hesitated. 'Go on – ' hissed Tarciana nervously. So I closed my eyes and said 'Yes,' thinking of the wild *pomba gira* in her red dress.

Knowing that Maria was planning to spend the next day ironing clothes at Zenaida's house, we dropped in to see her mother instead. The older woman was standing outside in the street doing two weeks' worth of laundry, surrounded by strange doughnut-shaped bowls made from huge truck tyres cut in half. Wesley was squatting naked in the mud beside her, decorating a headless doll and two Matchbox cars with suds, while two other children scooped the foam into strange sculptures with their hands.

'I'll punish them later,' said Maria's mother wearily, straightening her back with a groan. 'They know they're not supposed to play with water.' She bent to wring out an unidentifiable piece of clothing and threw it on to the growing pile of wet washing on the pavement.

'Maria was telling us she'd split up with Zilda,' I remarked conversationally. 'About time too – ' she scowled, wiping her hands on her dress. 'We were managing fine before she came along. Maria used to come here and help me, and gave me fifty thousand each week for the children. Then Zilda moved in, and she took the children back to live with her. Now I see thirty thousand if I'm lucky – ' She lowered her body on to a stool with

216

a grunt, and reached into her pocket for the makings of a ciga-
rette. 'Women are not made to go with women – ' she said
disapprovingly, then lowered her voice: 'People say Zilda's a
witch – because she never sleeps and sees visions – '

Stiffening suddenly, she broke off: Ruberlanio was running
down the street shouting. Dropping her cigarette, she sprang to
her feet. 'It's Maria – some kind of trouble – ' she called over
her shoulder as she sprinted like a tiger to defend her beloved
daughter.

We ran after her, but stopped when we saw what was hap-
pening. Maria was in the middle of the road, shouting at the
house opposite. Watched by a growing crowd of amused on-
lookers, she was obviously drunk, flailing her arms and stagger-
ing in the dust. 'We'd better stay here,' said Tarciana nervously.
'I didn't like the look of that knife yesterday.' 'Can you hear
what's going on?' I asked, but she shook her head: 'They're just
insulting each other – I can't work out what it's about.'

Just then a police car rounded the corner and skidded
to a stop. Maria veered violently, and stumbled heavily against
the bonnet. A second later she had been bundled into the back
seat.

Yvonette was drunk too, standing red-eyed and unsteady
in her doorway. 'It's not fair!' she mourned. 'It was that bitch
who started it.' And she aimed a lewd gesture across the road.
'She was insulting *mia comadre* Maria, calling her a *saponiera*.
So Maria called her a soft-cunt, because she has so many
penises when her husband's away.' She giggled and sat down
heavily on her bed. 'So then she accused Maria of tricking
Debbie into staying the night – '

'But we've got to do *something*,' I said desperately. 'Anything
could happen to her in that jail – especially if they know she's
a prostitute.'

It was evening and I was sitting with Tarciana at the hotel,
discussing whether we'd make things worse if we tried to get
Maria out of prison. 'Okay,' agreed Tarciana at last. 'Maybe if
we just visit, it will warn the police to treat her properly.'

The jail was a squat concrete building with bars on the windows and wide steps leading up to an imposing front door. It was situated five kilometres out of town – in the middle of nowhere, as Maria had said – surrounded by cacti hung with flapping fragments of cellophane. A single spotlight illuminated the forecourt, and a large yellow dog sat in the circle of light staring dolefully at the closed door. Beside it, equally motionless, sat a small grey cat and a toad. None of the animals moved as we mounted the step and rang the bell.

The policeman was friendly but firm: yes, they had Maria; no, we couldn't see her because she was sleeping. If we wanted to get her out, we'd have to go to the Chief of Police's house and get a letter of authorisation. The Chief of Police was equally friendly, considering we'd interrupted his dinner. 'If I let her out while she's drunk, she'll only make more trouble,' he said reasonably. 'Better to let her sleep it off and send her home in the morning.'

It was all so reassuring, so sensible. But I kept thinking of the thief, and the truncheons thudding into his skull.

The next day was cattle market day once more in Trindade. And the streets were again filled with a procession of vehicles, people and animals: like so many ragtaggle applicants for some latter-day Noah's Ark. I saw the honey man stride by with his black coat flapping; the ice-cream boys with their cool-boxes on their shoulders. I wondered whether Maria was awake yet.

A police car brought her home at midday. To my relief she seemed unscathed by her experience: 'A taxi there, and a taxi back – and a real toilet all to myself – it was better than a hotel!' she joked as she unlocked her door. 'But I wish I'd given her a good thump before they carted me off – that would have made it all worthwhile. You know, when that woman dies, they won't be able to fit her tongue in the coffin!

'Now I've got to wash to get rid of the smell of that place,' she went on, filling a bucket from her oil drum. 'Every cell has

218

a toilet, but there were four men to each one, so the whole place stinks of shit.'

'Did you have to share with the men?' I asked.

'No, they moved them around so I'd be on my own. But I don't know why they bothered – there were no curtains or anything, so they could see everything I did.'

She sprinkled a handful of salt crystals in the water and unhooked a towel from the back of the door. 'The thief was still there,' she said quietly. 'His face was all bloody and he couldn't see out of one eye. He said he'd been beaten every day since he got there and no one had given him any food. My mother brought me some couscous for breakfast, so I gave it to him.'

She was back ten minutes later, shoulders sparkling with droplets of water and a towel knotted over her breasts. 'Right – I've been to the *mictorio*; now it's time for the *perequitorio*!' she declared, pulling on a pair of brief panties.

Tarciana laughed, throwing back her head: 'The *perequito* is a little bird – a parakeet. But it's also an affectionate word for a woman's genitals.'

The *Bar dos Vaqueiros* seemed less busy than before, with fewer men crowding round the bar. 'It depends on the cattle prices,' a cowboy told us as we sat down. 'They've been bad here for months, so the farmers take their animals somewhere else.' He nursed his beer and stared moodily at the dance floor.

Yvonette was there, bobbing gamely against the belly of a burly cattle dealer. Her pretty face was averted and her slim fingers splayed tensely on his back in an unconscious expression of distaste. 'Look – there's a new girl,' said Maria. 'The blonde with the yellow shorts – Zenaida told me she's never done it before.' The girl couldn't have been older than sixteen: winsome and willowy, with fierce red lipstick on her uncertain mouth. I saw her whisked on to the dance floor by a young man, who pressed his groin against hers while she stared petrified into space over his shoulder.

'The girl she was with is a *saponiera*, like me. The men like

her because she's so young, but she's hopeless at dancing – '
It was true: the men would jig around with her for a while, then
give up and return to the bar shaking their heads. One lost his
temper, inserting a booted foot between her bare legs and tip-
ping her on to the floor. A look of bewildered pain flashed over
her snub-nosed face, but she was smiling flirtatiously again by
the time she'd scrambled to her feet.

'This is my favourite song,' said Maria, sashaying on to
the dance floor to demonstrate the proper way to move to the
foro rhythm. Yvonette pranced over and they began dancing
together, singing along to the music: 'Your strong arms, your
fine smile, I couldn't resist you, my *vaqueiro*. And all the pain,
all the tears, it was worth it all, my *vaqueiro* – '

When the song ended, Maria ran to the record-player to
put it on again, then tugged me to my feet and urged me to
dance too. I found it almost impossible to combine the various
movements. If I got the shoulder shake right, I couldn't rotate
my hips properly; when my feet speeded up, I forgot to shake
my shoulders. And I was acutely conscious, through it all, of
the men's eyes on my overdressed body. After a glass of *cachaça*
it seemed easier; I relaxed in Maria's arms and let her lead me,
while the other women looked on and applauded. For a while
I moved like a true Brazilian – co-ordinated and sensual and
free. Then the elements fell apart again and I lost it.

I collapsed into my chair, laughing, and sloshed beer into a
thick-bottomed glass. Next moment I felt a firm hand on my
arm and was tugged to my feet by the biggest cowboy I'd ever
seen. Everything about him was outsize: his white stetson and
embossed boots, his grey moustache. Shirt buttons strained over
his chest, and a thick wad of cruzeiros padded his breast pocket.
I remember the smell of cigarettes and *cachaça* as I stared up
into his smiling mouth, at his four gold teeth gleaming with
saliva. I tried to squirm out of his grip as he pulled me into a
back room, but he just laughed and tightened his huge hands.

I looked round wildly for Tarciana, but she'd gone outside
while I was dancing. The cowboy towered over me, smiling
curiously; like King Kong squinting at a terrified virgin. That
was what frightened me: not his strength, but his simple

assumption that he could fuck me if he wanted – for the price of a kilo of meat.

In the end it was Maria who rescued me, tickling and teasing him to loosen his grip, then leading him quiet as a lamb back to the bar.

At four, as before, the bar started to empty, and by seven only a handful of men were left. It was dark and Zenaida switched on the lights, while Maria turned down the music and began sweeping the floor.

'It's even worse than last week!' she leaned on her broom and took a long swig from a beer bottle. 'I'll have to move out of the *palacio* at this rate – ' She spoke lightly, but there was an anxious note in her voice. She ran a practised eye over the few remaining men. 'They're either too poor or too drunk to bother with,' she concluded in disgust. Then, grinning: 'Just as well, I suppose. Because I forgot to go to the clinic for my pills.'

She slumped into a chair and let her thighs loll apart. 'Someone told me there was a job going at the supermarket,' she said wistfully. 'But forty girls have applied already. Anyway, they'd never hire someone like me.'

'You'll have to get married instead,' teased Yvonette, coming over and offering her a drag. 'That's what I'm going to do: find a nice rich crippled man, who'll be so-o-o grateful that he won't mind looking after my sons.' 'No – a blind man for me!' Maria banged her bottle on the table. 'Then he won't see my grey hairs.'

Just then two men stepped in from the dark street and stood blinking in the light. They went to the bar and ordered beers, then brought them over to the table next to ours. Maria sat up straight and grinned encouragingly, while Yvonette shifted her chair slightly to include them in our party. One was young, barely out of his teens, with the hangdog look of the chronically shy. He took off his baseball cap, then put it on again, darting covert glances towards the women. The other was in his thirties, with carefully greased black curls and an immaculate white shirt under a leather jacket.

'He's a salesman from Petrolina.' Tarciana nodded towards the older man. 'Have you see the way he's staring at our friend? I think she may strike it lucky after all.'

I looked up in time to see him catch Maria's eye and make some secret gesture with his hands under the table. She nodded imperceptibly towards the door to the back room, and the transaction was complete.

'Let's cross beers!' she cried suddenly, turning towards me. 'We throw our beers into the air so they cross each other – it's a way of honouring the great *pomba gira* – '

Like the trails of two sparklers, the amber arcs hung in the air for a split second, then splashed gloriously on the concrete floor in a perfect cross. Maria laughed victoriously and slapped her empty beer bottle on to the table. Then she took the man by the hand and led him out of the bar, pausing briefly in the doorway to blow me a kiss over her shoulder.

Meg

(STRANRAER, SCOTLAND)

The number of one-parent families in the UK increased from 14 per cent in 1985 to 20 per cent in 1992. In Scotland, latest estimates put the figure at twice this: two out of every five Scottish families are now thought to be headed by single mothers, a rate that is the highest in Europe. This increase is due largely to the rise in illegitimate births – from one quarter to one third of births in the five years up to 1990.

Meg lives on a grey council estate in the Scottish port of Stranraer. She is unmarried and unemployed, with three children under the age of three – nappies and Neighbours *fill her week. Having spent half her own childhood in institutions, she is desperate to be a good mother. But her sickly youngest son is being monitored by social workers, and she is frightened that he'll be taken into care.*

It was drizzling the day I met Meg. The sky was grey; the pebbledashed houses were grey; the stones were grey in the graveyard up the hill behind the estate. A few of the houses – semi-detached, flat-fronted, featureless – were fenced with grey corrugated iron. An ice-cream van tinkled unseasonably somewhere down the hill towards the harbour and a grey-backed seagull, still in winter plumage, paced stoically along the ridge of one of the wet roofs.

Number sixteen had Venetian blinds in all the windows. Downstairs the slats buckled at eye level, then sprang back as I approached.

It was Alice – Meg's sister – who opened the door. With her cropped hair and thick shoes, I took her for a boy at first:

223

a chunky, apple-cheeked thirteen-year-old, perhaps, with those small doughy breasts that some plump adolescent lads have. 'I told you it was her, Meg!' she announced triumphantly, leading me into the front room. 'I said: "It must be that writer because she's wearing an old leather jacket and she's dyed her hair red".' So much for my hopes of blending in.

Meg was sitting in a maroon velour armchair, part of the three-piece suite that was the only furniture in the room. She gave me a quick appraising look, nodded a curt 'Hello', then turned her attention back to spooning Milky Bar Dessert into the mouth of the baby on her lap. She was thickset like Alice, and dressed like Alice: jeans, heavy shoes, polo shirt, cropped blonde curls. The two sisters even had matching cold sores in identical places on their upper lips.

The baby smiled at his mother in a glazed kind of way, and brought up a casual mouthful of curdy white vomit. I sat down on the sofa.

'I got him back from hospital yesterday,' Meg told me by way of explanation, mopping gently with a towel. 'He was puking up blood and skinny as a wee skeleton, so they decided to take him in. They think maybe he can't take cow's milk. I think it's because of that jab they gave him when he was five weeks. He started puking and having diarrhoea straight away. He was all right before that.'

She gave him another spoonful. I studied her face as she expertly scraped up the overflow and shovelled it firmly back in. She was difficult to read: something guarded, half-sullen, kept her freckled, square-jawed features almost expressionless. 'They've given me some soya powder for his bottle,' she said, lighting a Silk Cut and resting it in the ashtray on the carpet. 'But he pukes that up too, so I thought I'd try this.'

'She spends hours in the supermarket reading all the labels, don't you, Meg?' chimed in Alice.

'Are you worried about him?' I asked, and Meg nodded. 'Aye' – brusquely, tight-lipped, not looking at me – 'They've put his name on a list and the doctor says they'll take him into care if he doesn't put on weight.' 'Does he think it's your fault, then?' Another brusque nod: 'Aye.'

'She was crying, so she was,' volunteered Alice eagerly, plonking herself down in the other armchair. 'The doctor came round and accused her of starving him, or letting Jimmy batter him, and Meg went crazy: screaming at the doctor, then chasing after him down the street. You should've seen her!' 'I just told him to fuck off,' said Meg, shrugging modestly. Then: 'I love my kids,' she said, suddenly defiant.

'Who's Jimmy?' I asked.

'My boyfriend.' Meg tilted her chin up proudly. 'His real name's Mandeer Singh Sidhu, but we all call him Jimmy. He's Jordan's father – isn't he, Jor-dan, Jor-dan, Jor-dan?' And she crooned the baby's name in a singsong voice, bouncing him gently on her lap. 'He works in an Indian takeaway in Glasgow. Usually he comes here twice a week, but he was lifted last Friday and put in jail for two nights. So he has to do overtime this week.'

'Lifted? You mean arrested?' Though I was back in my own country, I still felt like a foreigner. Their Scots vocabulary and accent, plus the sheer speed with which they rattled through the words – dropping every other consonant in the mud of the glottal stop – all meant I could decipher only about a third of what the two women were saying.

'Aye, arrested.' Meg chuckled and looked at her sister. 'That was some night, eh, Alice? I thought you were going to murder him!'

'He was going to hit Meg, so I split a chair over his head, so I did,' said Alice with a satisfied grin.

'It's because he was on the vodka,' Meg explained. 'He's okay if it's just beer. But he was steaming drunk and swearing, saying: "Meggie, you big bastard, you fat cow", and it sounded so funny in his Indian accent that I just pissed myself laughing. That made him even madder, so he says: "I want my son, give me my son", staggering around, so then Alice split the chair over him and phoned the police to get him lifted. They put an injunction on him to stop him coming here – so he'll have to sneak in at night now.'

'You're not afraid of him, then?'

Meg picked up the cigarette and took a deep drag, shaking

her head as she exhaled; 'No, he's hit me a few times when he's drunk, but he's never really battered me. Not like Dave did. Or Dad. Anyway, I've got Alice to protect me now, haven't I, hen?'

'Who's Dave?'

'Gemma and Jade's father. He used to batter me stupid.'

'How old are they?'

'Gemma's two-and-three-quarters and Jade's sixteen months. They're in a foster home till tomorrow, because Alice couldn't manage them on her own when I was with Jordan in the hospital. The foster parents took Jason too – that's her kid – so she could have a break, because he's a bit hyper – '

'Hyperactive, you mean?'

'Aye. He's two-and-a-half,' she supplied helpfully.

I began to do sums in my head. 'So you've got four kids under three in the house, is that right? Three of yours and one of Alice's?'

'Aye. All in nappies, the wee stinkers. We spend twenty quid a week on nappies, don't we, Alice?'

'And how old are you?'

'I'm twenty-one, and Alice is twenty-three next month.'

'So you had your first baby when you were – what? Eighteen?'

'Aye. Sixteen if you count the two miscarriages. That's one thing I'm really good at, isn't it, Alice? Having babies.'

'Like a fucking rabbit, so you are,' said her sister fondly, going into the kitchen.

'Do you want tea or coffee?' she called. 'It's Typhoo and Nescafé – we never buy that stinking supermarket stuff.'

While the kettle was boiling, I embarked on a little speech about the book and Meg resumed spooning, mopping and scraping the white goo around Jordan's mouth. Single-parent families were now one quarter of all families in the world, I explained. And I'd come to Scotland because the proportion of single mothers was greater here than in any other part of Europe. If she agreed to take part in the project, I wouldn't use her real name . . .

*

It was Linda, at the local Resource Centre, who'd suggested Meg. 'She's had a terrible childhood, but she's managing so well,' she'd said warmly. 'Her kids are always spotless, and they've had all their jabs.'

'Is she divorced?'

'Oh no. Very few of the girls get married these days. They'll fall in love and live with a man for a few years, then he'll disappear off with someone else and leave her holding the baby.'

This confirmed what I'd found out at Gingerbread Scotland, a support organisation for single parents. 'Births outside marriage have nearly trebled since 1980,' said Richie Smith, its National Co-ordinator. 'Most of the women are in a steady relationship when they get pregnant. They just want to settle down with the father and live happily ever after. But it doesn't work out like that. Even if they were married it wouldn't make much difference – Britain has one of the highest divorce rates in Europe.'

'And Scotland?'

'The statistics are changing so fast! One in seven Scottish kids was being brought up by a single parent ten years ago. Year before last it was one in four. But the latest figures I've seen make it two in five – nearly half. And three-quarters of them are living on benefits. That's more than twice as many as in 1979.'

He thought unemployment was partly to blame. 'Since the Ravenscraig steelworks closed last year, we've had a big rise in enquiries from that area. It's the same all over Scotland. Suddenly the man's around all day, and he's depressed and there's no money coming in. Then maybe he'll start drinking or getting violent, and the woman'll think: "I've had enough of this". Then there are those places where there's been no work for years and half the town's on benefits. How many relationships are going to survive a situation like that?'

When I came back to Meg's house the next afternoon, the place seemed to be full of children. Their bright down jackets hung

like huge balloons on the pegs in the narrow hall; their over-turned sit-on trains and tortoises and pink-pig prams littered the sitting-room like a pile-up on a cartoon motorway.

A dark-haired little boy with a blue dummy clenched between his teeth careered madly round the room on a tricycle, deliberately ramming the lurid plastic carnage and narrowly avoiding baby Jordan, now wide awake and bouncing blithely in a baby-walker. I became aware suddenly of two large porce-lain figures in traditional Chinese costume, perched on either end of the mantelpiece above the gas fire. They were the only items of decoration in the room. They began to seem alarmingly impermanent.

A tiny blonde toddler with sharp elfin features was stoop-ing unsteadily to pick up the baby's bottle. She stood up again, braced on splayed legs, and drank thirstily from it, while liquid dribbled in a sticky stream from the drinking spout of a red plastic cup in her other hand. A slightly older girl, with flaxen hair and a large blue bruise over one eye, was eating Jumbo Cheese Puffs, which she was tipping out on to the sofa in a rain of pungent orange crumbs. A pink drinking cup lay on its side beside them, leaking gently into the red velour. Some of the cheese puffs had dropped on to the floor and she began, uncon-sciously but remorselessly, to trample them into the carpet.

Picking up an overturned blue drinking cup, I sat down in one of the armchairs and put my bag on the floor beside me. Jason, the two-year-old on the tricycle, immediately skid-ded to a halt and hurried over to me, shouting 'What's that?' over and over in a high-pitched voice, muffled to near-incomprehensibility by his dummy. He pounced on my satchel and started undoing the buckles while Gemma, the cheese puff-trampler, plodded solemnly across the room proffering the empty packet.

Jade, the toddler, took the bottle out of her mouth and stared raptly at me for a moment before overbalancing and falling with a wallop, banging her head on the arm of the sofa on the way down. I braced myself for that terrible silence while she filled her lungs with air, then that terrible non-silence as she let out her breath in a great '*Wah*' of shock and pain.

Alice brought me some tea in a brown Smarties mug. 'I don't know how you people can stand it without sugar,' she said, identifying me with the stream of middle-class social workers and probation officers who had passed through her life. Meg came in with a biscuit tin and sat down in the opposite chair. 'Help yourself,' she said. 'There's Clubs and Kit-Kats and Bourbons. We don't let the kids have these, do we, Alice? These are our treat.'

I put the mug on the floor and discovered that Jason had taken all my Biros out of the satchel and was leafing through my notebook, still chanting 'What's that? What's that?', while Gemma struggled with the zip on my make-up bag. 'This is my notebook,' I said, retrieving it, 'and this is my make-up bag. And they all go in here.' And I rebuckled the satchel and rammed it firmly behind me on the chair. Undeterred, Jason began feeling in the pockets of my leather jacket, extracting car keys, a handkerchief and an envelope of money.

'You little monkey! That's for your mum and Auntie Meg,' I said, snatching the envelope away from him and handing it to Meg. 'It's to pay for food and things while I'm here,' I explained. 'So you can include me without having to worry about your budget. Is that okay?' While I was talking, a tearstained Jade tottered over and started trying to climb on to my lap, pushing Gemma out of the way and kicking over my mug of tea. Quick as a flash, Meg was on her feet with the baby under one arm, and had slapped her across the back of her legs.

By the time I'd finished mopping the carpet, Meg was striding off down the road with the money, a broad figure in a mauve and duck-green shell-suit, leaving an unfinished mug of tea and Gemma wailing 'Mummy!' heartbrokenly at the window.

'Where's she gone?' I asked Alice, visions of crack dealers and open-all-hours pubs in my head. Alice shrugged. 'Oh, she's always sneaking off,' she said, going back into the kitchen, where she was frying a pan of chips. 'Can't stand being cooped up in here all day. Jason used to be terrible when I had him on my own. He wouldn't let me out of the house. It was like a jail sentence, so it was. He was up till midnight every night banging

229

his head on the floor. Honest to God, I thought I was going crazy.'

'Did you take him to the doctor?'

'Aye. And they gave me some medicine for him. But he's been much calmer since I've been with Meg. She's better at controlling him than I am.' The chips were ready and she tipped them into three plastic bowls, added some Chick Sticks and three spoons, then put them down on the bare concrete floor in the corner of the kitchen.

The children treated their supper as entertainment rather than sustenance, dipping Chick Sticks in tomato ketchup and scribbling on the floor, or stubbing out chips on each other like cigarettes. While they ate, Alice got out the Hoover and began vacuuming orange crumbs in the sitting-room.

Meg burst back into the house an hour later, brandishing an armful of carrier bags. 'Gemma! Jason! Come and see what I've got for you!' It was clothes: pink dungarees for Gemma, and navy ones for Jason; both with matching T-shirts and striped sneakers. 'We take turns when we've got any money,' she told me. 'Gemma and Jason, then Jade and Jordan, then me, and then Alice.' Watching her lay out the pretty new clothes, I felt ashamed of my suspicions about street corners and addictive substances.

'Now don't touch, you filthy wee buggers!' she said, slapping their ketchup-caked hands. Then glancing at the clock: 'Alice – it's five o'clock!'

What followed was an operation of military precision. Alice filled the washing-up bowl with warm water and brought it into the sitting-room, while Meg fetched towels and a sponge from the bathroom. Then – working systematically, in age order, from Gemma down to baby Jordan – Meg took each child in turn and removed its clothes. Next she laid it down on the floor, peeled off and rolled up its disposable nappy and rubbed a soapy sponge thoroughly over its face, hands and bum – ignoring squeals of protest – before passing it, dripping and shivering, to her sister. Alice then rubbed each child all over

with a towel, laid it down on its back as before, then strapped on a thick wodge of clean nappy, and finally pulled on pyjama top and bottoms, and snapped the waistband in place with an expert flick of the wrist.

The whole operation took less than quarter of an hour from start to finish. By five-thirty the three older children had been kissed good night and put to bed, and Jordan was propped up in the corner of the sofa with a bottle balanced on a cushion on his chest. No fuss, no arguments.

'We always get them to bed before *Neighbours*,' said Alice, turning on the television and settling down with a cup of coffee and a Kit-Kat.

'And do they sleep through?'

'Aye. Unless they lose their dummies or fall out of bed.' Meg chuckled and lit a Silk Cut. 'They used to come down, but we put locks on the outside of the doors.'

They turned their attention to *Neighbours*' eternal sunshine. As soon as the credits came up, Meg switched over to *Home and Away*'s athletic teenage intrigues and playschool interiors. 'There's nothing on now till *Emmerdale* at seven; then it's *EastEnders* and *The Bill*,' said Alice when it was over, switching off and going into the kitchen.

'We take it in turns to cook each day,' explained Meg in answer to my question. 'But Alice gets up with the kids in the morning because I have to see to Jordan during the night.' She picked up the baby, sniffed his crotch – 'You're stinking again, aren't you?' – and laid him on the carpet to change him. 'Nothing stays inside him for more than two minutes. He either pukes it up or shits it out,' and she pressed her lips together, half anxious, half disgusted, as she rolled up the nappy and dumped it in a black plastic bin liner with the rest. 'If he hasn't put on weight when he goes to the clinic next week, they say they'll have to take him away from me.'

'How long have you been here?' I asked a bit later, as, following an age-old tradition, she rubbed his gums with whisky from a Bell's miniature, then squirted medicine into his mouth with a syringe. 'Six months. We did a council swap with a house in Dumfries. Before that we were in two different flats.

Alice and me have only been living together since I had Jade. She came to stay for a holiday and she never left. They were going to get me a home help, but I told them not to bother. Alice is better than any home help, aren't you, hen?'

Alice appeared briefly at the kitchen door, grinning and holding a half-peeled potato. Suddenly there was a loud thud from upstairs. 'That'll be Jade falling out of bed,' said Meg, and hurried out of the room. 'That kid's always falling over,' Alice confided quietly. 'I think there's something wrong with her. She's so wee and she's much slower than the others. Jason was jabbering away like crazy when he was her age, but she never says a word.'

'Do you go out much?' I asked later, as we ate our supper: a dauntingly large coil of boiled smoked sausage, processed peas and chips, balanced on our laps in the sitting-room and washed down with glasses of day-glo Irn Bru.

'I used to,' said Meg. 'When I was pregnant with Jade I used to get steaming every night. It was just after I broke up with Dave, and I didn't want to think about anything. I was working at the fish factory in Dumfries, and leaving Gemma with Dave's mum. I got really skinny – do you remember, Alice? I didn't feel like eating anything. I just wanted to drink.'

'And now?'

'Jimmy's old-fashioned. He doesn't like to see a woman drinking. Anyway, we can't afford to go out now we're not working. A babysitter costs ten quid before you've even started, and you can't leave the kids on their own. We had enough of that when we were wee, didn't we, Alice? See that scar?' She pulled up the leg of her shell-suit and showed me a livid red smudge on her calf. 'That's from when my nightie went on fire. Mum had gone out and left us with this alcoholic uncle, and he was messing around with paper and matches trying to light a fire, and my nightie just went up. His wife murdered him eventually – suffocated him with a pillow, so she did.'

'Did your mother often go out and leave you?'

'Oh aye. She was a right drunken slut,' said Meg care-

lessly. 'She'd start in the morning with Carlsberg Special as soon as she got back from cleaning the school. All her money went on booze. She even sold our First Communion dresses. Auntie Mary made them for us, but Mum just grabbed them and sold them before we could wear them.'

'And she never fed us,' Alice chimed in.

'Our brother Bobby used to go and steal bread rolls from the Paki shop for us, or sometimes one of the neighbours would take us in and give us a meal. We were always starving, and freezing cold because our clothes were always three sizes too wee.'

Meg grinned suddenly. 'She was good at cleaning, though, wasn't she, Alice? The house was always spotless, and she used to whiten her teeth with bleach.' I rolled my eyes in disbelief. 'Honest to God,' she insisted. 'That woman could feel no pain. Once I hit her over the head with a frying pan and she didn't feel a thing!'

'She was that drunk, she just went out like a light,' said Alice, giggling.

'So where was your father when all this was happening?'

'He pissed off when I was a baby,' said Meg. 'Couldn't stand her drinking. But he wasn't around much before then either, because he was in the Navy working on the submarines out of Helensburgh. After he left she started bringing lots of sailors home from the base. There was even a Negro – she told us he was our uncle!' So their mother was a single mother too: a woman alone with three children under five and a husband away at sea half the time. I wondered how she managed on a school cleaner's pay. I wondered whether she got money from the sailors.

'We used to hang out of the window watching for her when she went out drinking,' said Alice, 'and she always used to bring us back a Curly Wurly each so when we saw her we'd shout "Curly Wurly, Curly Wurly!". Once Meg got so excited she fell right out the window and cut her head open on the pavement.'

'I hated it when she was drunk,' Meg wrinkled her nose in disgust. 'She'd cuddle us and pass out, and there would be this big heavy arm round me, and I wanted to escape.'

'At least she never battered us,' said Alice.

'No, she left that to Mike,' said Meg bitterly. 'That was one of her boyfriends after Dad left: Mike fucking Baron. We went to live with him in Dumbarton. He worked at the whisky distillery, so she knew when she was on to a good thing, didn't she? He used to get drunk and hit us, and she was too pissed to even notice. So we had to protect each other, especially when Alice got leukaemia. Bobby and me used to stand in front of her so Mike would hit us instead of her.'

Leukaemia? On top of everything else? I tried to imagine it: two skinny kids of five and nine facing up to a flailing red-eyed drunk, while a pale seven-year-old with eyes like black bruises lay limply on an armchair behind them. I looked at the two thickset, freckle-faced sisters, tucking enthusiastically into their food, and I thought of their clean, plump, well-dressed children safely tucked up in bed, and I was suddenly aware of what an achievement that was.

'How old were you when you had leukaemia?' I asked Alice.

'I can't remember. It went on for years with jabs all the time and gallons of blood and big bruises all over my body. I swear to God, I woke up once and there was a priest there giving me the last rites! It must have been before Meggie was at school, because Mum used to bring her to the hospital to visit me and she was so starving she used to eat all my food.'

'Do you still see your mother?'

'Hardly ever,' said Meg, putting her empty plate on the carpet and lighting a Silk Cut. 'Not since they put us in the home in Helensburgh. She doesn't even know I've had Jordan. Last time I saw her she had arthritis and a kind of heart thing, and her face was all red and puffy. But she was still drinking like a fish – I reckon she'll kick the bucket soon.'

'How old is she?'

'Dunno,' said Meg. 'Forty-five,' said Alice.

'Were you upset to be taken away from her?'

'You're joking!' exclaimed Alice, collecting up the plates and taking them into the kitchen. 'We had the best years of our life in that children's home. They fed us proper food and took us on holiday to a caravan site. It was great.'

'We got taken there when I was about seven,' explained Meg. 'Just before Christmas. She'd gone out drinking and there was no one at home when we came back from school. So we had to wait outside on the stairs in the freezing cold. We were crying because we were so cold and we hadn't had anything to eat. Anyway, at about one o'clock Bobby knocked on one of the neighbours' doors and they called the police.

'That car was so warm,' she said, getting up to reposition Jordan's bottle on the cushion. 'They piled us all in the back and bought us fish and chips on the way to the station. And when we got there they gave us cornflakes and toast as well. We were in luxury, weren't we, Alice?'

I slept in Gemma's bed that night – 'She can come in with me and Jordan,' said Meg – beneath a duvet with a teddy-bear design on it. Jade was curled up like a kitten on the pillow of the other bed. There was no other furniture in the room; no light bulb in the bare fixture; no toys or clothes cluttering the spotless square of red carpet on the floor.

Coming downstairs the next morning, I narrowly missed stepping on a suspicious brown object on the bottom step. The three children were all pinkly and chubbily naked, and the remains of their breakfast – toast and cornflakes – were distributed, in various forms and consistencies, on their faces and hands, the carpet, the three-piece suite and the kitchen floor. Alice was ironing on the breakfast bar in the kitchen, dressed in pink furry slippers and a thigh-length T-shirt with a green rabbit grinning on the front. The inevitable black bin liner full of soiled disposable nappies was at her feet. I made myself some tea and toast, and sat down on the sofa.

Her pudgy little breasts quivering, Gemma waddled across the room, lifting her feet in a strangely distorted way. 'I think Gemma's shitting on the carpet,' I remarked, as neutrally as I could.

Alice flew into the room and delivered a ringing slap to

her niece's bare back. 'Just you sit there and don't move,' she shouted, ramming the offending bottom on to the potty, then picking up the pieces, dumping them in the bin liner and scrubbing furiously at the carpet with Dettol. 'There's a turd on the stairs, too,' I added helpfully.

'They're like fucking wee horses sometimes,' she exclaimed in exasperation as Gemma's bawling went up an octave. 'Just shitting as they walk along!'

'A Shit Parade, you mean?' I quipped. She laughed and dragged the bin liner into the hall, while Jade and Jason homed in on the immobilised Gemma and began amiably assaulting her with soup spoons and sprinkling her with generous libations of sweet coffee from the spouts of their drinking cups.

'Right! Bath!' Alice shouted, bringing the hostilities to an end, and they all trooped off upstairs obediently, eager to embark on the next entertainment of their day. Ten minutes later they scampered back into the room, shrouded in towels like three jolly little nuns, and charged over to investigate my notebook, my earrings, my half-eaten slice of toast, the little mole on my chin. Alice followed, heavy-footed and exhausted already, and removed them – one by one, in age order as before – laid them on their backs on the floor, and began to strap on their nappies and dress them in their newly ironed clothes.

Just as the final one was set on her feet, Meg appeared at the door with Jordan in her arms. 'Look what Gemma's done to my fags!' she exclaimed good-humouredly. 'Broken them all so she has, the wee cunt.' She sat down on a crumb-encrusted armchair and lit a flattened stub, beaming affectionately at the children, who clustered round her and tried to clamber on to her lap with the baby.

'Friday's great,' she said, as Alice hoovered up the remains of breakfast and then escaped upstairs to the bathroom to get dressed. 'I get my eighty quid income support and the three kids go to playschool for two hours so we can go shopping.'

'Is there playschool every day?'

She shook her head, disentangling herself from the children and going to the kitchen to fetch a bottle for the baby. 'It's all bits and pieces,' she complained. 'There's two lots of Sunday

school for Jason and Gemma; playgroup at the Resource Centre for two hours on Monday and Wednesday. But that's just Jason and Gemma, too, because they're older, so you can't do much because of Jade. Then there's the Special Needs playschool today and Tuesday. That's much better, because they take kids as young as twelve months.'

'So how often do you go shopping?'

'Whenever we get the money. There's twenty-five quid family allowance on Monday, Alice's sixty quid income support on Wednesday, then my eighty quid today. We added it up: we spend ninety quid on food and twenty on nappies. So we've got seventy-five left over between us each week for bills and TV rent and shoes and clothes and things.'

'And fags,' I added.

She grinned and stubbed out her Silk Cut. 'Aye, and fags.'

Nine-thirty, I discovered, was promenade time in Stranraer. Babies and pre-schoolers in immaculate clothes were paraded along dogshit-daubed pavements in state-of-the-art prams. This was how a woman in this part of town was judged: by the crispness of newly ironed dungarees, the whiteness of mittens and bonnets. They nodded and shouted cheerful greetings across the road to one another, sharp eyes missing nothing.

'Her children are always as dirty as tinkers,' hissed Meg as a chap-cheeked older woman passed out of earshot. We were walking into town: Meg and Alice in trainers and pastel shell-suits, the children puffed up in down jackets, me conspicuous in scuffed black leather. Jordan was lying in the pram; Jade sitting in a baby-seat on the front; Gemma stumbling along, whingeing, holding on to the handle. And Jason dawdling, picking privet leaves off a hedge, poking an ice-lolly wrapper in the gutter with a stick, blithely ignoring Alice's pleas for him to 'Hurry up!'

We dropped the children off at playschool, then walked to the shops, calling into the post office *en route* to collect Meg's money. The So Lo supermarket had narrow aisles and red and yellow Special Offer posters hanging from the ceiling. The two young women headed straight for the processed meats, where

they scrutinised the prices and sell-by dates before deciding on crimson barbequed chicken pieces. The next few selections were easier: two-litre bottles of Coke and Irn Bru; biscuits of various kinds, and sliced white bread; tins of spaghetti, meatballs, and baked beans; packets of crisps and instant noodles; coffee, hot chocolate, washing-up liquid.

I noticed that they always selected the brand-named rather than the cheaper supermarket version. Despite the additional expense, nothing which had not been advertised on television could be trusted to be good enough for their children.

Meg hesitated for a long time at the chilled desserts display, picking up carton after carton of sweet puddings and reading the ingredients with an expression of concentrated anxiety on her boyish freckled face. Milk was good for babies, she'd been told that; but she'd also been told that it was bad for *her* baby. So she was searching for something milky yet not milky for Jordan: something like Milky Bar Dessert; something that might stay in his stomach long enough to nourish him and stop him being taken away from her. Eventually she sighed and put a pack of expensive Chambourcy Real Fruit Desserts into the trolley.

At the toiletries display she added disposable nappies, baby powder and baby shampoo: 'That Johnson's stuff is dear, but they don't smell proper with that other rubbish.' Next came toilet paper and air freshener – then finally an item that had always mystified me when I'd seen it advertised on television: Shake 'n Vac carpet freshener.

We made our way slowly back to the playschool: past dark shops selling fishing tackle; past the cheap shoe shop and the expensive one – 'We don't even look in the window' – the baker, the greengrocer and Petrucci's Italian café – 'We have pizza and chips there every Wednesday'. We went into Mackay's 'for a look', and Meg and Alice held brown and navy-blue trousers, at least two sizes too small, against themselves, and white viscose blouses, either ignoring or avoiding the mirrors, each trusting the other to be the best judge of her appearance.

There were four other young mothers at the playschool when we arrived, and the air was blue with cigarette smoke. 'I can introduce you to lots of other cases,' offered the woman in charge, and I cringed inwardly – though no one seemed to mind being referred to as 'cases'. 'I'm quite happy where I am, thank you,' I said briskly, and retreated behind my camera. Gemma, Jason and Jade were playing quietly, utterly absorbed, surrounded by cars and blocks, dolls and dolls' houses, crayons, paper, Play-doh and plastic animals. I had to call their names to get them to look at the camera.

I wondered why they had so few of these things at home. Was it the expense? Or because Meg and Alice had never had them when they were children, so didn't see them as a priority? Or because no one had ever bothered to explain that children need their minds fed as well as their bellies? Or maybe it was simply the labour involved in clearing the toys up five times a day, just so that social workers could report 'that house is always immaculate'.

'I'm getting sterilised on the twenty-third,' announced Meg proudly to no one in particular. 'They said they'll do me when they do my abnormal cells.'

'Abnormal cells?' I asked. What now?

'On my cervix.' She seemed unconcerned. 'They say if they take them out now I won't get cancer later.'

'You're lucky,' grumbled one of the women, lighting up a Silk Cut. 'The doctor said he wouldn't give me a sterilisation in case I met a man who wanted more kids. I said "So what if I do? I still don't want any more", but he wouldn't listen.'

'What does Jimmy think about you getting sterilised?' I asked Meg later as we walked home, wondering how a man with a traditional Indian upbringing would react to the news.

'I thought I'd break it to him gently, when it's all over. The doctor said it's a tiny scar, so he'll think it's from the abnormal cells.'

'He'll go daft!' Alice warned. 'You know he wants another kid.'

'Fuck him, it's my body!' Meg retorted, her chin in the air.

*

The afternoon was a repeat of the day before, with minor variations. Meg cooked instead of Alice, for example, and we all had toasted sandwiches for lunch, with a ham and cheese filling, sealed and scalloped in a Breville machine. Gemma burnt her tongue and yelled; Jade was smacked for stealing Jordan's bottle from his mouth yet again; Jason cycled into the baby-walker and tipped Jordan on to the floor; and everything and everybody was anointed with Ribena drink out of little purple cartons. Then Meg changed all their nappies, while Alice embarked on the washing – a huge pile hidden behind the sofa – heaving steaming loads between the chambers of an ancient churning twin-tub in the kitchen.

Meg disappeared again soon after, and returned with a black machine which she plugged into the television. This was my first acquaintance with Sonic the Hedgehog, a redoubtable blue creature who leapt and somersaulted through a bewildering shifting landscape, continually dying and being reborn to the strains of a jolly electronic tune. Keeping him alive called for incredible concentration and hand-eye co-ordination. I was hopeless at it, but Meg had clearly become an expert. Plugged in and hunched cross-legged in front of the TV, she was impervious to the antics of the children in the room behind her.

By now I had begun to notice a pattern to the children's behaviour. For perhaps half an hour they would potter, with only minor grizzles, entertaining themselves with whatever was available: cutlery, me, food, tricycles, the potty, Meg's ashtray. Then a crescendo of frustrated energy would begin to build, with Jason ramming Gemma too hard and her bawling and tripping over Jade, who would retaliate by kicking her head until the noise would reach a critical pitch, when either Meg or Alice would wade in among them, swearing and administering slaps all round. There would then be an agonising climax of yelling, followed by protests, sniffs and sulks, and then blessed peace for another half hour. And this, I began numbly to realise, this ebbing and flowing of mayhem, went on all day. All day, every day. From seven till five-thirty – punctuated by nappy

changes, washing, cooking, ironing and hoovering, with just a brief respite, three times a week, when the two young mothers went shopping and were able to look, for twenty minutes at the most, at a few things they couldn't afford.

I was as relieved as they were when five-thirty came, and the older kids had been fed and dispatched safely to bed, the bulging black bin liner was finally dumped outside, and we could bask at last in the soothing sunshine and mundane melodrama of Australian soap. In the hiatus before *Coronation Street* and *Brookside*, we had the crimson chicken pieces, with baked beans and chips, followed by Coca-Cola – and chocolate cheesecake 'because it's Friday'. A recent survey had dubbed the Scottish diet 'the worst in the Western world', but that evening my heaped plate felt like a reward for getting through another day.

Afterwards it was Alice's turn with Sonic the Hedgehog. Meg laid Jordan on the carpet and changed him yet again, frowning, grim-faced, as she rolled up yet another goo-filled nappy. I remembered her defensive 'I love my kids' the first day we met – as if I might doubt it. Watching her tight lips soften with an almost-reluctant tenderness as she wiped him and talced him and put on another nappy, I wondered how on earth she would cope if they took him away.

'How did your mum react when they put you in the children's home?' I asked her later, as the three of us stared, mesmerised, at Sonic cavorting and expiring in time with his cheery jingle. 'She got three months for neglect, so she never got a chance to react. But she kicked up a helluva stink at court when Dad got custody of us. It was after we'd been in the home for two years. We went before the Children's Panel and they asked us who we wanted to live with. Alice and me didn't even recognise Dad because we were so wee when he was around. But Bobby remembered him and he really hated Mum by then. So he said he wanted to go with Dad. And we said we wanted to go with Bobby. She was well pissed, wasn't she, Alice?' Alice nodded absently, her eyes on the screen, her fingers busy.

'She screamed: "You fucking wee traitors, I'm the one who's looked after you all these years". Then she thumped Dad and they started battering each other – right in the middle of

the courtroom! So he took us home for Christmas, to this dump in Greenock where half the houses were boarded up. We hated it without our friends at the home, and we were going to miss the pantomime they were taking us to. So we ran away.'

'How old were you then?'

'I must have been nine. And Alice was nearly eleven, but she told the police she was sixteen so they'd leave us alone. But they didn't believe her. We got all the way to the Erskine Bridge before they caught us,' she said proudly. 'We walked along the beach because we didn't have a map. It was in the middle of the night and we were frozen to the bone. But they took us straight back to him. He started interfering with me six months later.'

I suppose I should have guessed. There had to be some reason why Meg's freckled face was so closed, and Alice's so open; something more than mere physical abuse. 'Do you mind talking about it?' I asked, and she shrugged: 'I don't care. Put it in your book. Nail the bastard.'

It had begun on her tenth birthday, she said, speaking matter-of-factly, avoiding my eyes. He'd brought her a cake and some presents, and then gone out to the pub. So she'd invited a couple of friends in from the street, and they'd all had a slice. 'When he came back he went loopy because we'd started on the cake,' she said. 'And he started smashing everything: plates, cups, the lot, and all the presents. We were terrified, weren't we, Alice? We thought he was going to murder us.'

'What happened then?'

'He battered us and told us to get to our fucking rooms. Then later he came in and sent Alice out, and said he was going to punish me specially because it was my fault. After that he used to do it whenever I'd been playing up.'

'As a punishment?'

'Aye,' still not looking at me.

'What about Alice?'

'He never touched her. I don't know why. Maybe because she had leukaemia when she was wee and he thought he might hurt her. He used to say I reminded him of Mum. Maybe that's why he picked on me.'

'Did you tell anyone?' I felt rather than saw Alice's plump

back tense. Sonic the Hedgehog exploded in a fountain of electronic stars. She pressed the 'hold' button, and turned round to face us. 'We shared a room, so I could hear what he was doing,' she said. 'But I didn't say anything because I thought Meg would call me a liar. Then he'd find out and kill me. So I used to stick my fingers in my ears or sneak downstairs to Bobby sleeping on the sofa. And I'd be crying and wake him up and tell him I'd had a nightmare.'

'I thought she was asleep,' said Meg bitterly. 'So I didn't think anyone would believe me.' Alice turned abruptly back to the television and released Sonic from his moment of frozen annihilation. The infernal bouncy tune filled the room again.

'How long did it go on?' I asked, picking up a tension between the two young women I'd never noticed before. Was this why Alice did most of the cleaning and Meg was allowed to sleep in in the mornings?

'About five years. I ran away when I was fifteen. I thought maybe I was old enough so they wouldn't make me go back to him. So I went to stay with a friend and told her mum, and they called the social worker. They put me in a children's home in Newton Stewart, and he was always coming to visit me and begging me to come home. It was pathetic,' she sneered.

'Was he prosecuted?'

'Alice refused to testify,' said Meg coldly. 'And the lawyer said we couldn't take him to court without a witness. She was still living with him, you see,' she explained, a little more kindly. 'She thought he'd murder her. But I got my compensation anyway – thirteen thousand quid for what he did to me. She still sees him, though,' she added, nodding at her sister's rounded back. 'He paid for the three-piece suite and the carpet as a Christmas present.'

'Guilt money?' I suggested, and she snorted: 'He doesn't know the meaning of the word. He behaves as though nothing happened – likes to think we've forgotten all about it. He's living with Bobby now, in Scunthorpe. Went for two weeks and ended up staying ever since.' She got up, opened a tin of Heinz Banana Vitamin Dessert, and began shovelling it into the baby's mouth. It was time to change the subject.

'Why didn't you breastfeed him?' I asked brightly. 'Wouldn't that have solved all these problems with cow's milk?'

Meg shook her head vehemently, screwing her face up in real disgust: 'Ugh – I couldn't do that. Someone sucking at you like that. It's not nice.'

Saturday dawned: the day when people with jobs go shopping. But Meg and Alice had already spent most of Friday's money on food and nappies. With no playschool for the kids, the hours stretched remorselessly ahead. 'Saturday's boring,' complained Meg when the kids were dressed. 'You can't do anything. And Tuesday's boring because there's no playschool. And Sunday's the fucking pits because the kids go to Sunday school but everything's shut so there's nothing to do.'

She switched the TV on, but no one took any notice of it. Damp clothes covered the radiators and steamed up the windows. The kids began squabbling over the pink handle Jason had wrenched off Jade's pram. My nose told me that at least two of them needed changing. Jordan started projectile vomiting on the sofa. Meg sighed heavily and went to fetch a towel, while Alice got out the Hoover again. The world was this sitting-room, with its grey Venetian blinds and flat blue carpet; its textured white walls and red velour three-piece suite.

They had almost no furniture, I realised. One bed each, plus the sofa and armchairs; that was all. Clothes were bundled, clean, into the few built-in cupboards, and ironed as they were needed. Dirty clothes lived behind the sofa. Bills were kept under the cushion of one of the chairs. 'What happened to your compensation money?' I asked Meg, wondering how they had managed to amass so few belongings.

'Spent it in two weeks, so I did.' She raised her chin, proud of the fact. 'It was when I was with Dave. I went out and bought furniture for the flat and lots of clothes, and a TV, and video, and a stereo, and two cars.'

'Two cars?'

'Well, I didn't like the first one, so I sold it and bought another. I couldn't even drive!'

My mind reeled. 'So where is all that stuff now?'

Now she was laughing. 'Dave sold it all,' she said. 'And spent all the money on slot machines. The three-piece suite cost a thousand quid, and he sold it for a hundred.'

I was aghast. 'Couldn't you stop him?'

She lit a Silk Cut and shook her head without rancour. 'I was scared stiff of him, wasn't I? He was bigger than me, and by that stage he was battering me every other day. I wouldn't stand for it now, though,' and she inhaled, throwing out her substantial chest. Was that why women were so big in this town: so that they could stand up to their men? Or was it because they ate chips and chocolate all day, imprisoned in their sitting-rooms with their kids?

The day crawled past. We progressed through coffee and Club biscuits, with crisps and Seven-Up for the kids; then Heinz vegetable soup an hour later; then tea and more biscuits. 'How did you meet Dave?' I asked Meg, while Alice completed the latest round of nappy-changes and none of us watched *Grandstand*.

'It was at this teenage hostel in Dumfries. I had to leave the second children's home because I turned sixteen. But I didn't want to go home to Dad. So I stayed with friends for a bit, but then I had to leave, so I ended up on the street. The police took me in for a night, then sent me to the women's refuge till they got me into the hostel. It's a special place for kids with bad backgrounds,' she explained. 'I was there for a year and started getting myself sorted out. They put me on tranquillisers and got me on to a YTS scheme as a bricklayer.'

'A bricklayer?' I raised my eyebrows, impressed.

'Aye. I was a good worker, too. It was a family business – they thought it would be a challenge to take on a lassie. But I caught on really fast. And I was so proud of myself – loved working there.' I could just see her in blue overalls and working boots, trading insults with the lads, with her arm muscles swelling and cement dust on her snub nose.

'So what happened?'

Her face hardened. 'It was just while the scheme lasted. They couldn't afford to keep me on after that. And I couldn't

245

get a job anywhere else because there's a rule that women have to have separate toilets. What building site's going to bother putting themselves out for one lassie?'

So that was that. 'Were you depressed?' How could she not have been? It must have been such a relief to find something she liked, something she could do: to see a chance of putting her horrific childhood behind her. She shrugged noncommittally: 'I went a bit wild after that. That's when I took up with Dave. He came to the hostel because his mum had thrown him out. He asked me to sleep with him the first night and I told him to get stuffed. But the next night I thought: "What the fuck?"' She grinned. 'We were turfed out soon after because you weren't supposed to have sex at the hostel and this girl I was sharing with grassed on us. They caught him hiding behind the wardrobe with just his bare bum sticking out!

'We had to go to Dave's mum's because there wasn't anywhere else and neither of us could find jobs. That's where I had the first miscarriage. I got on really well with his mum, but she couldn't stand Dave. So we went to stay with a friend, and then Dave got this caravan and we moved in there.' She shuddered and stubbed out her cigarette. 'God, that place was disgusting! Miles out in the middle of nowhere, dripping with damp and fucking freezing. There wasn't a cooker, so we had to eat sandwiches all the time. When the winter came we couldn't stand it any more, so we went homeless and got put in a B and B in Dumfries.'

She got up and fetched a carton of Real Fruit Dessert and began spooning it into the baby's mouth, ignoring the fight that had broken out between Gemma and Jason over who had the right to ride on Jade's pink pig. As the decibels mounted, Alice marched in and slapped them both, then picked them up unceremoniously one by one and dumped them on the kitchen floor in front of their bowls of fish-fingers and chips. Jade tottered off after them, snivelling in sympathy with their howls of outrage.

'So when did Dave start hitting you?' I asked, when the commotion had died down.

Meg shrugged. 'I dunno. We always used to hit each other – just for a laugh, you know. Then he started hurting me. I can't remember when it changed.'

'He was already battering you when we were in that B and B,' said Alice, standing at the kitchen door. 'Me and Jason's dad were homeless too,' she explained to me. 'And we were sharing with Meg and Dave in this one room. I was worried about him battering her, so when I heard this thumping in the middle of the night, I got up ready to murder him. But when I switched on the light, there was Meg sitting on his chest and battering him instead!' She chuckled admiringly.

'How long were you there for?' I asked, trying to imagine what life must have been like for the two teenage couples in that one room.

'Only a few months,' said Meg. 'Then we got the flat and my compensation came through, and I got pregnant with Gemma. But then Dave spent all the money, and we had to leave the flat and go to stay with his aunt in Stirling because this drug dealer was after him. He would've killed him, too, if we hadn't got out of town.'

I had begun to lose count of the number of times she'd moved: to children's homes and hostels, friends' and relatives' floors, caravans, police stations, women's refuges, council flats and bed-and-breakfast hotels. No wonder she had so few possessions.

'I already had Gemma by then,' she went on. 'But Dave's aunt didn't like having a baby in the house, so we had to go homeless again and they put us in another B and B. We were going daft stuck in one room with the baby, so my best friend Martha said we could go and stay with her in Stranraer. Filthy cow.' She almost spat the words.

'What do you mean?'

'Fucked him as soon as my back was turned, so she did. I got a job at Beattie's factory cutting shellfish by the front, so they were alone with Gemma and her kids all day. Well, one afternoon I got off early and found the kids on their own downstairs, all filthy and eating rubbish. So all the time I was working in that stinking factory, they were at it upstairs in her room –'

'Were you hurt?' It was a silly question: she must have been, but she wouldn't want to talk about it.

'I packed up that afternoon and went to stay with Alice. Then the next Saturday we bumped into the two of them in the street, and Martha had this big cheesy grin on her face – so I battered her.' And she nodded her head, lips pressed together, satisfied that justice had been done.

The football results came on the television, and the kids began trailing back into the sitting-room with OK Sauce on their chins and hands. 'God, this is depressing,' sighed Meg, opening the cupboard and tugging out the disposable nappies. 'Alice – go and phone Grace and see if she can babysit. I want to get steaming tonight.'

'Will I be allright like this?' I asked uncertainly as we were getting ready.

'You've got some weird clothes,' Meg commented, eyeing my red tartan romper-suit with disapproval. She was wearing a black-and-white blouse over jeans and clumpy black shoes. Alice was in a similar blouse, black trousers and identical shoes. We left our coats and bags at home, and each stuffed a ten-pound note in our pocket. We were to buy our own drinks, I was told: only rich people and show-offs bought rounds.

The door slammed behind us and we started walking, three abreast, in the middle of the road. The night smelt sharply of salt and ice. Above the stain of sodium, the air was clear as black water; the stars were like frozen crystals. We walked faster, panting and rubbing our bare arms, breathing orange clouds into the cold air. Then suddenly we were running: away from the TV and the shit, the Hoover and the half-eaten chips; along the road, past the grey houses, out of the estate, down the hill towards the quay.

'I hope you're not going to embarrass us by having wine,' hissed Meg as we went into the first pub.

'I'll have whatever you have,' I declared stoutly, and she

winked at Alice. 'A bareskin then: white rum, blue curaçao and Midori,' and she elbowed her way to the bar and waved her ten-pound note. The drink was turquoise, like cheap bubble-bath, with a similar consistency. It cost one pound twenty. Penned in by a wall of denim, acrylic and cigarette smoke, we sipped appreciatively, swaying slightly as men with red faces sashayed clumsily through the crowd holding brimming glasses above their heads.

Five minutes later we were outside again, gasping as the cold hit us. 'Don't go in there,' said Meg as I peered into a stained-glass saloon with a cheerful coal fire. 'It's full of posh people,' and she tugged me next door, where the light was brighter and there was a row of slot machines by the door. 'Vodka and Coke,' she said, slapping some coins on the counter. At the next it was Midori and lemonade, then pils, then vodka and lime; then the innocently named 'jellybean', a purple concoction of cider, white rum and blackcurrant. Once or twice we bumped into groups of uproarious tank-shaped women circling the town in the opposite direction. Geometric black-and-white was definitely *de rigueur*. Red tartan was definitely not.

By the time we reached our destination, we had nearly drunk enough not to care if we 'made right cunts of ourselves' on the dance floor, as Meg put it. The Devonshire pub was a slab of grey concrete on the harbour front, surrounded by car parks and wire litter bins. Like many of the pubs we'd flashed through *en route*, it had a disco-room at the back. Unlike many of the others, it was throbbing and packed to the gills. There were a couple of bouncers on the door counting people out and in to make sure that it didn't actually explode and to stop fights.

We queued up outside, stamping our feet and shivering. 'See her?' Alice nudged me as a tall woman in a skin-tight blouse and four-inch stilettos joined the queue. 'She's a right whore, so she is.'

'Pissed off and left the kids with her husband,' Meg added. 'I could never do that. And she sleeps with a different bloke every night, the dirty cow.'

When we got inside, the carpet was squelchy with spilt

drink and the basin in the ladies' loo was blocked with wet cig-
arette butts. Various people called out greetings, and amiable
drunks with leaden arms enveloped us as we ordered our
drinks. We pushed our way towards the dance floor and sat
stiffly around the edge waiting for our blood-alcohol to peak at
the required level. The air was like hot porridge, churned up by
people bouncing and jerking, packed together like puppies in a
sack. I smiled at Meg in a comradely way. She glowered back,
looking miserable and self-conscious. Beside her Alice beamed
maniacally at me, looking equally self-conscious. They drained
their drinks quickly and fought their way to the bar for refills.

Women – aged from thirteen to fifty – far outnumbered
men on the dance floor. Some were frantically fashionable: all
white elbows and cutaway halter necks. But the vast majority
of the women bobbing ebulliently to the acid house and soul
were Shit-Parade refugees like us in size eighteen trousers:
chips-and-chocolate junkies concealing corrugated bellies
beneath loose short-sleeved blouses.

After three pils, Meg began to grin. And at twelve-thirty
we ventured on to the dance floor, ramming our bodies into the
morass of clashing buttocks and perfumes. Occasionally a man
with glazed eyes would gyrate unsteadily in front of us for a
while, but mostly we just danced with each other like the rest
of the women; arms gamely pumping, breasts wildly jumping.
Towards two o'clock the emergency exits were thrown open
and the music throttled down to the modern equivalent of
'A Whiter Shade of Pale'. Men who'd slumped moodily over
their drinks all evening began to prowl around the herd of
swaying women, like cowboys selecting a heifer to rope. Soon
Alice was on tiptoe, necking with a pretty blond man in a black
shirt. I watched their tongues entwining, his hands roaming
tenderly over her plump back. Meg looked impassively in the
other direction.

Clothes wet with sweat, we spilled out under the wary
eyes of two pairs of policemen and began to trudge back up the
hill. 'There's that fat cow Belinda,' said Alice loudly, pointing
to a slab of a woman waiting outside Petrucci's pizza carry-out.
'She used to go with that John I was with, so she did,' she

explained. 'She can't stand to see anyone else with him.' The woman shouted something I couldn't decipher, and suddenly Alice had turned and was planting her feet firmly on the pavement, jutting her chin like a barking dog.

'Who're you calling a fat cow?' she screamed, apoplectic with righteous anger. 'I'll kick your fucking cunt in, so I will!'

'Shut up, Alice,' hissed Meg urgently, dragging her up the hill. 'There's a lassie with her the size of a lorry. They'll flatten us if you get in a fight!'

Alice squirmed out of her sister's grasp and started running back down the hill, her hands already forming into fists. Meg tore off after her and managed to pin both arms to her sides in a bear hug. They wrestled for a while, swearing colourfully at one another, then collapsed into drunken giggles. 'We always look after one another,' said Meg, winking at me.

The house was a mess when we got back. Jason was bawling, and the other kids were all up and running around in pyjamas and dirty nappies. Grace, the babysitter – a middle-aged woman with hugely bloated, flaking legs and tiny feet in fluffy slippers – greeted us cheerfully, surrounded by the remains of a Chinese takeaway. The news of Alice's pugnaciousness met with admiration and gales of hilarity, plus reports of other fights where women had 'battered' or 'been battered' by each other, or their men.

Meg lifted baby Jordan on to her knee, and the smile drained off her face. His nappy was so full it had overflowed at the waist.

After the high of Saturday evening, Sunday was, as Meg had predicted, 'the pits'. The kids were grouchy from being up half the night, and the TV blared non-stop, unheeded, in the corner. Meg and Alice winced and squinted with king-size hangovers. I didn't feel so great myself. Gemma and Jason were whisked off twice: in two different minibuses, to two different denominational Sunday schools. Niceties of dogma obviously paled to insignificance beside the chance for a few hours of blessed peace.

'Do you believe in God?' I asked Meg as she waved them goodbye at the door.

'Are you joking?' she snorted bitterly. 'With parents like mine? The Mormons came round once when I'd left Dave and everything was going wrong. And they said if you pray really hard everything will get better. I said if I thought I'd get some money I'd pray every day of my life. You wouldn't have to tell me.'

The more I discovered about Meg's life, the more she seemed the epitome of everything my right-wing government found abhorrent: the illegitimate pregnancies, the dependence on benefits, the violent boyfriend.

I wondered whether I should have chosen a more conventionally virtuous single mother? But I'd already written about someone like that: it would be hard to find someone more virtuous than Helen in Australia. But what good had virtue done her? Within her own class she was as poor as Meg was in hers. The difference was that whereas Helen's economic situation might have improved if she'd remarried, Meg's would hardly have altered at all: because in Stranraer, as in much of Scotland, the young men were as poor as she was.

I began to think that Meg and Alice were better off as they were: pooling welfare benefits and grumbles when the kids were in nappies, then later sharing chores so that at least one could go out to work.

If they could find jobs. If they could hold on to their children until then.

'You should get your man to buy you a new jacket,' said Meg, watching me hang it up the next day. 'I don't know how you can bear that old thing. Jimmy'd buy me a new coat if I asked him. He gives me thirty quid each week for Jordan, and he got me this ring – ' She thrust a lozenge of tiny diamonds under my nose. 'I told him: "Where's the necklace and earrings to go with them, then?" and he said he'd get them for my birthday.'

I laughed. 'Bill's a poet,' I said. 'He can't afford to buy clothes for himself, let alone for me. Actually, I bought a second-hand jacket for him last year.'

Meg shook her head in disgust and disbelief. 'You'd never catch me wearing someone else's old clothes,' she said, then: 'When you went to all those different countries, how long were you away from him?'

'About three months.'

Now she was really aghast. 'What, no sex for three months? I couldn't stand that. I've never gone longer than a month without sex. They say your fanny expands after you've had kids, but I reckon mine's shrunk! Sex with Jimmy's been much better since he got arrested. He's been really nice to me. Before that it was beginning to get really boring.'

She sat down and lit a Silk Cut. 'Dave was a real two-minute wonder. I used to say: "Is that all the fucking I'm getting? You'll not get another baby if that's the best you can do".'

'He wanted to have children, then, did he?'

'Oh aye. He wanted them allright. At the time. He's got babies all over the place with different lassies. First me, then two with that cow Martha; then another with some other lassie. Now he's in a caravan with someone else, and I think he's had a kid with her too.' And they probably all believed that he would settle down with them, I thought.

'Don't you want kids?' she asked after a pause.

'I'm infertile,' I said, feeling the usual faint thud of pain as I spoke the word. 'We tried having a test-tube baby last year, but it didn't work.'

'I'll have one for you,' she said flippantly. 'I don't seem to be able to stop.'

'Don't you use contraception?'

'Aye –' she seemed affronted. 'I'm not ignorant. We both tried the Pill, but it made us put on weight. So we switched to the injection. It stops your periods, so that's great. But it means you can't tell if you're pregnant.' She was referring to the notorious Depo Provera. I'd written about its dangers many times. It had been field-tested on working-class Glaswegian women, and was now widely used in poor countries. Its controversial

side-effects included headaches, 'menstrual chaos' and an as-yet unproven link with breast cancer. No doctor would dream of offering it to a middle-class woman.

We spent the rest of the day waiting for Jimmy. Not just that, of course, because there were all the usual chores to do. But the fact that he was coming gave the day a purpose other days seemed to lack. Meg became obsessed with keeping Jordan clean. She changed his nappy three times in one hour, and bathed him twice. 'Jimmy's very particular about his son,' she said with a touch of pride, dredging the baby's dark skin with talc. 'Look at his little black balls! Now you'll be a wee white boy, won't you?'

'Did you meet Jimmy at a disco?' I asked, and she laughed aloud. 'No, he never goes to things like that. It was when I was staying with Dave's mum, when I was pregnant with Jade. She was going with Singh, who owns this Indian restaurant where Jimmy works. I liked the look of him, so they fixed me up with a date. We went to the pub, then got a Chinese takeaway and a bottle of wine and took it back to his flat. He wanted me to stay the night, but I don't think you should have sex with a man on the first date.'

'It's disgusting, so it is,' agreed Alice. 'I never go to bed with someone unless I know him really well.'

'That's because you're the fucking Virgin Mary,' said her sister fondly. 'Jimmy thinks Scottish lassies are really easy. I said: "You'll soon find out I'm not as easy as you think!"' And she lifted Jordan on to her knee and began spooning Heinz Banana Vitamin Dessert into his mouth.

'How's his diarrhoea?' I asked, and her face tensed. 'They'll weigh him tomorrow at the clinic. So I'll find out then.'

Jimmy arrived on the dot of nine, and went straight upstairs with Meg. Alice looked worried. 'Maybe he's pissed,' she said. 'She hates it when he's been drinking.' I began to feel nervous, wondering how he'd react to find me sitting here taking notes. Alice went back to Sonic the Hedgehog.

He came down again half an hour later, still wearing his

coat. Thrusting his hands into his pockets, he sat down stiffly on the sofa: a tall unshaven man of about forty-five, staring uncomfortably at the carpet, his shoulders hunched protectively. Meg sat beside him and laid a possessive hand on his thigh. 'Debbie's just come back from India,' Alice said in a brave attempt at conversation. Jimmy smiled shyly at me and went back to staring at the carpet while the rest of us turned our attention back to Sonic the Hedgehog. He kept his coat on for the rest of the evening.

Later on we had a brief conversation about vindaloo curry. 'The amount of spice you should use for a whole pot of curry,' he said, with a sneer and a palpable Glaswegian twang, 'but these people want it all in just one small dish!' Much later, when Jordan woke up and started gurgling in the corner of the sofa, Jimmy took his hands out of his pockets and leaned over his son. And his tense body opened like a flower, and his face softened into a smile of real sweetness and wonder.

'Could he really be arrested for coming here?' I asked Alice after they'd gone up to bed.

'Aye. Because he's been done for drunk and disorderly twice now, and the kids have been put on a list in case he batters them.'

'Do you think he would?'

She thought hard, screwing up her face. 'No. I don't think he'd hurt the kids. But he might batter Meg. He hasn't yet, but I think maybe he could.'

'And do you think she'll go ahead with the sterilisation?'

'Oh aye. She's dead set on that. But I don't know how she's going to tell Jimmy about it.'

I lay awake a long time, listening to Jade fidgeting and slurping her dummy. Then I must have fallen asleep, because the next thing I heard was the door opening and the little girl plodding sleepily along the landing wailing for her mother. A few seconds later Meg appeared, silhouetted in the doorway with Jade in her arms.

'Go to sleep, you wee cunt,' she whispered, tucking her

back under the duvet. 'I'll batter you if you get up again, so I will.' The words were vicious, but they were spoken with such tenderness that the daughter could have had no doubt of her place in her young mother's heart.

Jimmy slipped out early the next day while I was in the bath. 'He says I can have two nights next week,' said Meg smugly, buttoning the pink dungarees she'd bought for Gemma on that first day. 'Do you love Mummy?' she asked, and Gemma nodded sullenly. 'Well, I don't love you!' she said, with a grin. 'Now mind you keep nice for the social worker,' and she picked Jordan up to sniff his crotch.

Alice had dressed Jason in his new clothes, too, and Jade was kitted out charmingly in a little paisley dress and matching tights. 'What time is it?' asked Alice, hoovering frantically.

'Oh, she's always late,' said Meg, sighing and wiping a gob of vomit from the front of Jordan's white Babygro. Wearily she began to rip open the poppers and strip it off him.

'What's she coming for?' I asked.

'It's ever since Jordan's been sick,' Meg explained. 'She's checking if I'm a "fit mother" for him.'

'What kind of thing is she looking for?'

Meg shrugged. 'I don't know. They never tell you. But we always make sure the kids have nice clothes, don't we, Alice? And we always keep the house clean and tidy so they've no excuse to take them away.'

The social worker arrived a few minutes later: flat shoes, flat dark hair, black tights, green tartan skirt. She sat on the sofa and the children swarmed excitedly all over her. As Jason upended himself over her shoulder, she patted his bottom experimentally. 'Still in nappies, are we?' she said, and the two sisters exchanged anxious looks. 'I'm glad to see Jordan looking so well,' she said carefully. 'And the other children are immaculate, as usual. Is he still being sick?'

'Aye. Now and then' – tense, noncommittal.

'I'm taking him to the clinic this afternoon to be weighed.'

'And what about arrangements for when you go to hospi-

tal for your operation? Can you give me the dates so I can organise the foster parents again?'

As soon as she left, poor Jason was stripped of his nappy and plonked firmly on to the potty. 'Now sit nice,' said Alice. 'She says you're too old to be shitting in your pants.' It hurt me to see how she'd taken the woman's casual comment so to heart. And my heart sank at the fruitless battles that lay in store, as she tried to force her two-year-old's restless little buttocks to 'sit nice' five, six, seven times a day.

We set off to the clinic after lunch. It was quite a long walk: Meg and Alice had to mount a continuous barrage of threats and promises to keep Jason and Gemma walking at a reasonable pace. By the time we arrived, the children's pink little faces were stained with tears of frustration and exhaustion. We sat down in a big waiting-room crowded with mothers and toddlers. The walls were covered with posters painted by children, proclaiming National No Smoking Day with a variety of gory images combining skeletons, graveyards and packets of Silk Cut. Our arrival elicited the usual exchanges of pleasantries and the usual covert comparisons of prams and children's clothing.

An hour later Meg was asked to bring Jordan to be weighed. Her face, as she stripped off his clothes and placed him on the scales, betrayed nothing of what she must have been feeling. She didn't look at the needle as it swung round and settled on a number. Her eyes were fixed on the nurse, who pursed her lips and noted down the weight on Jordan's clinic card.

'Good. Two pounds up on last month. He seems to be coming on nicely,' she said briskly.

Also of interest from Virago

SOUL PROVIDERS
Writings by Single Parents

Edited by Gil McNeil

One in five families in Britain are single-parent households. In 1994 2.1 million children are being raised by one parent. Patronised and pilloried, single parents are blamed for all of society's ills. This important and moving book, written by the parents themselves, goes far beyond the statistics and the media stories, and shows the real lives of single parents and their children. For most it's a constant battle against poverty, and for all it's a juggling game of time and energy. But against overwhelming odds their love for their children shines through, confounding the myths of failure and hopelessness. Including contributions from Glenda Jackson and Lynne Segal, an address from Gingerbread, and a preface by their president, Claire Rayner, this book is a unique and inspiring tribute to the 1.3 million parents who are their families' soul providers.

A PERCENTAGE OF THE PROCEEDS OF EVERY COPY SOLD GOES TO GINGERBREAD, THE NATIONAL ORGANISATION FOR ONE PARENT FAMILIES

BALANCING ACTS
On Being a Mother

Edited by Katherine Gieve

Thirteen women explore motherhood in this eloquent and moving collection. There are recurring questions and a wide variety of responses. How do children change women's lives? Do you, must you, become another person when you have a child? How do women who care for children also look after their own needs and desires? Can we balance children and work? How much do fathers engage in parenting?

The circumstances in which these women are bringing up their children vary hugely, and many speak of society's disregard for the needs of mothers, both over practical matters and deeper needs. Remarkably candid, *Balancing Acts* tells us much about a state 'both more overwhelming and entrancing than I could have dreamed'. The contributors are Yasmin Alibhai, Gillian Darley, Helena Kennedy, Hilary Land, Rahila Gupta, Katherine Gieve, Victoria Hardie, Elizabeth Peretz, Jean Radford, Margaret Smith, Jennifer Uglow, Julia Vellacott and Elizabeth Wilson.

BECOMING A MOTHER

An Essential Guide to the facts, feelings and emotions of pregnancy and birth

Kate Mosse

Parent and baby books are many, but the emotional passage of becoming a mother is largely uncharted territory. Interweaving medical, historical and scientific fact with candid revelations by ordinary women about how it feels to be pregnant and give birth, this book takes you week by week, from the decision to conceive through to the first few days with your baby. Here is reassuring and invaluable information on:

* Conception – if and when
* Feelings for your growing baby
* Your career and financial position
* Fear of something going wrong
* Relationships with friends and family
* Sex and love
* Choosing where and how to give birth
* Many women's labour stories
* First impressions of life with your child

Like your own mother or best friend who's been there before you, *Becoming a Mother* is a wonderful companion to the astounding process of creating a new life.

MAMATOTO
A Celebration of Birth

Introduction by Anita Roddick

Mamatoto (Swahili for mother and child) is a glorious pot-pourri of birthlore.

Here is the dramatic and moving story of birth – from conception to caring for your newborn – woven throughout with birth customs from around the world.

Mamatoto tells us about Aboriginal spirit babies; what remedies medieval English women used to treat morning sickness; illustrates myriad birthing positions and shows how different cultures help the baby draw its first breath. Here, too, is information about massages and oils to heal stretched skin or to help you soothe a crying infant.

Delighting us with outlandish ideas and commonsense wisdom, *Mamatoto* is an exuberant and stirring celebration of the diverse human pageantry of birth.